Prestel Museum Guide

Österreichische Galerie · Belvedere Vienna

Prestel Munich · New York

Österreichische Galerie · Belvedere
Prinz Eugen-Strasse 27, A-1037 Vienna
Tel. 01/79 55 7
Fax 01/79 84 337

Opening hours
Tuesday – Sunday 10 a.m. – 5 p.m.

Other branches
Studio in the Augarten
Gustinus-Ambrosi-Museum
Scherzergasse 1A, A-1020 Vienna

Gustav Klimt's *Beethoven Frieze*
Secession
Friedrichstrasse 12
A-1010 Vienna

**Belvedere – General information
(recorded message)**
Tel. 01/79 55 7-333
for details of current exhibitions and
activities at the Österreichische
Galerie · Belvedere

**Information
Guided tours**
Tel. 01/79 55 7-167
Fax 01/79 55 7-134

Press Office
Tel./Fax 01/79 55 7-113

Bookshop
Opening hours as above

Café Belvedere
Opening hours as above

Library
Opening hours
Monday – Friday
10 a.m. – 12 noon and 1 p.m. – 4 p.m.
Tel. 01/7 95 57-232

Contents

The History of the Österreichische Galerie

The collections of the Österreichi-sche Galerie [Austrian Gallery] offer the visitor the best and the most thorough survey of Austrian art, ranging from the Middle Ages to the present day, and embrace a great many major works from all periods. The Museum of Medieval Art is as much a part of the Öster-reichische Galerie as is the Baroque Museum or the extensive collections of nineteenth and twentieth-century art, each of these sections also including small but very valuable holdings of international painting and sculpture.

All these collections are housed in the Belvedere in Vienna, which consists of two palaces linked by a park, the whole forming a splendid Baroque ensemble. The Belvedere complex was commissioned as a residence by Prince Eugene of Savoy (1663–1736), a figure whose importance — be it as a military commander and a diplomat, as a courtier and a confidant to three Austrian Emperors, or as a patron of the arts and sciences — is still evident today in both the architectural and the decorative qualities of these structures. When the prince died he left no will. Accordingly, his only living relative, his niece Victoria (who later married Prince Joseph Friedrich von Sachsen-Hildburghausen) inherited his enormous estate in its entirety.

This very soon proved to be a great misfortune: Victoria at once attempted to make as much money as possible from the sale of the contents of the two Belvedere palaces. The precious statuary from Herculaneum was sold to the Saxon court at Dresden; the invaluable collection of paintings was catalogued and auctioned and thus dispersed to the four corners of Europe; and even the famous menagerie was disbanded. Fortunately, Emperor Karl VI was able to purchase Prince Eugene's library; and this, housed at the Hofburg [Imperial Court] in the splendid library hall designed by Johann Bernhard Fischer von Erlach, became the core of the Hof-bibliothek [Court Library] (now part of the Österreichische Nationalbibliothek).

It was not until 1752 that the Empress Maria Theresia acquired both Belvedere palaces and their park. She had wanted to do so earlier, in order to establish her summer residence there, but Prince Eugene's heir had always demanded too high a price. It was in fact only at this stage that the complex received the name 'Belvedere' — an appellation that could not have been bettered. Because the buildings and park were not in constant use, however (Maria Theresia having meanwhile decided to continue using the palace at Schönbrunn as her summer residence), ceremonial events and court festivities only occasionally took place there. The most sumptuous of these occurred in spring 1770 on the occasion of the marriage of Marie Antoinette (daughter of the Empress) to the French *dauphin*, the future King Louis XVI.

The situation changed fundamentally in 1776 when Maria Theresia's son and co-regent, Joseph II, decided (very much in the spirit of the Enlightenment) to transfer the rich collections of the Imperial picture gallery from the Stallburg — a part of the Hofburg in the city centre — to the Oberes Belvedere [Upper Belvedere]. The Basle scholar Christian von Mechel arranged the installation, hanging the pictures according to artistic 'Schools', and also prepared the first catalogue. The gallery was opened to the public in 1781, thus becoming one of the first publicly accessible museums in Europe. Two years earlier, at Maria Theresia's wish, the Belvedere gardens had been opened to the public.

As long as the Imperial picture gallery remained housed in the Oberes Belvedere — that is to say, until 1891 — a series of celebrated painters served as its directors. Especially notable among these was Friedrich Heinrich Füger,

the most important representative of Austrian Neo-Classicism. His period in office (1806–18) embraced the difficult time of the French occupations of Vienna in 1805 and in 1809 (during which the collection of paintings had to be transferred to other locations), the removal of many works on Napoleon's orders and their eventual, albeit not complete, return in the autumn of 1815. It was also during Füger's time that the tall ground-floor arcade at the centre of the Oberes Belvedere was enclosed with wooden doors and glazed. The Unteres Belvedere [Lower Belvedere] initially served as accommodation for various members of the Imperial family; but from 1815 it became a rather cramped gallery for the Imperial art collection previously housed at Schloss Ambras near Innsbruck.

Another noteworthy nineteenth-century director of the picture gallery was Johann Peter Krafft, who was appointed in 1828 by Emperor Franz I, having already testified to both his technical skill and his patriotism in a series of large-scale compositions based on events from earlier Austrian history and the life of the Emperor. Krafft oversaw the restoration of both Belvedere palaces and their park, regarding it as especially important to do justice to the function of the complex as a whole while maintaining and partially adapting the original buildings. Even from a modern point of view, this impressive early example of architectural conservation has to be acknowledged as a great success. Krafft was also concerned that the Imperial picture gallery should present the work of contemporary Austrian artists, and he reserved half of one floor of the Oberes Belvedere for such a purpose. In 1834 part of the Imperial collection of Antiquities was transferred to the large hall of the Unteres Belvedere, causing an even greater crush of exhibits. A delightful series of watercolours painted at this time offers eloquent testimony to this tightly packed collection but also to the eagerness with which visitors came to see it.

A new era began in 1891 with the completion of the Kunsthistorisches Museum [Art Historical Museum] on Vienna's new circular boulevard, the Ringstrasse. After the collection of the Imperial picture gallery had been transferred to the new museum, the subsequent history of these pictures was distinct from that of the Belvedere complex. Here, there was no further change until 1897, when the Oberes Belvedere was selected as the official residence of the heir to the Austrian throne, Archduke Franz Ferdinand. In ordering adaptations to the building, the Archduke was concerned to emphasize its Baroque character, even in the case of the re-decoration of quarters intended for accommodation and for offices. The series of engravings made in 1731–40 by Salomon Kleiner served, accordingly, as a guide and an inspiration. The Oberes Belvedere was nonetheless adapted to modern requirements, both electricity and central heating being installed.

After the Archduke's assassination in Sarajevo on 28th June 1914, the Oberes Belvedere again remained empty for several years. The Unteres Belvedere had, however, already been serving a new function since 1903. The immediate history of the Österreichische Galerie may be said to begin in this year, when the Unteres Belvedere became the home for the new Moderne Galerie, which was provisionally allotted rooms to the west of the central Marmorsaal [Marble Hall]. The decision to establish what was to prove the first Austrian state museum had been taken in 1901 on the advice of the Arts Council of the Austrian Ministry of Culture. After plans for the construction of a new museum building had been abandoned (designs by Otto Wagner being among those rejected), this temporary solution was found.

The establishment of a gallery for modern art had been urged by the Vereinigung bildender Künstler Österreichs — Secession [Association of Austrian Artists — Secession], founded in 1897. The Secession had also offered practical help towards the realization of such a scheme in donating several important works of contemporary art to the new collection (even before the gallery opened). These included *The Plain at Auvers-sur-Oise* by Vincent van Gogh and *The Evil Mothers* by Giovanni Segantini. The art works exhibited from 1903 in the Unteres Belvedere were initially derived from several sources: from donations such as those mentioned, from the state acquisitions made from 1851 onwards with the founding of such a gallery in mind, and as loans from other collections in the city and in its immediate environs in the province of Lower Austria.

A specially appointed commission was responsible for enlarging the new collection (in 1908, for example, Gustav Klimt's *The Kiss* was acquired), but it was not until 1909 that a separate director for the gallery was appointed: Friedrich Dörnhöffer, who remained in this post until 1914. Dörnhöffer initiated the systematic enlargement of the collection. It was also at this time that more serious consideration was given to the idea of extending the activities of the gallery beyond acquiring and exhibiting contemporary art to include the exhibition of representative examples of the whole of Austrian art from the Middle Ages to the present. This significant change was reflected in the new name now assumed by the institution: K. K. Österreichische Staatsgalerie [Imperial and Royal Austrian State Gallery]. Nonetheless, as only a part of the Unteres Belvedere was available for such a purpose, there was a severe lack of space.

After the end of the First World War the gallery was thoroughly reorganized and again re-named — as the Österreichische Galerie. The new scheme, devised by the art historian Hans Tietze, at the request of the Austrian Ministry of Culture, was implemented in 1920–21 by the director Franz Martin Haberditzl (who held the post from 1914 to 1938). Tietze's idea was for a tripartite division of the gallery holdings into a Baroque Museum (housed in the Unteres Belvedere), a gallery of nineteenth-century art (housed in the Oberes Belvedere, which was again available, having been taken over by the newly established Austrian Republic on the fall of the monarchy) and a modern gallery (housed in the Orangerie).

These three sections of the Österreichische Galerie were opened to the public in 1923, 1924 and 1929 respectively. Austrian works of the Baroque period had been transferred from the Kunsthistorisches Museum, while those of the nineteenth century had been drawn from the collections already amassed after 1851 for the modern section of the Imperial picture gallery. Haberditzl was concerned that recent and contemporary Austrian art be shown alongside the work of leading artists from across Europe so as to allow comparison and demonstrate interconnections. In spite of considerable economic difficulties during these years, important examples of nine-teenth and twentieth-century European art — above all French and German — were acquired.

Haberditzl's successor as director was Bruno Grimschitz, apppointed in 1938. By closing the modern gallery, he was able to save many of the works endangered as a result of being branded 'degenerate' by the Nazi régime. During the last years of the Second World War the collections were removed from the Belvedere complex and stored outside Vienna. In October 1944 the West Wing of the Oberes Belvedere was severely damaged by bombing, and in February 1945 the West Wing of the Unteres Belvedere met with the same fate.

After years of restoration, the various parts of the Österreichische Galerie were at last able to re-open — the Baroque Museum in the Unteres Belvedere in February 1953, the Museum of Medieval Art in the Orangerie the following December, and the collections of nineteenth and twentieth-century art in the Oberes Belvedere in July 1954. On 15th May 1955 the Oberes Belvedere was the venue for an event of considerable historical significance: on this date the foreign ministers of France, Great Britain, the Soviet Union, the United States of America and Austria gathered in the Marmorsaal to sign the Austrian State Treaty reconfirming the freedom and independence of the Austrian state after ten years of post-war occupation by the Allied Powers. The situation in Austria during the post-war period — continuous foreign occupation ending in the recovery of national independence — makes it understandable that the first priority at the Belvedere was the exhibition of Austrian, rather than foreign, art. In 1953, accordingly, the collection of French and German art of the nineteenth and early twentieth centuries was despatched to the Kunsthistorisches Museum and, in return, their holdings of Medieval Austrian art were transferred to the Österreichische Galerie.

It was not until 1987 that there occurred any substantial alteration in the resulting distribution (and in reality this was only a partial revision of that distribution). The holdings of international art forming the Neue Galerie of the Kunsthistorisches Museum (housed in the Stallburg) were returned to the Österreichische Galerie. It now became possible, in line with contemporary art

historical practice, to show Austrian art of the nineteenth and early twentieth centuries alongside European art of the same period. This arrangement was thus able to highlight the distinguishing characteristics of Austrian art as well as those qualities linking it closely with contemporary European developments. The holdings of the Österreichische Galerie had by this time also been expanded through the addition (in 1978) of the Gustinus-Ambrosi-Museum, housed in the spacious studio complex built in the 1950s for the sculptor Gustinus Ambrosi (1893–1975) and located in the Augarten park in the north-east part of Vienna (see p. 188). In 1992 this was adapted to serve as a venue for temporary exhibitions. Four of these are held each year, mostly devoted to the work of younger artists.

After many years of planning, extensive renovation work at the Belvedere started in autumn 1991, financed by a scheme that came to be known as the 'Museumsmilliarde'. The roofs, facades and outer sculptural decoration of the Oberes Belvedere and Unteres Belvedere were thoroughly restored. In the interiors, improvements and installations were undertaken in as far as these were necessary to meet the contemporary needs of a busy, large museum. At the same time, care was taken not to harm the precious architectural structure or decoration of buildings not originally intended to serve as museums. Changes and improvements were made with the needs and comfort of visitors in mind (museum shop, restaurant, substantial cloakroom, lifts and so on), but also in response to the requirements of the curatorial and technical staff (store-rooms, administrative offices, workshops and the like). The completion date set for this programme of rebuilding and restoration — the most extensive ever at the Belvedere complex — was spring 1996.

In the period leading up to this date, the individual sections of the Österreichische Galerie were in turn closed and then re-opened as this became possible (only in the case of the collection of Medieval art in the Orangerie was it possible to avoid a temporary closure). In each case the installation of exhibited works was altered. The Baroque Museum, re-opened in spring 1995, was followed by the sections now called 'Art at the turn of the century' and 'The Ringstrasse

Era and Historicism', both on the first floor of the Oberes Belvedere, and 'Neo-Classicism and Romanticism' and 'Biedermeier' on the second floor. The rooms of the ground floor of the Oberes Belvedere will now be reserved in part for temporary exhibitions and in part for the display of painting and sculpture after 1918, from the Österreichische Galerie holdings.

The history of the Österreichische Galerie has always been closely bound up with that of Austria itself, and it remains so. No less a role was played by the Belvedere complex that houses it — from Prince Eugene's day to our own. The principal task of the Österreichische Galerie, and its goal, is to provide a broad survey of the art of Austria, both by displaying works from its own collection and by serving as a venue for temporary exhibitions that allow the visitor to place Austrian art within the international context and so better to understand and appreciate it. A great many of the major works produced by Austrian artists over the last nine centuries are now housed in the two palaces of the Belvedere complex, where they are accessible to the public. It goes without saying that an equally important aspect of the work of the Österreichische Galerie is an engagement with contemporary art, its acquisition and its display. Our predecessors understood their own role in these terms, and in this we are honoured to follow them.

Prince Eugene and his Belvedere

Like his contemporary the Duke of Marlborough, Prince Eugene of Savoy (1663–1736) was one of the greatest military commanders of his age. In the context of Vienna, and indeed of Austria, he is no less significant for having commissioned the Belvedere palaces and their park. He was born in Paris, and his parents, a prince of Savoy-Carignan and Olympia Mancini (a niece of Cardinal Mazarin), originally intended him to take holy orders (he came to be known as *le petit abbé*). He eventually settled on a military career but was refused the position he had sought in France by Louis XIV and came penniless to Vienna in 1683. Here he joined the Austrian Imperial army, distinguishing himself almost at once at the relief of the Turkish Siege of Vienna. In 1687 he played a decisive role in the Battle of Mohács, and in 1697 he achieved the crucial victory over the Turks at the Battle of Zenta.

At around this time the prince acquired a house in the centre of Vienna, in the street now called Himmelpfortgasse. In 1695 the celebrated architect Johann Bernhard Fischer von Erlach was commissioned to convert this into an imposing town palace. The prince also acquired the former vineyards on the Rennweg in order to build a summer palace with its own park outside the city walls, in accordance with the prevailing fashion. This eventually became the complex we know as the Belvedere.

Prince Eugene was also a successful Imperial military commander during the War of the Spanish Succession

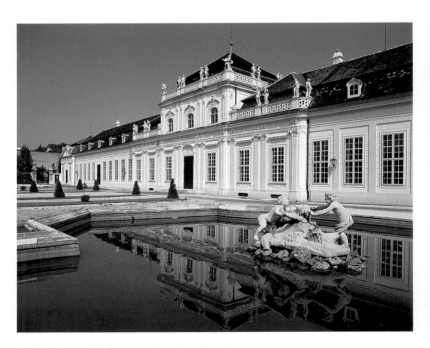

Fig. 1 The Unteres Belvedere viewed from the garden side

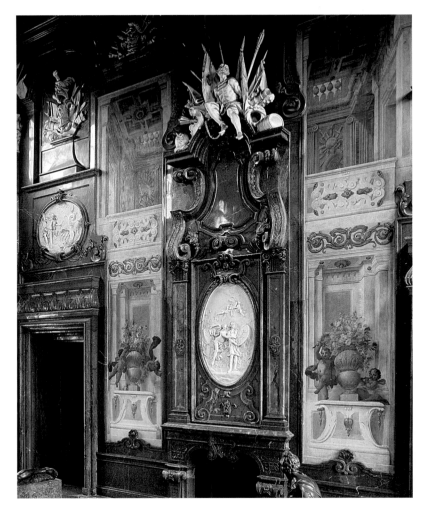

Fig. 2 The Marmorsaal in the Unteres Belvedere

(1701–13). In 1703 he was appointed President of the Austrian Imperial War Council, and in 1704 he beat French and Bavarian forces at the important Battle of Höchstadt. After further Austrian victories in battles against the Turks and against France, the Peace of Rastatt (1714) ushered in an era of greater stability. The prince took full advantage of this development, commissioning the architect and Imperial Court Engineer Johann Lucas von Hildebrandt (1668–1745) to build the palace we now know as the Unteres Belvedere, which was completed in 1716.

Victory at the Battle of Peterwardein earlier in the same year offered the prince a chance to allude to his military prowess in allegorical form in the ceiling fresco of the Marmorsaal of this palace. This 'monument' to the prince's achievements set the tone in determining dominant themes in the iconographic language of its decoration. The mythological glorification of the prince — usually as a 'second Hercules' or a 'second Apollo' — was, of course, serving here as a substitute for the more overt forms of asserting power and importance that were no longer acceptable to those also concerned to insist on their nobility and refinement.

Before the start of work on the upper palace, intended to correspond to

the lower one in terms of symmetry and overall layout, and nonetheless to surpass it, the prince's military career was crowned with his victory at the Battle of Belgrade (1717), an achievement that lived on for two centuries in Austrian folksong. After the Peace of Passarowitz (1718), with which Austria achieved its maximum expansion in the Danube Basin, Prince Eugene was able to concentrate entirely on his most ambitious plan — the construction of the building we now know as the Oberes Belvedere. The design, by Hildebrandt, was eventually evolved from the original scheme to erect merely a form of gloriette on the appointed site; the building work was carried out between 1721 and 1723.

In 1719 Prince Eugene had already received the Turkish Ambassador Ibrahim Pasha at the Belvedere — the sources refer to court buildings, pleasure buildings and garden buildings. According to the *Wienerisches Diarium*, this visitor viewed 'both the imposing building and the rare plants and animals as well as the ponds and artificial waterways'. The enormous sums expended on the terracing of the gardens and in the building work itself — during certain stages up to 1,300 day labourers were being employed — appear to have been met by the prince out of the income he received as Governor General of the Austrian Netherlands, a position he held from 1716 to 1724. Though reserved in his dealings even with his equals, Prince Eugene gave his administrators and architects precise instructions regarding both the palaces and the park, even when he was away on military campaigns.

As political adviser to three emperors — Leopold I, Joseph I and Karl VI — Prince Eugene repeatedly demonstrated his mastery of affairs, both where the security of the House of Habsburg was concerned (he thoroughly approved of Karl VI's 'Pragmatic Sanction' ensuring the succession of Maria Theresia), and elsewhere, keeping abreast of the scientific concerns of the time. In addition to his enthusiasm for architectural projects — these included Schloss Ráckeve in Hungary and the fantastical garden laid out at the Schlosshof in Marchfeld — Prince Eugene was in contact with some of the leading thinkers of the time (for

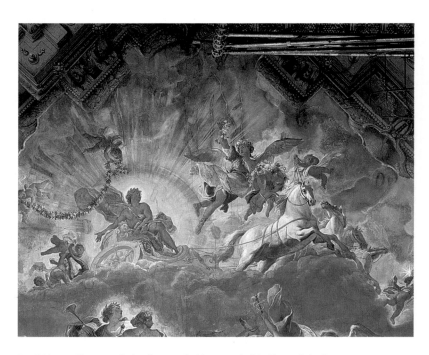

Fig. 3 Martino Altomonte, Ceiling fresco in the Marmorsaal of the Unteres Belvedere
Apollo in his Triumphal Chariot

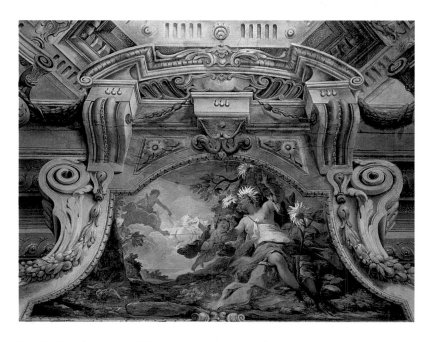

Fig. 4 Martino Altomonte, Lunette fresco in the state bedroom in the Unteres Belvedere
Apollo and Clythia

example the German philosopher Gottfried Wilhelm Leibniz), and was also very attached to his well-stocked library, most of which was housed in his town palace.

After Fischer von Erlach had retired from Prince Eugene's service, he was formally replaced by Hildebrandt. Born in Genoa, Hildebrandt had served the prince as Chief Field Engineer during his campaigns in Piedmont. Before starting work on the Unteres Belvedere, he had overseen the construction of Schloss Ráckeve and the completion of the prince's town palace. The lower Belvedere and its *cour d'honneur* were to occupy the entire breadth of a long, narrow strip of land to the east of the garden of the Mansfeld-Fondi Palace, running between the Rennweg in the north and the line of the wall that once served as the city's outermost defence in the south. To the west, in an enclosed triangular area, there lay an intimate walled garden with an orangery (now the Orangerie housing the Museum of Medieval Art) and the stables. As the site as a whole formed a slight slope, it was possible to divide it into a wooded lower area and a 'French' upper park with various pools and artificial water basins (these last designed by Domin-

ique Girard, who had been a pupil of the French architect and garden designer André Le Nôtre). From the Oberes Belvedere one could then obtain a splendid view across the city of Vienna, which Fischer von Erlach had initially planned to build at Schönbrunn.

As Hildebrandt's principal model was seventeenth-century French architecture, he was ultimately concerned to achieve an optimal integration of living quarters and those intended for recreation, so as to allow maximum scope for social and representational functions. His designs were thus intended to do equal justice to the imperatives of function and elegance. The Imperial Councillor and naval commander Claude Le Fort du Plessy assisted Hildebrandt as a sort of interior decorator, selecting textiles and furniture and also seeing to the arrangement of pictures and wall-hangings. Information on the original appearance of the interiors is to be found in the series of engravings published between 1731 and 1740 by Salomon Kleiner, Engineer to the Elector of Mainz.

As Prince Eugene's own archive has not survived, Kleiner's record assumes considerable importance for any enquiry into the original function of the

palaces and their park. In Kleiner's scheme, the Oberes Belvedere, a ceremonial structure placed at the highest point of the site, is mythologically, but also architecturally and hierarchically, understood as the Olympian haunt of the gods. It is thus placed above Parnassus, the seat of the Muses and the source of rivers (principal cascade). Coaches and carriages originally drove up to the Oberes Belvedere not on the city (i.e. north) side, now used by museum visitors, but rather on the south side, beyond the *cour d'honneur*, or pool court. This allowed the pool itself to enchant the visitor with a simultaneous view of the Oberes Belvedere and its reflection in the water surface. It is clear that the gardens at Versailles, with their *parterres d'eaux* and magnificent artificial waterways, served as a model here. Both Belvedere palaces are thus inseparably linked with the park that divides them: the text accompanying Kleiner's series of engravings refers, accordingly, to 'the garden and its buildings outside the city of Vienna'.

Both palaces are firmly anchored within the garden's symmetrical layout.

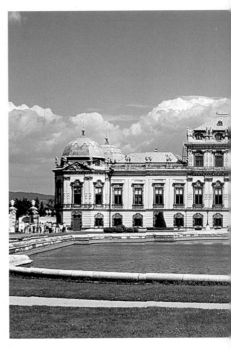

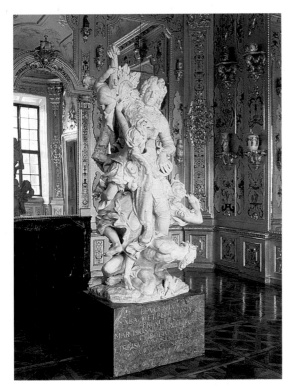

Fig. 5 Balthasar Permoser,
The Apotheosis of Prince Eugene
Sculptural group in the Gold-
kabinett of the Unteres Belvedere

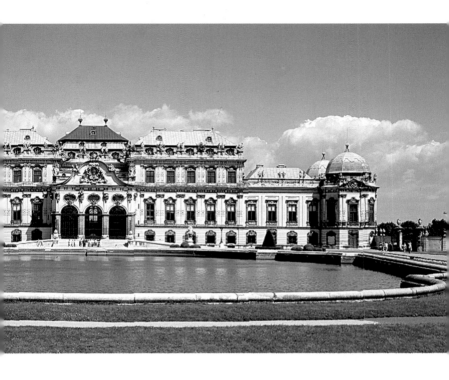

Fig. 6 The Oberes Belvedere viewed from the south

One might even say that they are 'inserted' into it, and in such a manner that they mutually condition the way each is perceived, with features in one constantly referring to elements of the other. The long, narrow strip of the garden offers scope for establishing a very effective sense of distance within the complex; similarly, at Hildebrandt's Schloss Schönborn near Göllersdorf, the orangery serves as a second architectonic focal point. The present-day entrance from Prinz-Eugen-Strasse (the former Heugasse) was first created by Johann Peter Krafft in the nineteenth century. This allows the visitor to come upon the Oberes Belvedere suddenly, with a diagonal view focused on one corner. From this perspective, the palace appears to have far more in common with the block-like solidity of Italian *palazzi* than with the elaborately articulated, elongated structure designed by Hildebrandt to complete the view across the park.

In examining the two palaces in more detail, we shall follow the intended 'reading' of the splendid gardens from north to south, beginning therefore with the Unteres Belvedere (fig. 1). The semi-circular main entrance on the Rennweg leads through an elaborate wrought-iron gate (crowned with the Savoy cross and the letters E and S in allusion to Prince Eugene) into the *cour d'honneur*. The former servants' quarters, set at an obtuse angle to the main block, are only minimally articulated, their jointed ashlars and bands following the traditional French treatment of purely functional structures. The central section (the *corps des logis*) dominates the palace building, being set off from those flanking it by means of double pilasters, tall framed windows and a sculpturally decorated attic. The central pavilion, which is half a storey taller than the rest, indicates the position of the Marmorsaal (fig. 2).

This was used for ceremonial occasions and for princely receptions and was the first room a visitor to the prince's court would see. The highly polished artificial marble is a deep, glowing reddish brown, the *trompe-l'oeil* architectural elements gleam with gilt, while the prince's claim to greatness is recalled in the splendid polished

white stucco figures of shackled Turks, posed against clustered spears and banners, and in the reliefs placed above doors and windows. Further reliefs, on the chimney-breasts, allude allegorically to Prince Eugene's military feats — *Venus asks Vulcan to make Arms for Aeneas* appears on the west wall and *Venus offers Arms to Aeneas* on the east wall. On the principal wall *trompe-l'oeil* architectural elements are combined with features in marble and *stucco lustro,* challenging the visitor's ability to distinguish between real and unreal space.

The ceiling fresco, by Martino Altomonte (1657–1745), serves as further glorification of Prince Eugene, who appears twice in allegorical form. Beyond a complex illusory gallery, we see a blue sky; towards its centre we find the Sun God Apollo in his triumphal chariot drawn by a team of four white horses and, beyond him and glowing around him, the rising sun (fig. 3). Aurora, meanwhile, Goddess of the Dawn, strews rose petals to announce the arrival of the day. Ahead of them all is Phosphorus, the Morning Star, who lights up the darkness of night with his torch. Also forming part of this day-and-night symbolism, so typical of Austrian Baroque, and hinting at the cycle

of life itself (it was taken up again in the nineteenth and early twentieth centuries in the work of Hans Canon, Edmund von Hellmer and Gustav Klimt, among others), are the Nine Muses, whom we find at the lower left, enthroned on clouds, here serving to acknowledge Prince Eugene's interest in the arts and sciences.

On the right can be seen a scantily clad, reclining hero of Antiquity (a further embodiment of Prince Eugene) accompanied by allegorical figures of Fame and Strength, and receiving Mercury's announcement of a gift from Pope Clement XI. This motif alludes to the granting of a consecrated cap and sword, glorifying the prince as a warrior for the True Faith after his victory at Peterwardein. The timing of this event allowed Altomonte to integrate it as a *fatto storico* within his work as this was nearing completion. The banner held by a putto refers to the event in a Latin hexameter that reads: 'Great genius, accept the gifts of Latium [i.e. the Pope] and enjoy them.' The banner also incorporates the date 1716, which was that of the completion of both the fresco and the Unteres Belvedere. The Pope's gifts to Prince Eugene prompted the Austrian Emperor Karl VI to write:

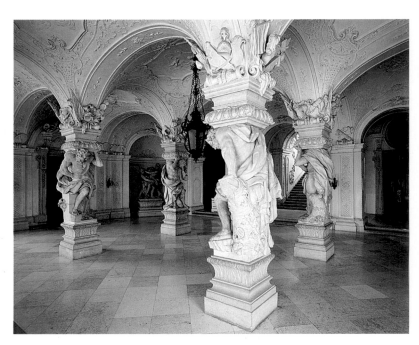

Fig. 7 The *Sala terrena* in the Oberes Belvedere

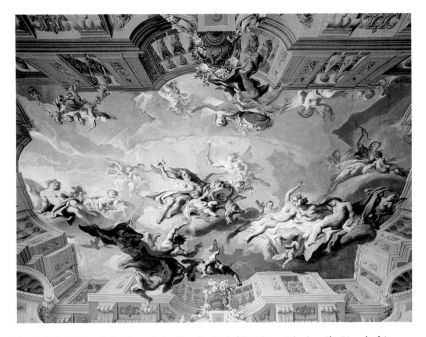

Fig. 8 Carlo Carlone, Ceiling fresco in the Gemelter Saal of the Oberes Belvedere, **The Triumph of Aurora**

'Besides, I'm pleased to see my dear prince in this role and with this beautiful cap, and I smile a little to myself for I know the pleasure you take in such honours.'

Around the Marmorsaal are grouped the former living quarters. To the east is the dining room, leading to the service room and the picture gallery. To the west is the state bedroom with a gilt trompe-l'oeil cupola (like the trompe-l'oeil decoration in the Marmorsaal, the work of the Bolognese painters Marcantonio Chiarini and Gaetano Fanti) and two lunette frescoes by Martino Altomonte symbolizing, respectively, Day and Night: *Apollo and Clythia* (fig. 4) and *Luna and Endymion*. The bed was so positioned that the prince, on waking, would be able to see the bust of Sol in the park through one of the windows. The walls were covered in moiré silk edged, below the cornice, with a fringed lambrequin.

From the state bedroom, corridors lead to the dressing room and to the Gemaltes Kabinett [Painted Cabinet] At the end of the western sequence of rooms (now part of the museum but originally serving as orangeries), there is a further sumptuous chamber, the Groteskensaal [Hall of Grotesques]. Its

decoration, following in the tradition of the *grotteschi* of Antiquity and the Renaissance popularized by Raphael, was carried out by the Augsburg painter specializing in such work, Jonas Drentwett. On the walls, medallions contain the figures of *The Three Graces* and the scene of *The Forge of Vulcan*, embodying, respectively, the female and male principles. On the ceiling there appear allegories of the Four Seasons and of the Actions of the Elements.

Running along the enclosed garden that was once reserved for the prince's personal use, is the sumptuously decorated Marmorgalerie [Marble Gallery] with its mirrors and statuary by Domenico Parodi as well as a set of antique sculptures acquired by the prince, the 'Ladies of Herculaneum'. Prince Eugene received these figures in 1713 as a gift from the general commanding the Imperial troops in the Kingdom of Naples. The archaeologist and art historian Johann Joachim Winckelmann wrote of them in 1755: 'These great masterpieces of Greek art had already been moved to Germany, and were greatly admired there, before Naples could boast of being in possession of a single monument from

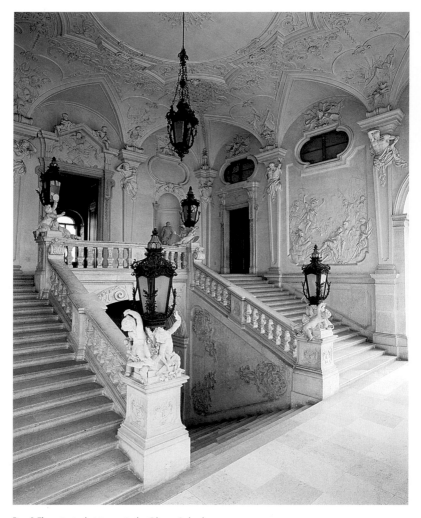

Fig. 9 The principal staircase in the Oberes Belvedere

Herculaneum. They were found in Portici near Naples, inside a buried vault, when the ground was being excavated in preparation for the construction of a country house for the Prince of Elboeuf, and they came directly [...] into the possession of Prince Eugene in Vienna. In order to have the best possible place in which to install these three figures, this great connoisseur of the arts had a *sala terrena* built especially for them, and here they are fittingly housed alongside several other statues.'

Beyond the Marble Gallery lies the Goldkabinett [Gold Cabinet], a mirror-cabinet with East Asian decoration of the type then fashionable (fig. 5). This had originally been located in Prince Eugene's town palace and was only transferred in the mid-eighteenth century to the Unteres Belvedere, where it probably served as a bedroom. Its decoration attests to a very high level of workmanship. The small library — most of Prince Eugene's books remained at his town palace in Himmelpfortgasse — completes this sequence of private quarters.

Viewed from the Unteres Belvedere, or from the present-day north entrance, the Oberes Belvedere (fig. 6) at first appears as a facade very effectively and festively marking the upper edge of the

park. It is richly articulated and its attic is decorated with statues. Particularly striking is the lively silhouette of the roof, the alternating rise and fall of its ornamentation bestowing a picturesque — one might almost say playful — character on the palace as a whole. As in the case of the Unteres Belvedere, the taller central pavilion stands out from the rest of the building; it also projects slightly at three distinct levels, while the elongated octagon of the Marmorsaal rises behind it. Its double columns and double pilasters create a most imposing entrance motif. To both east and west there extend further pavilions, while the two low wings link these with octagonal corner towers. Here, the originally rather severe and 'martial' air of the palace gives way to a sense of grace and festivity. Articulation is achieved by means of the characteristic layered motif of the pilasters and through the use of bands and floral festoons. Low relief ornamentation and the large openings of the portals and windows achieve an effective dematerialization of the main facade, above all when the palace is seen from some distance

On the ground floor of the Oberes Belvedere there is a square-shaped *sala terrena* with champfered corners

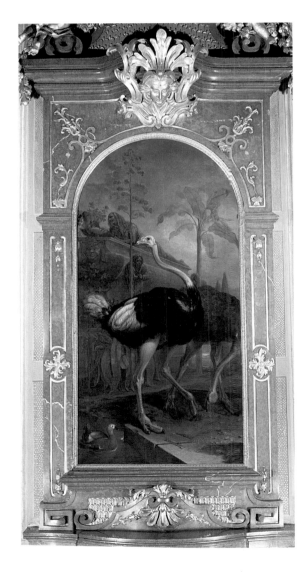

Fig. 10
Painted chimney-breast in the Marmorsaal of the Oberes Belvedere

(fig. 7), which has a vaulted, stuccoed ceiling supported by Atlantes. To either side of the *sala terrena*, lie the summer reception rooms, only one of which — the Gemalte Saal [Painted Hall] — has been preserved in its original state. In addition to its entirely frescoed walls, this has a ceiling fresco by Carlo Carlone, the *Triumph of Aurora* (fig. 8): Apollo holding his lyre and Diana with her bow and arrows symbolize, respectively, Day and Night.

The principal staircase, albeit now glazed for use as access to the museum (fig. 9), still retains its original form. A central, semi-enclosed flight leads to an intermediary landing, from which two side-flights run up to the level of the Festsaal [Ceremonial Hall]. The character of the space enclosing the staircase imitates that of a sumptuous campaign tent, a hint at Prince Eugene's military prowess that is also taken up in the stucco decoration. This incorporates themes from the life of Alexander the Great, in allusion to the prince's role as a magnanimous victor.

The core of the Oberes Belvedere is formed by the two-storey Marmorsaal, its festive splendour immediately conveyed in its dominant tones of red, brown and gold. The antiquarian and historian Johann Basilius Küchelbecker writes as follows: 'One then enters the great hall, about two storeys in height, with its ceiling frescoed with uncommon beauty, though with heavily gilt columns on the walls. From this hall one has the most beautiful view, both into the garden laid out around this palace and also towards the city, which, along with a large part of the suburbs, can be seen from this vantage point. The floor is covered in red marble, and everything is arranged in the most splendid manner, with no cost or effort spared, which can only contribute to the air of grandeur and magnificence.' As the principal antechamber of the entire Belvedere complex, this Marmorsaal did indeed have to radiate the 'magnificence' noted by this and other contemporaries of the prince.

An especially exotic element in the decoration of this hall is provided by the 'chimney-paintings', which show rare animals and birds — a pair of ostriches (fig. 10), a hyena, an antilope and a cassowary. Further motifs include banana and agave plants and cactuses. These allude to Prince Eugene's love of botany and zoology. The ceiling fresco (1721) by Carlo Carlone shows the victorious military commander enthroned beneath the coat-of-arms of Savoy, which is unveiled by the figure of Chronos. Mars, waving a standard with the Imperial double-headed eagle, presents the prince with a victory garland.

The rooms located to the east of the Marmorsaal, the prince's real state apartments, originally formed a sequence of antechamber, conference room, audience chamber, library and bedroom, corresponding to the contemporary conception of princely requirements. The conference room, intended for meetings called by the leader of the Privy Council and the president of the Court War Council, was an absolute necessity here. It has a surviving ceiling painting by Giacomo del Pò that celebrates the prince's virtues as a military commander. In 1731 Prince Eugene, in his office as president of the Court War Council, used the audience chamber to receive the Turkish Ambassador Nasif Mustapha when he came to announce the accession of Sultan Mahmud.

From the library one gained access to the palace chapel by way of a gallery. The chapel has a ceiling fresco by Carlo Carlone and an altarpiece by Francesco Solimena showing the Resurrection. The date (1723) appearing above the altarpiece and the inscription 'Pax mundo resurrectio Christi' allude to the completion of the building programme in this year.

The sequence of rooms to the west of the Marmorsaal originally served the practical purposes of eating and recreation; it contained a dining room, a coffee room, a gaming room, a picture gallery, a further bedroom and a service room or buffet. After eating, the prince and his guests might stroll in the picture gallery, which occupied the entire breadth of the west facade. Here there hung Italian works from the prince's picture collection, including paintings by Titian and Guido Reni (some now in the Galleria Sabauda in Turin but otherwise dispersed all over Europe or untraced).

The Museum of Medieval Austrian Art in the Orangerie

The Österreichische Galerie collection of Medieval art is strongest in work from the Late Middle Ages, above all in examples of Late Gothic art. The collection of panel painting and sculpture includes an astonishing concentration of major works, indeed real masterpieces, and offers the visitor a remarkably full and representative record of artistic evolution — from the 'International Gothic' ('Soft Style' or 'Beautiful Style') of the years around 1400 to the concluding phase of Late Gothic in Austria in the early sixteenth century. Even though the collection is not particularly remarkable in terms of the sheer number of individual objects it contains, it is nonetheless of importance because of their quality. In this respect it occupies a special place among museums of its type, and particularly among those within Central Europe.

The artistic evolution illustrated in this section of the Österreichische Galerie is embodied in a series of outstanding works, which, in every respect, are as high in quality as any to be found in Europe in the Medieval period — from the work of the Master of Grosslobming (an anonymous sculptor from the early years of 'International Gothic') to that of the painter Rueland Frueauf the Elder. Alongside the 'Western' style of the Master of the St Lambrecht votive panel from the late phase of 'International Gothic', we find, for example, works by anonymous, albeit stylistically distinct, artists such as the Wiener Darbringungsmeister [Viennese Offering Master], the Master of the Friedrich and Andreas Altarpieces and the Master of Lauffen.

In the panel paintings of the Albrecht Master (active in the 1430s) we can recognize a style akin in many respects to that of Hans Multscher, Konrad Witz or Lukas Moser. The Albrecht Master too evolved a style of his own based on his response to the influence of the recent innovations in Early Netherlandish painting. The same is true of the Master of Schloss Lichtenstein, who was active at a slightly later date. Conrad Laib, meanwhile, is one of the leading painters of the mid-fifteenth century active in the Austrian Alps. Laib worked largely in Salzburg, while his surviving work is also to be found in Styria (Graz Cathedral) and what is now Slovenian Styria (Pettau Altarpiece). In evolving a style of his own, he adapted and combined Early Netherlandish and Italian innovations (particularly the work of Altichiero). Especially novel in work produced north of Italy was the atmospheric component (a Venetian-style *sfumato*), which achieved the intended effect despite its combination with an ornamental gold ground.

In the realm of sculpture, alongside the already mentioned Master of Grosslobming and the work being produced in Wiener Neustadt and Scnr tagberg as early as the fourteenth century, the field is dominated by the most significant piece of wood carving to be produced in Europe in the first half of the fifteenth century — the Znaim Altarpiece. This triptych, which is exceptional in its bold colouring, attests to its artistic dependence on the early phase of Early Netherlandish painting and does, indeed, function as if it were a two-dimensional work transposed into the form of a brightly coloured relief. In terms of style, the influence of this masterpiece is to be found in sculptures made in the workshop of the versatile artist Jakob Kaschauer.

The notable speed with which currents of artistic influence followed each other in moving from west to east is illustrated in the Österreichische Galerie collection through a sequence of works spanning the later Middle Ages. At a somewhat earlier period, south Netherlandish influences served as a source for motifs and stylistic elements that were then taken up and adapted in northern Netherlandish art. These emerge, in turn, in the work of the Viennese Schotten Master and of his

numerous followers, including those at work in Transylvania (Medias Altarpiece); and here they encouraged some truly significant innovations. In the Medieval collection of the Österreichische Galerie there are two panels from the Schotten Altarpiece as well as several works clearly influenced by it — panel paintings by the Master of the Hauser Epitaph, the Master of the Oswald Legend, the Master of the St Vitus Legend and the Master of the Martyrs.

Sculpture in Austria was influenced from about 1470 by the work of the North Netherlandish artist Niclaes Gerhaert van Leyden (tomb of the Emperor Friedrich III in the Stephansdom in Vienna), who was responsible for introducing his followers to a second 'International Gothic' style. In the work of the Tyrolean painter and sculptor Michael Pacher we find a novel form of the adaptation of Early Netherlandish and Italian influences (Andrea Mantegna) in compositions making emphatic use of central perspective. The Österreichische Galerie's collection of masterly examples from every significant phase of Pacher's development offers compelling proof of his versatility. His panel paintings from St Lorenzen (in the Pustertal) reveal the influence of Mantegna but also a knowledge of Masaccio's frescoes, in particular the scene of the Chairing of Saint Peter in the Brancacci Chapel in Santa Maria del Carmine in Florence. In the work of artists active during the later years of Pacher's career, such as the Passau painter Rueland Frueauf the Elder, forms of pictorial organization learnt from Pacher's generation undergo a certain exaggeration. They become more monumental, particularly with regard to figural composition, and evince great attention to 'atmospheric' values. In the cycle of panel paintings produced in 1490/91, the Österreichische Galerie may be said to possess Rueland Frueauf's most outstanding work. In the panel paintings of the ambitious Master of the Krainburg Altarpiece, a constant engagement with artistic innovations is issued in a mannered combination of certain Late Gothic conceptions of form with the stylistic devices and colouring associated with Utrecht painting of the early sixteenth century.

As is clear even from this short introduction, the Medieval collection of the Österreichische Galerie is not able to offer the visitor an extensive or very thorough overview of the artistic development of Austria in the Middle Ages. It has not been possible to muster a survey as complete as that found in the Medieval section of the Národní galerie in Prague (housed in Jiřský klášter, to the east of St Vitus Cathedral in the Hradschin complex). On one hand, a large number of Medieval works are fortunately still *in situ* (i.e. to be found in the buildings for which they were originally made); on the other, a great many other institutions in Austria have concentrated on assembling Medieval collections. In order to attain a full and representative impression of the development of Austrian art in the Medieval period it is therefore necessary to look at works that are still *in situ* and also to visit other collections.

Apart from the other museums in Vienna — the Kunsthistorisches Museum (Schatzkammer), the Museum für angewandte Kunst, the Historisches Museum, the Dom- and Diözesanmuseum and the Schottenstift Museum — there are also the many important museums forming part of monasteries and other religious foundations. Especially notable are the collections of the Augustinian monastery at Klosterneuburg and of the Cistercian monastery at Heiligenkreuz. Other collections worthy of attention are those of the Cistercian monastery at Zwettl, of the Augustinian monastery at Herzogenburg and of the Benedictine abbey at Seitenstetten (these last three all in Lower Austria). One should also see the Medieval holdings of the Augustinian monastery at St Florian, of the Premonstratensian monastery at Schlägl and of the Benedictine abbey at Kremsmünster (all three in Upper Austria). Last, but not least, there are the rich collections housed at the Benedictine convent of Nonnberg (in Salzburg), at the Premonstratensian monastery in Innsbruck-Wilten (Tyrol), at the Benedictine abbey at St Lambrecht (Styria), in the Diözesanmuseum of St Pölten (Lower Austria) and that of Gurk-Klagenfurt (Carinthia), and in the Dommuseum in Salzburg and the Landesmuseums.

As a result of a programme of sales implemented during the First Republic (1918–38), important Medieval works of art of Austrian provenance entered the collections of museums abroad (Munich, Berlin, Paris, London, New York).

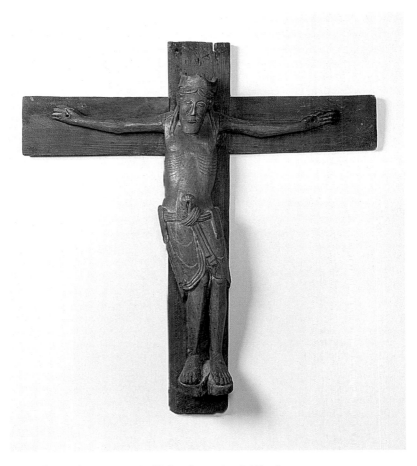

Sculptor from Tyrol, **Romanesque Crucifix from Stummerberg in Zillertal**,

Sculptor from Tyrol (active around 1150)
Romanesque Crucifix from Stummerberg in Zillertal, c 1160
Alder-wood, 88.5 x 78 cm (figure)
Inv. No. 5986

The beams of the cross, though certainly Medieval, are not original. The carved figure is an example of the 'Christus Triumphator' type traditional from the Carolingian era (c.f. the casts taken from the crucifix of Charles the Bald that was in the original Basilica of St Peter in Rome), that is to say, a figure with wide-open eyes and crowned head, presented as the Conqueror of Death and thus already hinting at the idea of Resurrection. Only the inclination of the head and the slightly bent arms tell of the agony of death on the cross. The individual sections of the body are rendered with an emphatic stereometric solidity, but this is offset by the refined treatment of the internal contours — the delicacy of the lines indicating the rib-cage, the emphasis on the almond-shaped eyes and the sinuous strands of hair. The way in which the loin-cloth is knotted and the modelling of its drapery folds achieve emphatic ornamental accents in spite of their adaptation to the body. On this account, and also because of the hint of slight *contrapposto* in the otherwise stiff and elongated figure, a date of around 1160 seems probable. North Italian influence would appear to have played a determining role in its style, as it is similar to the crucifix from San Candido in Innichen in South Tyrol, now part of Northern Italy). The crucifix from the Zillertal (Tyrol), acquired by the Österreichische Galerie

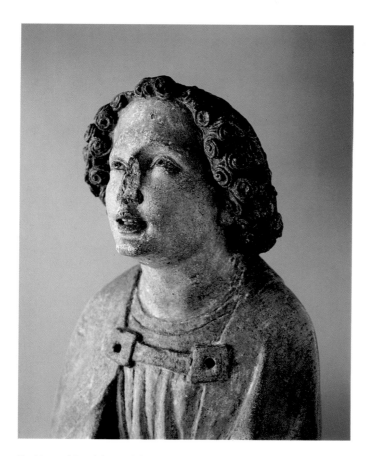

The Master of Grosslobming, **Saint George**

only in 1973, is among the few pieces in the collection dating from the High Middle Ages. Its original location is unknown, though we may assume that it served as part of an altar or choir screen in one of the Tyrolean monastery churches.

The Master of Grosslobming (active during the last quarter of the fourteenth century)

In the early twentieth century, in the small village church of Grosslobming in Upper Styria (not far from the monastery of Seckau), five sculpted figures were discovered. These proved to be key examples of Central European sculpture from the early phase of 'International Gothic'. Although the Master of Grosslobming remains biographically anonymous, his unmistakable individual style is so distinct that analysis of it

alone has allowed scholars to trace his artistic development. Drawing on the most significant contemporary achievements in Western Europe (that is to say, works produced in France under the influence of Netherlandish artists) and on sculpture in the Stephansdom in Vienna exhibiting strong mid-fourteenth-century Tuscan influence, the Master of Grosslobming evolved a sculptural treatment of the figure combining great physical stability with psychological and emotional force, the latter above all in the treatment of facial expression.

Angel of the Annunciation, c 1380 (?)
Chalky sandstone from Breitenbrunn, traces of
original colouring, 78 x 45.5 x 25.5 cm
Inv. No. 4901

Saint George, c 1375 (?)
Chalky sandstone from Breitenbrunn, traces of
original colouring, 105 x 44 x 28 cm
Inv. No. 4891

The lively face of the Annunciating Angel goes beyond merely recording the physical changes that occur during the articulation of speech. There is also an almost impish element in the facial expression, suggesting perhaps that the Angel knows of the human tragedy implicit in his ostensibly happy announcement — the Immaculate Conception eventually issuing in the Passion of Christ. This emotional exploitation of physiognomy, which is worthy of the art of portraiture, was doubtless inspired by the work of the Netherlandish sculptor attached to the Paris court, Jean de Liège.

In this Saint George group, the sculptor effortlessly freezes action taking place in time. The saint's facial expression has a certain sensuality, enabling the artist to hint at a feeling of apprehension and one of relief, both serving as an emphatic contrast to the snarling jaws of the dragon. The figure of the knight, youthful like that of a David, is only able to keep the heaving monster at bay through his knowledge of how to turn the physical imbalance of the struggle to his own advantage. The group as a whole retains its inner stability despite the shifting of axes introduced through the twisting and turning of each figure. It is clear, however, that

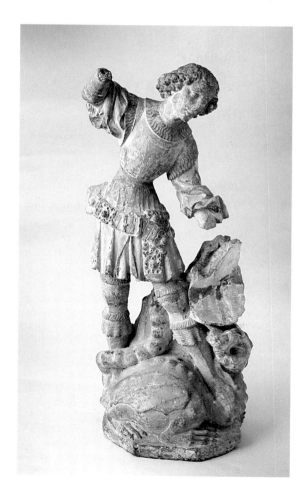

The Master of
Grosslobming,
Saint George

25

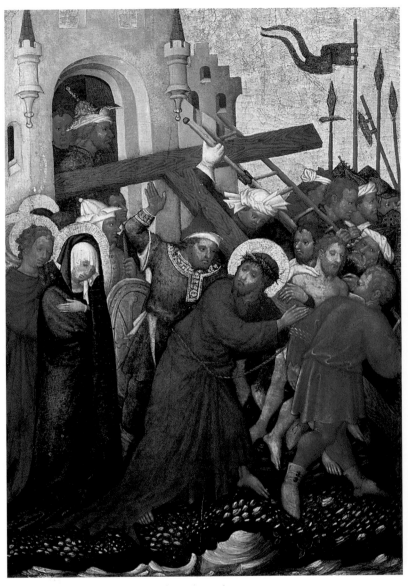

Master of the St Lambrecht votive panel, **Christ Carrying the Cross**

greater stability was originally derived from the presence of the saint's cloak (now only preserved in fragments), which bestowed an exaggerated compactness in terms of overall contour in spite of the attention to detail in its realistically rendered decoration. In its compact concentration, this group proves just as effective as the expansively treated Prague Saint George group of 1373, cast in bronze with the saint on horseback (Prague, Hradschin, now in the Národní galerie). Both groups, indeed, suggest the influence of the relief of the Conversion of Saint Paul on the Singertor of the Stephansdom in Vienna, particularly with regard to the shifting axes and the contrast of the slight human figure and the massive animal body. The pose of the standing figure of Saint George is, in effect, a paraphrase of that of the mounted Prague figure.

Master of the St Lambrecht votive panel
(active in the first quarter of the fifteenth century)
Christ Carrying the Cross, c 1420 (?)
Spruce-wood, 74 x 50.3 cm
Inv. No. 4903

The formal determinants of Sienese painting of the mid-fourteenth century continued to exert an influence on Austrian art both in terms of iconographic types and with regard to the structure of pictorial composition. On the other hand, approaches associated with painting in Prague around 1370 had a lasting impact on the articulation of the human figure through encouraging a tendency towards brighter colouring. The insertion of many articulated figures into a picture essentially conceived as a tapestry necessitated an opening up of the depth of the composition. This was initially achieved by means of crowding figures into the composition so that only the principal figures of the foreground remained fully visible. Further factors contributing significantly to the same end were a marked increase in realistic details (in this example, the banners, the lances and the ladder) and an additive approach to locating the depicted event. The pictorial structure here retains a certain integrity through the correspondence between the terrain (which appears uneven and rocky) and the evidence of the positioning of the feet and the contours of the drapery borders. Also effective in this respect is the anecdotal element introduced through the collision of the ladder with the Cross. The sense of direction of the moving crowd, strengthened through the inclination of the Cross itself and taken up in that of the ladder, and finally the soaring city walls and gate (in contrast to the 'empty' right background of the picture picked out only by means of the lances) point to the ephemeral influence of the scene of the same subject painted by Jacquemart d'Hesdin (Paris, Musée du Louvre). The poetic suggestiveness of such rare connections is a characteristic of Viennese painting in the late phase of 'International Gothic'. Another good example is the votive panel from St Lambrecht now in the Alte Galerie of the Joanneum in Graz.

Viennese (?) wood carver and Viennese painter (both active in the first third of the fifteenth century)
The Znaim Altarpiece, c 1427 (?)
Frame: oak; relief work: lime-wood, original, very bold colouring
(restored, in several phases of work, between 1970 and 1987 by Giovanna Zehetmaier)
central panel 230 x 274 cm
each wing 216 x 124 cm
Inv. No. 4847

The carved inner sides of this triptych (those displayed to worshippers on Sundays and church festivals) show the events of Good Friday as recorded in the Gospel According to Saint Matthew. These are presented as if occurring simultaneously and are supplemented through the addition of motifs from traditional iconography derived from the Apocrypha. On the inner side of the left panel we find Christ Carrying the Cross; the central panel shows Christ's Death on the Cross and the Mocking of Christ, also the two crucified thieves, the Virgin fainting, the Pharisees arguing amongst themselves, the Roman soldiers squabbling over Christ's cloak, the Roman executioner pushing back the lamenting Mary Magdalen and John, the thrust of Longinus's lance, the perceptive commentary of the Roman centurion ('truly, this was the son of God'), as well as attendant soldiers, some in sumptuous drapery, who have already played their part in the preparations for the Crucifixion (as indicated by the instruments of torture), and who now look on, appearing to comment on the action. On the inner side of the right panel we find (uniquely among comparable works) the Deposition alongside the Lamentation and the preparations for the Entombment. In other cases of simultaneous presentation, these three traditionally separate phases of the story are given with repeated figures.

This compact and concentrated rendering means that the triangular shape formed by Christ's Cross and the two ladders — the one in front leading down from the transverse beam to the tomb (sarcophagus) — forms a compositional counter-weight to the city gate in the scene of Christ Carrying the Cross on the inner side of the left panel. Here in particular the overall unity of the arrangement comes into its own. The direction of the movement of those standing on the ladders

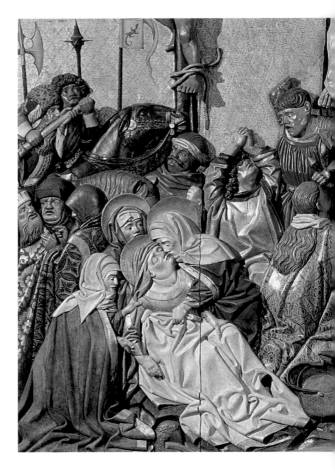

(Joseph of Arimathæa and Nicodemus), who are shown supporting the body of Christ, is emphasized by the anecdotal motif of the back-view figure of the assistant with the nails in his bucket who is seen descending the ladder.

It remains uncertain whether this concentrated composition effectively replicates the archetype that informs the version of the subject in a lost early work by the Master of Flémalle (reliably preserved in a contemporary copy), where the events of the Deposition and the Lamentation appear on either side of the centrally placed Cross, or whether the distinct poetic values arising from a rare concentration on pictorial description, and characteristic of the visual arts in Vienna in the early fifteenth century, is the more apposite explanation.

The tradition of using exceptionally crowded, episodic compositions in the presentation of the Crucifixion ultimate-ly derives from Sienese art of the fourteenth century (Pisa, Camposanto; now Pisa, Museo delle Sinopie). In the Znaim Altarpiece the crowd is woven from a carefully contrived system of figural groups that are both intertwined with, and opposed to, each other. The opposition and amalgamation of such self-contained groups arranged, on the whole, to accommodate each other emotionally, indicates that the artists collaborating here may have had a connection with the stylistic tradition established by the Prague painters who, working under Italian influence, were responsible for the *Manna* fresco in the cloister of the Klášter Na Slovanech of about 1360.

In the case of the Znaim Altarpiece, however, this compositional principle has been brought up to date through a strikingly recent Western influence — the move towards the pictorial representation of new aspects of reality that

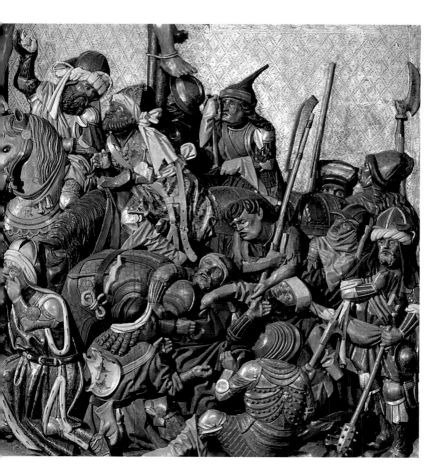

occurred at the turn of the fifteenth century. This would appear to derive in part from the example of a fresco cycle in the chapel of the favourite hunting lodge of the Burgundian duke Philippe le Hardi, itself not preserved but reliably recorded in a contemporary paraparase in nearby Bonnet-le-Château. While the treatment of the figures here still belongs within the 'International Gothic' of the period around 1400, those in the Znaim Altarpiece are notable for their pleasing corporeality, their expressively strong physiognomies and their detailed costumes — in short by what was, for this period, an entirely novel treatment of reality. On account of the social prominence of Philippe le Hardi, who was also an important patron of the arts, the Burgundian hunting lodge fresco would appear to have had a strong impact on pictorial composition during the early decades of the fifteenth century.

The style of the Znaim Altarpiece was also decisively influenced by the early works made by Early Netherlandish artists working at the French courts (and themselves under the influence of the lost decorative cycle from the chapel of the Burgundian duke's hunting lodge, as recorded in Bonnet-le-Château). Particularly striking are the connections between the Znaim Altarpiece and works by the Master of Flémalle and by the very important Master of the Turin Prayerbook (Hubert van Eyck). We can thus assume that the Master of the Znaim Altarpiece may have had further training in the region to which such similarities point.

The treatment of the groups of mounted figures and the ornamentation of the gold ground in particular establish parallels between this triptych and one in Esztergom, Hungary (with a Crucifixion in its central panel), by the Klausenburg painter Thomas de

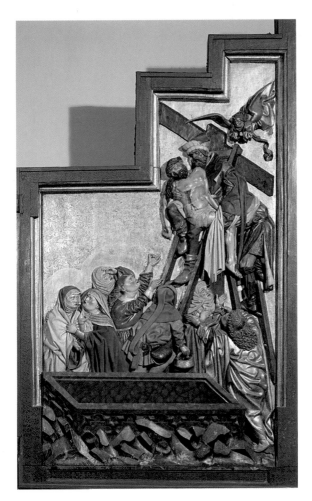

Coloswar. His work also anticipates the Znaim Altarpiece's inclusion of the figure of the Canon as the donor. The dating of the triptych in Esztergom to 1427 would thus serve as an indication for an approximate date for the Znaim Altarpiece.

Thanks to the painted outer panels, which (as the restoration reports confirmed) must have been the last phase of work on a piece unique in its colouring, we can securely associate the Znaim Altarpiece with the last phase of 'International Gothic' in Vienna, and indeed with a particular Viennese church. While the scenes painted on the outer panels are arranged as a continuous sequence, in the manner of a Lenten veil, the altar in its opened state reveals a painterly and incomparably detailed tangle of figures. It would seem that

the carving was, indeed, conceived and executed according to painterly principles. At the same time, the characteristics of the triptych form were clearly taken into account: when the side panels are open, only reliefs of the boldest colouring are visible. In order to enable the altar to be closed, these had to be located in the recesses of the middle and side panels. Bearing in mind that the posing and grouping of these figures appears to have been conceived in terms of panel painting, it was thus necessary to present those figures intended to occupy the foreground in low relief, whilst those of the middle-ground could then be allowed a far greater plasticity. Detailed examination of the carving work reveals how consistently this scheme was followed.

The bold colouring embraces not only an enormous variety of drapery decoration, but also a striking range of flesh tones. It forms a significant contrast to the gold ground with its pricked ornamentation. Correspondingly, the undulating outer contours of the groups of figures find their angular counterpart in the stepped outline of the frame.

Conrad Laib (active c 1440–1460)
The Crucifixion, 1449
Spruce-wood, 179 x 179 cm
Inv. No. 4919

In 1448 Conrad Laib applied to become a citizen of Salzburg and agreed to paint this Crucifixion, dated 1449, in lieu of paying the required tax (see the inscription 'pfenning' on the saddle of the horse at the base of Christ's Cross). A number of other works have been assumed to form part of the same altarpiece (Saints Hermes and Primus in the Museum Carolino Augusteum, Salzburg; also various scenes in the Seminario Patriarchale Vescovile, Venice and the Palazzo Vescovile, Padua). Laib's crowded Crucifixion scene recalls the treatment of this subject in Altichiro's frescoes in San Giorgio and in the 'Santo' in Padua. It is also striking that, in spite of the traditionally pricked gold ground, layers of glaze are used to attain a sense of atmosphere comparable to that achieved with Venetian *sfumato*. In Laib's altarpiece of 1457 for Graz Cathedral (his most important work) there is a much smoother gradation of scale in the relation between the figures in the foreground, middle-ground and background but also a much more daring exaggeration of scale than in the Salzburg panel of 1449.

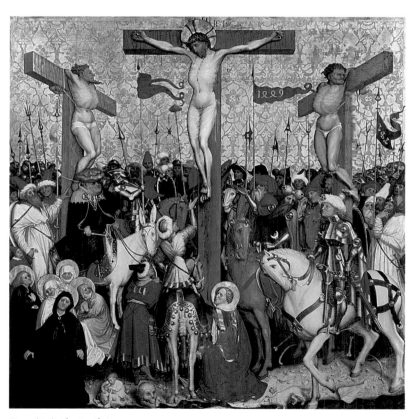

Conrad Laib, **The Crucifixion**

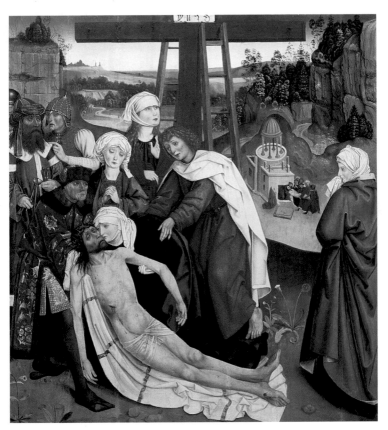

Master of the Viennese Schotten Altarpiece, **The Lamentation**

Master of the Viennese Schotten Altarpiece
(active in the third quarter of the fifteenth century)
The Lamentation, c 1469
Oak, 87 x 80 cm
Inv. No. 4854

Of the high altar installed in the Schottenkirche in Vienna in the Late Gothic period, most of the panels of the wings have survived (two are in the Österreichische Galerie, nineteen in the Schottenstift Museum). Particularly in the scenes of the Passion, on the side displayed to worshippers on weekdays (dated 1469, in the scene of Christ's Entry into Jerusalem), recent Netherlandish influence (Dierick Bouts) is just as evident as is its adaptation into a distinct individual style. In the *Lamentation* panel it is apparent that the artist has drawn on the model of a lost panel painting by Rogier van der Weyden (without doubt in the collection of Eleonora of Portugal, Consort of Emperor Friedrich III). In the mourning figure at the right, who seems to comment on the depicted event while stepping back to allow a view of what follows (the Entombment), the art historical significance of the Schotten Master is evident. Here, the viewer 'experiences' the depicted event from the point of view of one of those really present.

Michael Pacher
(active in the second half of the fifteenth century)
Joseph is Cast into the Well, before 1498
Cedar-wood, 261 x 85 cm (fragment)
Inv. No. 4816

This Tyrolean artist had an enormous range of talents. His workshop was in Bruneck in South Tyrol, but he knew of Netherlandish innovations from a period spent in the Upper Rhine (Alsace), and he was certainly also in Vienna, as is indicated by his *Marriage of the Virgin* panel (also in the Österreichische Galerie). It reveals the influence of the tomb of the Emperor Friedrich III and of the Marriage relief on the former pulpit canopy in the Stephansdom. Pacher knew of contemporary artistic developments in Italy, most importantly the work of Mantegna, which accounts for his obsessive interest in the study of perspective and its integration into painted images (in the present case this is reflected in the simple but very carefully observed 'architecture' of the well). He also anticipated Albrecht Dürer in turning to the study of natural forms (in which Martin Schongauer of Colmar had led the way); and he was able to attain an amalgamation of specifically Early Netherlandish and Italian innovations that allowed his personal style to emerge more effectively.

This fragment of the panel with a scene from the Story of Joseph from the Old Testament (Genesis xxxvii, 15–24) comes from the high altar of the former parish church (now the Franciscan church) of Salzburg and is a classic example of what Pacher was able to achieve. The under-drawing that remains visible in certain passages incidentally offers us an insight into the working methods of this period, from the initial application of the ground to the panel to the final stage of painting.

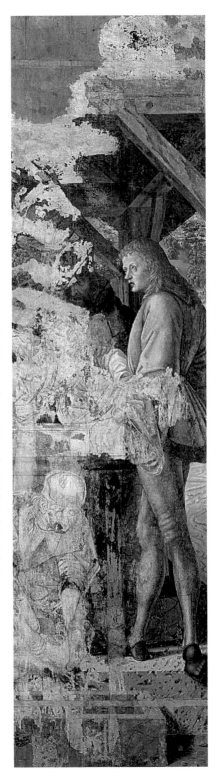

Michael Pacher
**Joseph is Cast
into the Well**

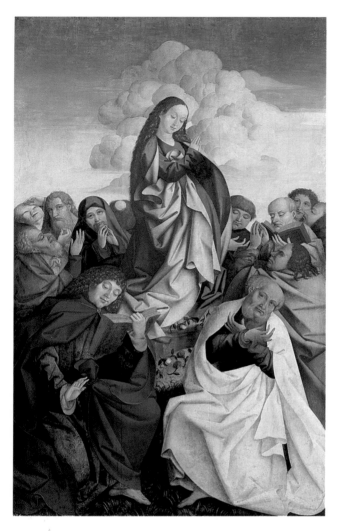

Rueland Frueauf the Elder, **The Assumption**

Rueland Frueauf the Elder (active in the second half of the fifteenth century)
The Assumption, 1490
Spruce-wood, 209 x 134 cm
Inv. No. 4844

It is possible that Michael Pacher had another Passau-based painter, Rueland Frueauf the Elder, to thank for the commission to paint the altar for the parish church of Salzburg (now the Franciscan church). Frueauf provided wings for the altar for Salzburg Cathedral and also for the altar in the city's Benedictine church of St Peter. It is for this last that the almost life-size figures of *The As-*

sumption (signed and dated 1490) were painted. This image was on the side of the altar displayed to worshippers on weekdays (in this exceptional case, the scenes with Christ's Passion with their ornamented gold-ground were to be found on the Sunday/festivals side). The Assumption is here almost entirely conveyed through the positioning and characterization of the human figures: we are shown, as it were, a structure 'built' of figures. The emotive impact of the light effects, meanwhile, conveys the mystical character of this event as experienced by each of the Apostles.

The Baroque Museum in the Unteres Belvedere

While so much that was sown in the seventeenth century blossomed in the eighteenth — in the architectural realm one thinks of the construction of Salzburg Cathedral, of the activities of the Jesuits, or of the building of the Leopold Tract of the Hofburg in Vienna. These developments are, however, only partially reflected in the range of paintings from the Baroque era to be found in the collection of the Österreichische Galerie. This is partly due to the fact that many paintings, above all canvases set into stucco ceilings as part of large decorative schemes, have remained *in situ*; but it is also explained by the fact that much seventeenth-century painting is sombre in its colouring — the term *tenebrosi* was widely employed — and thus proved unattractive to Austrian collectors.

It was during the reign of the Emperor Leopold I (*r* 1658–1705) that the Habsburg Empire rose to the rank of a great European power. With the help of Prince Eugene of Savoy the Turks had been decisively beaten. After the Relief of the Siege of Vienna and the Battle of Zenta, the Peace of Karlowitz (1699) marked a provisional end to the Turkish Wars. The Emperor, whose interest in the arts was well known, was a patron of the theatre, and in particular of Italian opera, thus ensuring Vienna's recognition as the music capital of Europe. The following years saw the implementation of plans to establish Vienna as the Emperor's city of residence — his *Residenzstadt*. Alongside a large number of new churches and of inner city palaces for members of the nobility, new buildings were erected within the Hofburg a first step in the evolution of Vienna's monumental High Baroque. In 1680 the Emperor had the Trinity Column Column (popularly known as the Plague Column, erected on the Graben as a signal of the 'pietas austriaca', and this remained a focal point of much subsequent building, as

did the decoration devised for the Jesuitenkirche. The fresco and easel painter employed there, Andrea Pozzo, dedicated his architectural treatise to the Emperor.

In the Baroque Museum, the painting of religious subjects is represented by the work of Johann Spillenberger (1628–79) from the collection of Count Attems in Graz, by that of Franz Carl Remp (1674–1718) and by that of Karel Skréta (1610–74) of Prague, whose vivid *Mocking of Christ* is clearly influenced by the style of Caravaggio. In a certain sense, the work of Peter and Paul Strudel may be associated with the seventeenth century. Their founding of an Art Academy in Vienna was, however, to have an enormous impact on the eighteenth century. Anton Faistenberger (1663–1708) worked as a landscape painter, combining elements found in Venetian art with those characteristic of Salzburg landscape painting.

A leading figure in the realm of sculpture was Meinrad Guggenbichler (1649–1723), who worked at the abbey church (now parish church) at Mondsee, and who was to prove one of the most gifted figures of the emergent High Baroque. Martin and Michael Zürn (still active beyond the mid-seventeenth century), as also Hans Waldburger (1570–1630), demonstrate how the formal power of the Late Gothic enters into a symbiosis with new elements drawn from local sculptural tradition.

The reign of Emperor Joseph I (*r* 1705–11) was too short to assess the impact of his cultural policy. While victoriously engaging in the War of the Spanish Succession, he sought to centralize power within the Empire and Johann Bernhard Fischer von Erlach's plans for an exceptionally large palace at Schönbrunn reveal the extent of his ambitions for Vienna as a *Residenzstadt*.

The monumental renovation of the Hofburg quarter initiated by Joseph I

was continued by his successor, the Emperor Karl VI (r 1711–40), with the construction of the Hofbibliothek (1723–35), the Imperial Chancellery Tract and the Winter Riding School. The Emperor found an executor for his own architectural plans in the person of Count Gundacker Althann (1665–1747) and is also remembered for ordering the construction of the Karlskirche (from 1713), the most important ecclesiastical building of the Baroque era in Austria. This was also the period of Prince Eugene's victories over the Turks, after which the territory under Habsburg rule reached its greatest extent. In 1725, after the death of Peter von Strudel, the Emperor formally re-established the Vienna Academy as a training institution for artists. Under the direction of Jacob van Schuppen, it was reorganized after the model of the Paris Académie des Arts and swiftly assumed a leading role in artistic production in the Austrian Empire.

Most of the paintings in the collection of the Baroque Museum are of religious and historical subjects. Works by Martino Altomonte (1659–1745), Johann Michael Rottmayr (1654–1730), Daniel Gran (1694–1757) and Paul Troger (1698–1762) include easel paintings and designs for fresco cycles and altarpieces. Many of the works of highest quality come from the Imperial collections and were integrated into that of the Baroque Museum when this opened in 1923. Alongside the work of Austrian artists, one finds that of Italians such as Carlo Carlone and Francesco Solimena, Bohemians such as Johann Jacob Hartmann and Norbert Grund, or South Germans such as Franz Anton Zeiller, Januarius Zick, Thomas Christian Winck and Johann Evangelist Holzer illustrating the extensive European connections of the Imperial court.

The Baroque Museum collection is also rich in the formal portraits so typical of the Baroque era: those painted by Martin van Meytens (1695–1770), Franz Anton Palko (1717–66) and Johann Gottfried Auerbach (1697–1743) are generally distinguished by their painterly extravagance, while those by Jan Kupetzky (1667–1740) and Christian Seybold (1697–1768) are impressive for their psychological penetration of the sitter. Also included in the collection are landscapes by Joseph Orient (1677–1747), Maximilian Joseph Schinnagl (1697–1762) and Franz de Paula Ferg

(1689–1740) and conversation pieces by Johann Georg Platzer (1704–61) and Franz Christoph Janneck (1703–61). Still lifes and animal paintings complete the collection.

Of the sculptural works in the Baroque Museum, the most important is the Mehlmarkt Fountain by Georg Raphael Donner (1693–1741), which is centrally displayed in the Marmorsaal of the Unteres Belvedere. Commissioned by the City of Vienna and selected in preference to the design submitted by Lorenzo Mattielli (1688–1748), the fountain was executed in an easily damaged alloy of tin and lead. In 1873 a bronze version replaced the original which, in 1921, after many phases of restoration, was entrusted to the Historisches Museum der Stadt Wien to the Österreichische Galerie as a long-term loan. Works by Donner now displayed in Prince Eugene's former state bedroom in the Unteres Belvedere include the dazzling *Apotheosis of Emperor Karl VI* and the relief for the font in the Stephansdom that came to the Baroque Museum by way of the Imperial Treasury.

Donner's predecessor in terms of virtuosity was Balthasar Permoser (1651–1732), whose complex *Apotheosis of Prince Eugene* (see fig. 5 on p. 14), also has an interesting story behind it. Donner's pupil Balthasar Ferdinand Moll (1717–85) is represented by a further sculptural group: the model, commissioned by the Imperial court, for the double sarcophagus for Maria Theresia and her consort Franz Stephan of Lorraine in the crypt of the Kapuzinerkirche in Vienna, and the sensitive portrait bust of Field Marshal Josef Wenzel, Prince of Liechtenstein, for the Imperial Arsenal. Numerous especially artfully devised reception pieces for the Vienna Academy, on the theme of Minerva as Protectress of the Arts, complete the sculptural collection.

The Empress Maria Theresia (r 1740–80), as the daughter of Karl VI, had to contend with a difficult legacy. During the War of Austrian Succession (1740–48), she had to fight France, Spain, Saxony and Bavaria. From 1756 to 1763 she fought, and lost, the Silesian War against the Prussian king Friedrich II, and so had to cede most of this rich province. Thrown back entirely on her own resources, except for the support of Hungary, her first priority was to implement a process of consolidation.

Even more than had Karl VI, she sought to turn the still feudally organized territory of the Empire into a modern, centrally administered state. This necessarily required some limitation in her commitment to the patronage of culture, as reflected in the decision to build the palace at Schönbrunn on a much more modest scale than originally planned. Alongside the painter Jean Etienne Liotard, whose services Maria Theresia was able to secure for a while, it was above all Martin van Meytens whom she favoured (cf. the works commissioned for Schloß Schönbrunn including the portrait *The Family of Count Nikolaus Palffy*). It is significant that this cosmopolitan artist, who nonetheless lacked the stylishness of his French contemporary, was able to attract the Empress's attention.

Maria Theresia's son, Joseph II (coregent from 1765, r 1780–90), was also committed to reform, though in his case very much in the spirit of Enlightened Absolutism. The changes he introduced did not, however, concern only bureaucracy or the practice of religion but also had an impact on the arts, particularly in as far as these reflected his interest in social questions. Important Imperial architectural commissions of this time included the Allgemeine Krankenhaus [General Hospital] (1784) and the Josephinum (1785), an institution for the training of military doctors.

While the treatment of religious subjects, formal portraiture, and the painting of landscapes and still lifes underwent no dramatic change during Joseph II's reign, there was a general trend, as the eighteenth century moved to a close, towards ever more marked secularization. The outstanding figure of this period was the versatile Franz Anton Maulbertsch (1724–96). The Österreichische Galerie contains dazzling easel paintings by this artist such as his *Holy Family* or *Saint Narcissus*, as well as a series of his charming and very painterly *bozzetti* (small oil sketches made in preparation for larger works). Especially admirable are the bold designs for the frescoes in the parish church at Schwechat.

Other important painters from this period represented in the Baroque Museum by both religious and secular works include Joseph Hauzinger (1728–86), Caspar Franz Sambach (1715–95), Joseph Ignaz Mildorfer (1719–75), Joseph Winterhalter (1743–1807), Franz

Sigrist (1727–1803) and Franz Anton Zeiller. All these (like Maulbertsch) had been pupils of Paul Troger, as was also Martin Knoller (1725–1804), who devised a new secular type of 'apotheosis' with his *Laying the Foundation Stone of the Concordia Temple in Laxenburg*. Here the Emperor, while serving as an *exemplum virtutis*, is depicted as a real, rather than mythological, figure among about two hundred others from all classes of society. The *Allegory of the Transfer of the Imperial Collection to the Belvedere* by Vinzenz Fischer (1729–1810) was painted in acknowledgement of the Emperor's cultural policy, as implemented by Christian von Mechel.

'Kremser [Martin Johann] Schmidt' (1718–1801), a very popular painter, is represented in the Baroque Museum by altarpieces, sketches and two Rembrandtesque reception pieces for the Vienna Academy. Maulbertsch too paid homage to this institution in his *Allegory of a Prize-Giving at the Vienna Academy under Prince Kaunitz*. A key work in the realm of portraiture was Maulbertsch's proto-bourgeois *Self-Portrait*. Peter Brand the Elder and Younger were the most important Austrian landscape painters of their age. The Baroque Museum contains the *Falconry* cycle from Schloss Laxenburg by the latter (who died in 1795). The work of Franz Edmund Weirotter (1733–71) is represented by brilliant small-scale paintings and by engravings and etchings.

Franz Xaver Messerschmidt (1736–83), whose 'Character Heads' may be seen as an idiosyncratic contribution to progressive attitudes to the study of physiognomy, had a strong influence in his earlier career on the style of court portrait sculpture through works such as the over-life-size figures of Maria Theresia and Franz Stephan of Lorraine and the portrait reliefs of Joseph II and Isabella of Parma. While the traditional style of the sculptor Jakob Gabriel Mollinarolo (1717–80) is that of a virtuoso of the old school, in the work of Karl Georg Merville (1751–98), above all in his design for a monument to the Russian Empress Catherine the Great, we can already detect the formal simplicity that signals the advent of Neo-Classicism. It should, however, be added that Austrian sculptors and painters generally proved able to ignore the implications of this development by seeking refuge for some time in the elegance and fluency of Baroque Classicism.

Johann Michael Rottmayr, **Mourning the Death of Abel**

Johann Michael Rottmayr (1654–1730)
Mourning the Death of Abel, 1692
Oil on canvas, 191 x 127 cm
Inv. No. 4298

This painting was conceived as one of a pair, as was often the case with religious subjects in the era of the Baroque. Its pendant, *The Sacrifice of Isaac*, is now in the Landesmuseum in Graz. In both cases the event depicted is to be understood as an allusion to the death of Christ. The body of the dead Abel is uncompromisingly presented as a perfect nude. Details such as fatal wound in his forehead, and the blood that has issued from it (deriving from an account of this episode in the Apo-crypha) are thus more shocking in their effect. The arrangement of the figure — braced within the foreground of the composition with bent arms and legs and a slightly twisted torso — is intended to meet the expectation that 'history painting' should both 'instruct' and 'persuade'. The aged, mourning figure of Adam and that of Eve, dressed in an animal hide and raising her arms in compassion, supply the true emotional centre of this picture. Both derive from the Venetian tradition embodied in the work of painters such as Karl Loth — a model for many German artists during the eighteenth century. Eve is shown looking up to God the Father who raises His finger in a warning gesture.

In the distance one can see the figure of Cain, his brother's murderer, alongside a dark pillar of smoke rising from an altar: with raised arms, he seeks to escape God's punishment. The landscape, painted in strong yellows and blues in the tradition of Jan Liss in Venice, anticipates the primeval worlds that Paul Troger was later to evoke in his visionary fresco cycles.

After training in Venice, where he remained for thirteen years, Rottmayr returned to Salzburg. Here, he held the post of court painter to the Prince-Bishop, providing painted decoration for ceilings in the Salzburg Residenz. In Vienna (where he was based from at least 1694) he was enobled, assuming the title 'von Rosenbrunn'. Further important works by Rottmayr are to be found in the abbey church at Melk and in the Peterskirche and the Karlskirche in Vienna.

Johann Kupetzky (1667–1740)
Self-Portrait at the Easel, 1709
Oil on canvas, 94 x 75 cm
Inv. No. 4939

Kupetzky, without doubt one of the most important portrait and figure painters of his age, appears to have had something of a split personality. He was anything but amenable, and would only agree to paint 'as a great favour'. Furthermore, he very rarely idealized his sitters and did not hesitate to record blemishes and irregularities. Kupetzky (who, like Seybold, often

Johann Kupetzky, **Self-Portrait at the Easel**

painted himself) produced at least eighteen self-portraits. He also ran a large studio, employing assistants to paint the drapery and backgrounds of his pictures while he himself attended to the heads and hands, which were regarded as the bearers of expression. He started training in Vienna in the 1680s, then travelled in Italy. In both Venice and Rome he copied the works of the Old Masters and established his own studio. In 1709 he returned to Vienna in response to an offer of work from Prince Adam of Liechtenstein, and here he received numerous commissions from the nobility and the Imperial court. In 1723 he appears suddenly to have left Vienna for Nuremberg, fearing religious persecution because he was a member of the sect of the Bohemian Brethren.

In the self-portrait illustrated here, Kupetzky is seen wearing the order of the Brethren — a sun surrounded with flickering rays suspended on a chain. The artist is shown working on a portrait — in all probability the sitter is Prince Eugene of Savoy, Kupetzky being one of the artists he employed — and appears to have just looked up to gaze very intently at the spectator. The elegant cloak and the fur-trimmed cap do not disguise Kupetzky's profession: his rough hands with broken nails, the sweat on his brow, the palette and brushes he holds, the small chest with bottles and the shell for mixing paints reveal that he is a painstaking craftsman who has risen to the rank of a virtuoso artist. Key influences on Kupetzky's commissioned portraits were the work of Caravaggio, and that of the followers of Rembrandt, as also the portraits of the French painters Hyacinthe Rigaud and Nicolas de Largillière.

Martino Altomonte (1659–1745)
Susanna and the Elders, 1709
Oil on canvas, 131 x 107 cm
Inv. No. 4243

Johann Michael Rottmayr and Martino Altomonte may be regarded as the founders of the independent Austrian painting style of the Baroque era. Born in Naples of Tyrolean and Bavarian descent, Altomonte studied from 1672 in Rome under Giovanni Battista Gaulli and later under Carlo Maratti. It is possible that he also attended the celebrated Roman Accademia di San Luca, to which some of the leading artists of his age belonged. After serving as court painter to the Polish king Jan III Sobieski in Warsaw (here he was above all engaged as a painter of battle scenes, including several based on the 1683 Siege of Vienna), he arrived in Vienna in about 1700, where his patrons included Prince Eugene. In 1716 he painted frescoes for the Marmorsaal and the state bedroom of the Unteres Belvedere. Other works surviving from this period include oil paintings for the decoration of Schloss Augarten (1708) and the ceiling paintings in the sacristy of the Stephansdom. In the period 1719 to 1728 Altomonte worked mostly in Upper Austria. Among other commissions, he provided painted decoration for the abbbey at St Florian, for the church at Stadl-Paura and for the monastery at Kremsmünster. During this time, his son, Bartolomeo, became his assistant and collaborator (he later had an independent career in Upper Austria, his work there in effect a continuation of his father's in terms of decorative detail). Thus, a style combining Neapolitan and Venetian traditions with the 'Ideale Ebene', ('ideal plane', a type of perspective view) became the foundation for the painting of the Austrian Baroque.

The picture illustrated here is one of the earliest by an Austrian painter working in a context where art was fully dependent on that of Italy. Although *Susanna and the Elders* is also one of Altomonte's earliest easel paintings, it has nonetheless been regarded as one of his best contributions to religious 'history painting'. The subject was very popular in the Baroque era (it served as an allegory of female virtue), and is taken from the Apocrypha. Altomonte shows the moment where the two Elders surprise Susanna while she bathes, depicting the old men as if they

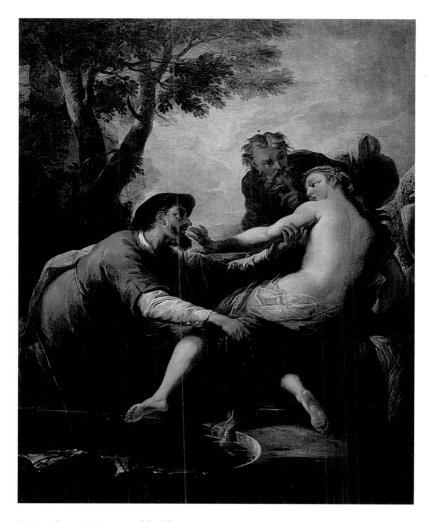

Martino Altomonte, **Susanna and the Elders**

were just as clearly visible as the woman herself (there is a lively use of gesture, one man putting his finger to his lips to urge silence). In showing Susanna braced to resist this assault, Altomonte is able to present the female nude in a complex twisting pose. A further demonstration of the painter's technical skill is to be found in the rendering of the elegant disarray of the translucent drapery (its striped pattern associated with Venetian cloth), which appears better suited to revealing than concealing the body beneath. Altomonte's mastery of the treatment of light is also apparent in the rendering of the reflecting surface of the water in the circular basin in the foreground. The sky too, with its light covering of clouds, has a part to play in this silent drama.

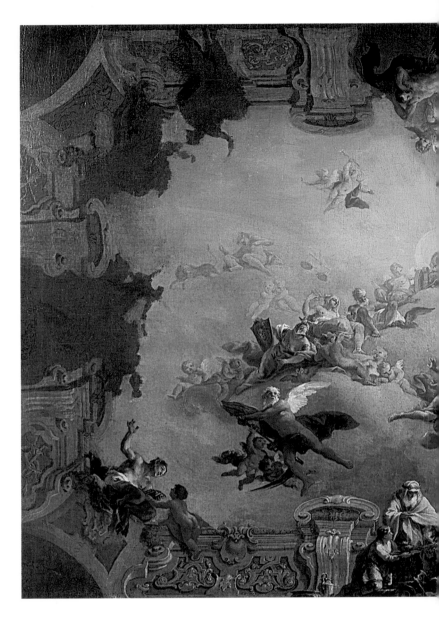

Daniel Gran (1694–1757)
The Reception of Diana in Olympia, 1732
Oil on canvas, 76 x 110 cm
Inv. No. 4178

This *modello* (the small-scale sketch of a proposed larger work) is for the ceiling fresco at the hunting lodge at Eckartsau in Lower Austria and is one of the first high-points in Gran's oeuvre. Count Franz Ferdinand Kinsky, in accordance with the purpose of the build-ing, wished to have a fresco in which both hunting and the role of Diana were glorified. Reminiscent of the work of both Solimena and of Ricci, the composition is centred around the Chariot of the Sun, behind which there appear the sun and the moon. Apollo and Diana approach from the left while Jupiter and Juno hasten to greet them (all four figures identifiable by their attributes). Below God the Father we find Minerva with her helmet and shield with the

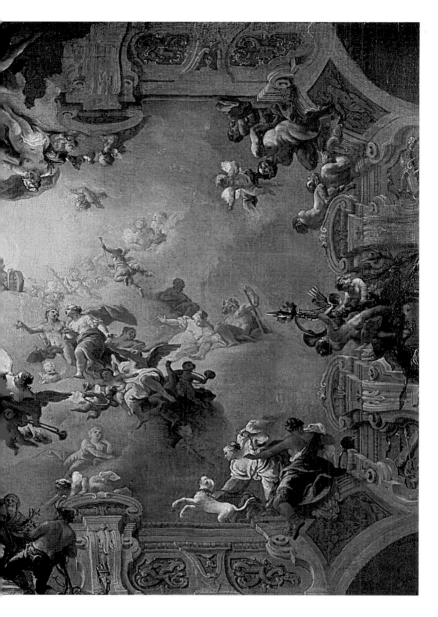

head of the Medusa. In front of her, Chronos, the God of Time, is about to move his scythe, but is prevented from doing so by a putto. Incorporated within the framing elements are scenes of the sacrifice of the roebuck in place of Iphigenia, and of Luna seeking her beloved Endymion.

Initially in the service of Prince Adam Franz Schwarzenberg, Gran spent two years in Italy, where he studied the work of Ricci, Solimena and Charles Le Brun (also collecting engravings by this last). After his return to Vienna, he painted the ceiling frescoes in the central hall of the Hofbibliothek (now part of the Österreichische National-bibliothek), which are now regarded as Gran's masterpiece. Further works of note are the frescoes in the pilgrimage church on the Sonntagberg and those in the Kaisersaal at Klosterneuburg. In these one can already detect an antici-pation of Neo-Classicism.

Georg Raphael Donner (1693–1741)
The Rivers Enns and March,
figures from the fountain in the Mehlmarkt
(now Neuer Markt) Vienna, c 1739
Alloy of tin and lead, 207 x 235 cm
and 121 x 209 cm
Inv. Nos. Lg 105/4 and Lg 105/3

From 1737 to 1739, in response to a commission from the City of Vienna, Georg Raphael Donner produced the work regarded as his masterpiece — the Providence Fountain in the Mehlmarkt, now the Neuer Markt. In 1802 the historian and lexicographer Hans Rudolph Fuessli judged this to be the most beautiful such fountain in Vienna.

Placed on the central column, the figure of Providence acknowledges the 'wise administration' of the City of Vienna. Posed gracefully in *contrapposto*, in one hand she holds a shield with a Janus head (alluding to the inconstancy of history) and in the other a snake (the symbol of immortality). Along the rim of the fountain basin are four reclining figures personifying the four rivers that flow into the Danube — the Ybbs, the Enns, the March and the Traun.

As stipulated in the contract, the *River Ybbs* is shown holding an urn, from which water flows into the main basin. The earliest of the figures to be made, she appears anxious not to leave the sphere of the fountain. The next figure, personifying the *River Enns*, is much bolder; his left leg, nonchalantly dangling, is in contact with the real world beyond that of the fountain. Crowned in reeds, he holds an oar, in allusion to the navigability of this river. A bunch of feathers symbolizes the

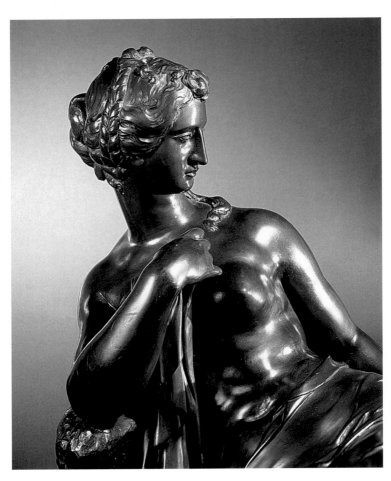

Georg Raphael Donner, **March**

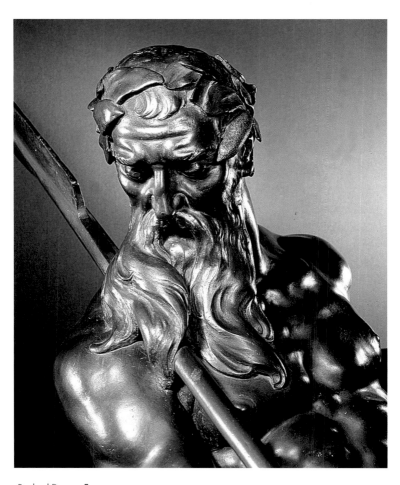

Georg Raphael Donner, **Enns**

steel-working industry in the Enns val-
ley. It is clear that Donner has here
referred to the model of Antiquity, above
all the many reclining personifications
of the Rivers Tiber and Nile. The sen-
suality in the treatment of this nude,
however, recalls Michelangelo's figures
of Day and Night for the Medici Chapel
in Florence, which Donner must have
known. The relaxed muscularity of the
figure is brought out in the pose as the
figure leans on the rock. According to
Fuessli, the poses and movements cha-
racteristic of old age are deliberately
contrasted here to those of the young
female figures. The female *River March*
is even more freely treated, and seems
fully aware of her own beauty. The
relief on the rock beside this figure
shows a battle between the Romans

and the Marcomanni and Quadi, which
took place in that region.

After training as a goldsmith, and
then under the sculptor Giovanni Giul-
iani at the monastery at Heiligenkreuz,
Donner moved in 1725 to Salzburg,
where he worked as a freelance medal-
list and monumental sculptor. From
1729 he was in Pressburg [now Bratis-
lava], where he worked for Count
Emmerich Esterházy providing the
interior sculptural decoration of the
Johannes-Elemosynarius-Kapelle and
the high altar for the Cathedral. Other
important works are the *Apotheosis of
Emperor Charles VI* and the relief on
the font for the Stephansdom. After
the Mehlmarkt fountain, Donner pro-
duced his final work, a Pietà for the
Cathedral at Gurk.

Franz de Paula Ferg, **Italian Landscape with Country Folk**

Franz de Paula Ferg (1689–1740)
Italian Landscape with Country Folk,
before 1740
Oil on canvas, 103.5 x 158 cm
Inv. No. 6619

Franz de Paula Ferg had an unsettled and unhappy life. Born in Vienna, he trained there under Josef Orient and Hans Graf before embarking on an itinerant career. In 1718 he went to Germany, working in Dresden with the landscape painter Alexander Thiele, for whom he painted staffage. After employment in Bamberg, Hamburg and Lower Saxony (where he was employed by the Duke of Braunschweig at his Palace at Salzdahlum), he went in 1724 to London. Here, according to the writer on art Christian Ludwig von Hagedorn, Ferg's career reached its high-point. In 1726 he published a series of etchings, the 'Capricci', very much in the tradition of Jacques Callot and the Italianizing artists. These are among the most astounding achievements of Austrian print-making. In London Ferg fell in love with the daughter of a poor portrait painter; unfortunately, she was not only socially ambitious and moody but also had a tendency to extravagance. As a result, Ferg had to work at a furious pace and to sell pictures for less than he might otherwise have done. Gradually this undermined his health. This precarious situation led to his early death, which (according to his friend Thiele) he had come to long for.

Ferg was highly regarded by his contemporaries: he was judged to be correct in his use of line, pleasing in his arrangement of compositions, strong in expression and possessed of a masterly lightness of touch. He was especially admired for his deft placing of small figures within landscape compositions. In Hagedorn's opinion, Ferg's landscapes were always 'enobled' through their mellow colouring and the presence of fine buildings. His fountains and arches convincingly possessed the qualities of stone, marble or alabaster (supplemented with incidental cracks and crevices), and his country folk were rendered charming through his flattering brush.

The picture shown here has all these qualities: the group of country folk with its horse, ass and dog is especially minutely rendered; cows and sheep are led to water under the footbridge across the stream. Compositionally, the landscape as a whole is framed between 'interesting trees' and crowned with a castle that marks the end of a chain of hills. The evidence of such a proto-Romantic rendering of landscape complemented by the delicate gradations of tone in the treatment of the sky leaves no doubt as to Ferg's suitability for his employment as a designer of motifs for porcelain — a post he held at the porcelain factories of Meissen and Chelsea.

Johann Georg Platzer (1704–61)
The Wrath of Samson, c 1740
Oil on copper, 76 x 95 cm
Inv. No. 2410

Platzer employs this Old Testament subject (Judges xvi, 25–30) not so much to show Samson's torment after he has been betrayed by Delilah but as a pretext for displaying to the viewer a paradise of the senses. Across the floor are strewn elaborate vases, amphorae, musical instruments, still lifes with fruit and goblets with wine spilling out of them. All this is integrated into an architectural stage-set of gigantic proportions that appears to be derived from the work of Giambattista Piranesi, even if the latter's profound and mysterious visions are here transformed into the excesses of the Philistines' pleasure palace. It is probable that the architectural painting of members of the Galli-Bibiena family may also have served as a source for this and other imaginative treatments of religious, mythological and historical subjects by Platzer. The eye is led past tumbling columns, masonry and timber, past balustrades and galleries towards the pale blue distance, which signals the presence of landscape and freedom beyond the present threat of material dev-

astation. The picture, which is painted on copper, is striking for its clear evidence of the pleasure the artist has taken in creating the *mise-en-scène* of the depicted event and in the rendering of costume and other realistic details.

Platzer was born in South Tyrol and, after training there, travelled to Passau and then to Vienna. Here, he progressed to become one of the most important painters of conversation pieces in the city — his only rival being his friend Franz Christoph Janneck from Graz. Paintings of this sort responded to an emerging proto-bourgeois taste and, on account of their small size and their rather appealing artificiality, were keenly acquired by collectors. After he had graduated from the Vienna Academy, Platzer found his first generous patron in the collector Albrecht von Sebisch, who swiftly fourteen pictures by the artist for his Kunstkabinett in Breslau. Platzer provided foreign courts in London, Moscow and St Petersburg with his much sought-after conversation pieces, as well as mythological and historical paintings. Platzer spent the last years of his career once more in Eppan in his native Tyrol, where he painted curiously blurred 'impressionistic' pictures composed with dabs of paint.

Johann Georg Platzer, **The Wrath of Samson**

Franz Anton Palko, **Self-Portrait**

Franz Anton Palko (1717?–66)
Self-Portrait, 1746
Oil on copper, 42 x 32 cm
Inv. No. 7645

Franz Anton Palko was the son of the painter Anton Palko, who had moved from Silesia to settle in Pressburg [now Bratislava, Slovakia]. Franz Anton trained at the Vienna Academy before himself moving to Pressburg, and then on to Brünn [now Brno, Czech Republic], where he established his own studio. In carrying out official portrait commissions, he adhered to the French style, above all as represented in the work of Hyacinthe Rigaud, while his group

portraits clearly draw on Venetian examples, particularly in their use of rather bright colouring. Palko's reputation in the realm of mid-eighteenth century court portraiture owed much to the quality of cosmopolitan balance in his work, which combined a restrained pathos with the judicious introduction of flattering accessories.

This soulful self-portrait was doubtless painted for the artist himself, as indicated by the unshaven chin, the scarf wound nonchalantly around the neck, the suggestion of self-absorption and the glasses perched half-way down the nose. It is among the most impressively 'unofficial' self-portraits to be painted in

Austria in the mid-eighteenth century. It appears to correspond exactly with contemporary descriptions of the painter as shy in company and invariably unassertive, even as a 'hypochondriac talent' and a recluse — characteristics that his rivals would exploit to their own ends. Joseph von Sonnenfels recognized Palko's talent as an artist. In his *Von dem Verdienste des Porträtmalers* [On the Merits of the Portrait Painter], published in 1768, he classed Palko among the most celebrated portrait painters of the past — a considerable honour.

Paul Troger (1698–1762)
Christ on the Mount of Olives, c 1750
Oil on canvas, 241 x 157 cm
Inv. No. 4147

In Paul Troger's work one encounters the revival of the deep emotionalism of Italian Baroque. Yet it was here that a specifically Austrian form of Baroque attained its first perfection, albeit without abandoning classical traditions of composition and a unified treatment of light — as was to occur slightly later in the work of Maulbertsch.

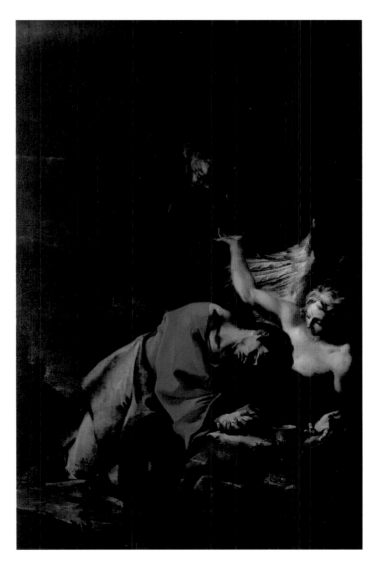

Paul Troger, **Christ on the Mount of Olives**

Born in Welsberg in the Pustertal (South Tyrol), Troger trained in Cavalese (thus thoroughly absorbing Italian influences) and then worked in Venice, Rome, Naples and Bologna. Notable influences on Troger's later work were the light-filled pictures of the Venetian Giambattista Piazzetta and the sombre images of Francesco Solimena. The impressions Troger received in Italy were, nonetheless, to be re-worked substantially and very individually. Troger moved to Salzburg, then to St Pölten, where he received several important commissions, before arriving in Vienna. Though thereafter based here, he subsequently travelled in response to further commissions for frescoes — in particular for monasteries and other religious foundations in Lower Austria (at Melk, Altenburg, Zwettl, Seitenstetten, Geras and Göttweig) but also for patrons in Moravia and Hungary. As director of the Vienna Academy, his influence on the work of artists of the next generation was assured.

Christ on the Mount of Olives is indisputably one of Troger's most important works and may also be seen as the most earnest and contemplative work from the beginning of his later career. While the picture is notable for its composition, centred on the two principal figures, Christ and the angel, and for the daring use of 'empty' space in the upper areas (where only suggestions of putti are to be found), it is striking, above all, for Palko's treatment of the psychology of the scene. The expressive value of pose and gesture — Christ's clasped hands, bowed head and closed eyes — is here intensified to convey a profound solitude. In a spirit of conscious reduction, Troger excludes the sleeping figures of the Apostles (often found in pictures of this subject, which they enlarge but rarely deepen) in order to insist on this tragedy as that of an individual. The striking use of colour — a rigorous red-blue accord — and the sparing but very effective use of drapery folds, also contribute to the imposing character of this picture.

Paul Troger treated the subject of 'Christi Todesangst' [Christ's Fear of Death] (as it was known in the eighteenth century) on many occasions, initially in about 1725, during his time in Bologna, later on a large scale in his work at the Benedictine monastery at Seitenstetten Markt and in the monastery of St Peter in Salzburg.

Franz Anton Maulbertsch (1724–96)
Saint Narcissus (?), c 1754
Oil on canvas, 162 x 103 cm
Inv. No. Lg 17

One can easily tell from this side altarpiece (made for an unknown church) that it comes from the hand of a practised fresco painter. This is evident not only in the 'dangling' feet of the angel (a common device in fresco painting) but also in the overall view *di sotto in su*. One would certainly not be tempted to see this painting as an exercise or as an uncommissioned work, as it is already clearly identified in an inventory of 1822 as a 'quadro d'altare' [altarpiece]. The saint's boldly upturned nose and the flickering light playing on his beard have the effect of 'dematerializing' his figure, so absorbing it as yet another 'abstract' feature into the overall pictorial arrangement. Of greater importance, in purely visual terms, is the white of the surplice at the centre of the picture: the surrounding swirl of dazzling tones finds its starting point in this non-colour. Above, there floats the golden pluvial, picked out in pearls, and the elaborately folded stole. The pose of the putto who holds the book reflects Maulbertsch's training under Paul Troger. Another putto presents the saint with a sword with trickling drops of blood — very much in the tradition of Martino Altomonte. Every element of the earthly and mortal is strictly reduced here: at the extreme lower left we find a tuft of green grass and the bishop's mitre, at the extreme right the saint's martyrdom by beheading.

Although Maulbertsch embarked on his career at the Vienna Academy, he did not especially shine there. It was 1750 before he obtained a First Prize and 1754 by the time he formally became a member of this institution. Although a professorship was proposed in 1757, he was never confirmed in such a post. His 'all too bold spirit' was feared by the more conventional and was too removed from the strictly academic. Elected to the Academy's Council in 1770, he was increasingly forced (partly on account of the lack of patronage in Vienna) to work in the outposts of the Empire, so that much of his best surviving work was done in Hungary and what is now the Czech Republic, though there are also important examples in Lower Austria — for example at Heiligenkreuz-Gutenbrunn and at Mistelbach.

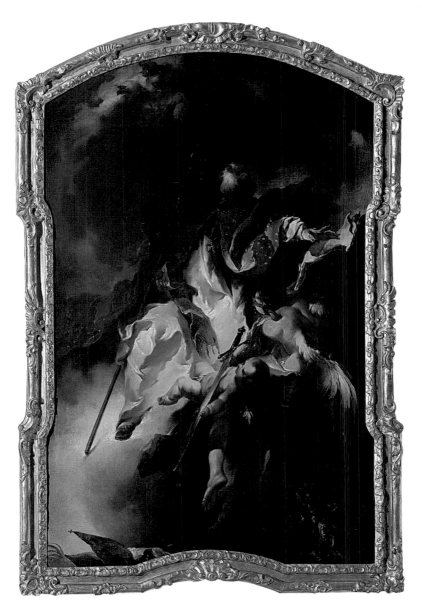

Franz Anton Maulbertsch, **Saint Narcissus** (?)

Johann Georg Dorfmeister (1736–86)
'Memorial', c 1761
Alabaster marble and silver gilt, h. 45 cm
Inv. No. 1778

We know in some detail from the artist's own account how this work came to be made. In his autobiography, he writes that the group — consisting of three figures, Apollo, Minerva and a Genius — was a form of petition. Apollo and Minerva, who are shown reclining on a golden cloud, are allegorical representations of the Emperor Joseph II and his Consort Isabella of Parma, who married in 1760. The Genius represents the artist himself: he lays his right hand on his heart and, with his left, presents a petition bearing the inscription 'Suspice celsa studentem'. The reference here is

to the stipend sought by the artist to enable him to study in Rome. This, however, was not forthcoming, a source of bitter regret for Dorfmeister. Such a subject was often selected for reception pieces at the Vienna Academy, the artist, in a child-like guise, placing himself under the protection of Minerva, the Goddess of Wisdom and the Arts. Comparable works were produced by Jakob Schletterer (*Minerva Triumphing over Envy and Ignorance*; Österreichische Galerie), Johann Platzer (*modello* in the Szépművészeti Múzeum, Budapest) and Johann Perger. The attributes of the depicted figures (Minerva's shield with the Medusa head, the future sculptor's mallet and Apollo's lyre and his quiver with arrows) lie in picturesque disarray on the base.

Dorfmeister may be regarded as effectively a distant pupil of Georg Raphael Donner, in that he succeeded in transforming the latter's monumental 'noble simplicity' into a characteristically Viennese Late Baroque grace. In 1753 he copied Donner's Providence Fountain, thereby attracting the attention of professors at the Academy such as Matthäus Donner, Balthasar Moll and Jakob Schletterer. When his reception piece — *Luna with Cupid Visiting the Sleeping Endymion* (Österreichische Galerie) — had been completed, Dorfmeister worked for the pilgrimage church on the Sonntagberg, the Mariahilf parish church, the church at Gumpendorf and the pilgrimage church of Maria Taferl. Notable among his last works, and already late rococo in character, is his tomb for Prince Grassalkovich in Besnyő near Gödöllő (Hungary).

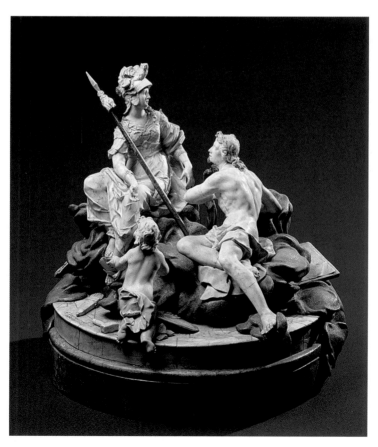

Johann Georg Dorfmeister, **'Memorial'**

Franz Anton Maulbertsch, **Self-Portrait**

Franz Anton Maulbertsch (1724–96)
Self-Portrait, c 1767
Oil on canvas, 119 x 93 cm
Inv. No. 3155

Franz Anton Maulbertsch was one of the most complex painters and printmakers of the Austrian Baroque. Born in Langenargen on Lake Constance, he came to Vienna at the age of fifteen and swiftly demonstrated his ability to merge impulses drawn from South German painting with the courtly style of Viennese Classicism. His work eventually evolved from the religious fresco painting of the Baroque — his first great achievement was the fresco for the dome of the Piaristenkirche in the Josefstadt district of Vienna — to the much more intellectual art of the Enlightenment encouraged under Joseph II.

In its complexity, Maulbertsch's astonishing *Self-Portrait* serves to reveal the problems posed by this development. While a true artist of the Baroque era would have shown himself sumptuously dressed as a token of his elevated position as a court painter, the emphasis

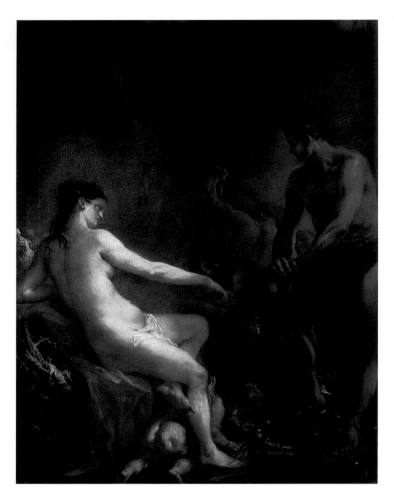

Martin Johann Schmidt, **Venus in the Forge of Vulcan**

has here shifted to the solid core, the reality of his existence. This is expressed in the figure's pose. The treatment of face and hands is exaggerated (in a manner almost anticipating devices favoured in twentieth-century painting) so as to allow these to carry a greater weight of expression, while the clothing and the background are treated in a rather summary fashion. Characteristically Baroque accessories such as the allegorical figure used as a symbol of Art, the twisted column (probably signifying Constancy) and the laced festoons of drapery fade in the ill-lit background, while the portfolio of sketches and the brush (the latter pointing at a portrait) are brightly lit.

This portrait within a portrait has already attracted a variety of interpretations — it has been seen as the artist's self-portrait in his youth or as the portrait of his son — but has as yet received no definitive clarification. Nonetheless, it is also possible that the composition as a whole was intended as a *vanitas* (a picture alluding to the transience of earthly happiness and of youth).

The collection of the Österreichische Galerie allows this portrait to be compared directly with earlier, equally serious works by Jan Kupetzky, Christian Seybold or Franz Anton Palko. Maulbertsch's own model from the point of view of composition must be assumed to be the 1767 portrait of his father-in-law Jacob Schmutzer by Franz Messmer and Jakob Kohl. Also of importance for

Maulbertsch's work were Italian, and particularly French, portraiture, for example the work of Hyacinthe Rigaud or of Nicolas de Largillière.

Martin Johann Schmidt
called 'Kremser Schmidt' (1718–1801)
Venus in the Forge of Vulcan, 1768
Oil on canvas, 152 x 120 cm
Inv. No. Lg 191

The artist, who was principally known for his work as a painter of religious subjects, chose this mythological theme for his reception piece at the Vienna Academy. Especially valued as reception pieces were subjects that offered scope for the anatomically correct representation of the nude while also offering proof of the artist's learning. The pendant to this picture, *King Midas Judging the Contest between Apollo and Marsyas*, exhibited in the same room in the Baroque Museum, formally complements this composition. The cult of Rembrandt emerging in the Late Baroque era is clearly reflected in these two works (see, for example, the figure behind Midas). A style of painting determined by very precise chromatic effects — note the pumpkin in the foreground — is here linked with the capricious character of French rococo. Striking use is made of contrast: the silky sheen of the flesh tones, the grace of the poses and the melancholy expression of Venus (who is posed in allusion to Antique models) are set off as sharply as possible against the world of Vulcan's forge. A mythological subject is here exploited to enable the artist to present symbolically a number of physical and spiritual opposites.

Born in Grafenwörth (Lower Austria), 'Kremser Schmidt' (called thus to distinguish him from 'Wiener Schmidt') came to be one of the most popular painters of the Austrian Baroque. While he did not receive important fresco commissions, as did his inspired contemporary Maulbertsch, he was nonetheless a key exponent of the Classical easel picture (whether as altarpiece, history painting or devotional image). While his work was initially informed by Venetian painting, he later responded keenly to the art of Rembrandt, which he came to know in the print collections of the monastery at Dürnstein and the Benedictine abbey at Göttweig. His work for ecclesiastical patrons reached its climax in the altarpieces painted for Pöchlarn and Krems and for Stein, where he had acquired a house. From the 1770s a certain 'dematerialization' is detectable, particularly in the artist's altarpieces; at the same time, he evolved a progressive style of genre painting derived from Netherlandish models (see, in particular, his tavern scenes).

Josef Ignaz Mildorfer (1719–75)
The Holy Trinity with Plague Saints, c 1770
Oil on canvas, 241 x 139 cm
Inv. No. 1653

This painted representation of the Holy Trinity was originally set into a stucco ceiling in the chapel of the Schloss of Thürnmühle near Schwechat. It came into the collection of the Österreichische Galerie by way of the Austrian Bundesdenkmalamt. As a result of these movements the canvas has been cut down on various occasions and now has a semi-circular upper edge.

The composition is arranged so that the figures of the saints overlap to some degree: in the foreground, placed on a cloud, is Saint Florian, presented as a knight, holding as his attribute a putto with a tub full of water, its contents seeming to spill over the sides as a sign of the protection of house and home. Behind him we find Saint Roch, shown wrapped in rough sackcloth, who points to the plague sore on his leg, at which a dog also peers. Behind him, in turn, we find Saint Sebastian, who displays his own attribute — an arrow. The composition is harmoniously rounded off with the figure of Saint John Nepomuk, shown in rapt contemplation of the Cross while a putto hands him a martyr's palm and a victor's crown. In a manner clearly drawing on Paul Troger's approach to composition, the entire upper half of the painting is occupied by the figures of the Holy Trinity and by the Cross.

In addition to a Last Judgement in the Wilten Basilica near Innsbruck and a Pietà at Telfs, Mildorfer's best work was his fresco in the dome of the pilgrimage church of Hafnerberg in Lower Austria (1743). Among his altarpieces, the picture for the high altar of the church at Neustift bei Brixen (1744) and the *Apostles' Farewell* in the Ulrichskirche in Vienna (c 1760) are especially notable. After 1770, when he assumed for a second time the directorship of

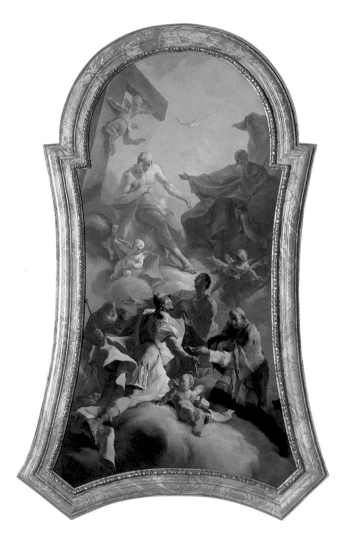

Josef Ignaz Mildorfer, **The Holy Trinity with Plague Saints**

the Vienna Academy (after Martin van Meytens had vacated this post), he worked, like Maulbertsch, largely in Moravia and Hungary.

Franz Xaver Messerschmidt (1736–83)
An Arch-Rascal, after 1770
Alloy of tin and lead, h. 38.5 cm
Inv. No. 2442

This is one of the casts of the series of 'Character Heads', in which veristically treated facial expression is pushed to an extreme. In this case it appears as if the depicted man wished to altogether deny the existence of the outside world. His head is pressed so far down into his torso that nothing is left of his neck beyond a mere line.

Franz Xaver Messerschmidt was one of the most idiosyncratic artists of the eighteenth century. Born in Swabia, and arriving in Vienna by way of Munich and Graz, he studied from 1755 at the Academy, where he was taught by Jakob Schletterer and Matthäus Donner. His first independent works were the

bronze busts of Maria Theresia and Franz Stephan of Lorraine (1760) for the Imperial Arsenal (now in the Baroque Museum). After producing portrait reliefs of Emperor Joseph II and his Consort, Messerschmidt was commissioned by the Imperial court to make over-life-size lead statues of Maria Theresia and Franz Stephan of Lorraine (also in the Baroque Museum), each of these works clearly evincing a tendency towards an exaggerated individuality. In addition to further large-scale sculptural works (a fountain for the Savoysches Damenstift in Vienna and also an *Immaculata* for its facade), Messerschmidt continued his series of emphatically realistic portraits (Gerard van Swieten, Franz Christoph von Scheyb), these eventually leading to his election to the Vienna Academy. Messerschmidt also taught sculpture at this institution. It appears, however, that around 1770, he suffered a severe psychic crisis that led, among other things, to a persecution complex. Accordingly, on Jakob Schletterer's death, Messerschmidt was passed over among his potential successors as Professor of Sculpture at the Academy.

After this insult, Messerschmidt left Vienna and went to stay with his brother in Pressburg [now Bratislava, Slovakia]. He lived there until his death, regarded as an eccentric, working on his 'Character Heads'. In devising these, he was in part influenced by Johann Kaspar Lavater's *Physiognomische Fragmente*. Messerschmidt is mentioned several times in Lavater's surviving writings.

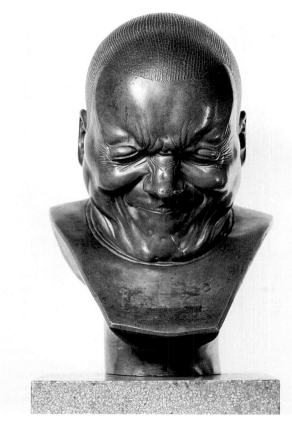

Franz Xaver Messerschmidt, **An Arch-Rascal**

Neo-Classicism — Romanticism — Biedermeier

The largest group of works in the collection of the Österreichische Galerie is that representing the period from the later eighteenth to the mid-nineteenth century. Its paintings and sculptures allow us to trace every step of the shift from Neo-Classicism, through Romanticism, to the emergence of the Viennese variant of Biedermeier. The history of this part of the collection is closely bound up with that of the Imperial picture gallery housed in the Oberes Belvedere and opened to the public in 1781. At this early date it had already been decided to show in four second-floor rooms in the West Wing only the work of contemporary Austrian artists. This was the first official public recognition of local and national artistic development, embracing the work of Viennese artists and also that of artists from the German-speaking lands of the Empire and from Austrian possessions in Northern Italy.

The basis was thus established for a 'modern gallery'; over the following years this collection of contemporary art was enlarged through a careful programme of acquisitions so that the selection on show to the public could be frequently changed. Purchases were most frequently made at the exhibitions of new work organized by the Vienna Academy. Until the mid-nineteenth century, decisions regarding new acquisitions were made by the Emperor, but these were usually in response to proposals made by the current director of the gallery. (Each director, in accordance with an Imperial decree, had himself to be a painter or restorer.) In making acquisitions, there was a concern not to buy too many works by any single artist but, rather, to represent a broad range of names in order to be able to provide a more thorough account of contemporary art. According to the gallery guide published by Albrecht Krafft in 1837, and listing one hundred and forty-one paintings, the aim was to convey the 'contemporary state of art in the Austrian monarchy and particularly in Vienna'.

The collection included works by Jakob and Rudolf von Alt, Friedrich Heinrich Füger, Josef Fischer, Josef Führich, Friedrich Gauermann, Angelika Kauffmann, Johann Knapp, Joseph Mössmer, the history painter Anton Petter and the flower painter Franz Xaver Petter. There were also pictures by Josef Rebell, Ludwig Ferdinand Schnorr von Carolsfeld, Franz Steinfeld, Matthias Rudolf Thoma, Ferdinand Georg Waldmüller, Sebastian Wegmayr and Michael Wutky. Among the more notable paintings already in the collection were Friedrich von Amerling's *Boy Fishing*, Josef Danhauser's *The Scholar's Room* and *Comic Scene in the Studio*, Peter Fendi's *Girl at the Lottery Stall*, Johann Peter Krafft's *The Soldier's Farewell* and *The Soldier's Return* and Johann Evangelist Scheffer von Leonhardshoff's *Saint Cecilia*. To these were added examples of sculpture (including works by Leopold Kissling, Josef Kaehsmann and Johann Nepomuk Schaller), displayed separately on the ground floor of the northern octagons.

In addition to the large number of genre paintings, there was a striking proportion of pictures with religious or historical subjects. These were intended, respectively, to document the powerful and supportive role of the church in national life and to strengthen the sense of nationality in the Austrian Empire (as newly re-defined in 1804–06) through stirring records of events from the nation's history. Works such as Anton Petter's *Emperor Maximilian I's Triumphal Entry into Ghent* met the requirements established by the court historiographer Baron Joseph von Hormayr, in whose view the purpose of history painting was to defend and represent the interests of the state. In the character of the works entering the collection in these years, one can detect

not only the continuing implementation of a plan to survey the whole of contemporary artistic production but also an insistent ideological programme.

Through numerous acquisitions made over the following years, this 'modern' section of the Imperial collection was enlarged to form a great part of the nineteenth-century collection as we know it today. In 1921, after the fall of the monarchy, it became part of the Österreichische Galerie. The collection was supplemented by a number of works presented in 1903 as long-term loans to the Moderne Galerie (the predecessor of the Österreichische Galerie) by the Vienna Academy in order to illustrate the evolution of Austrian art.

Under the direction of Franz Martin Haberditzl (in this post from 1914 to 1938) the predominantly nationally oriented collection was supplemented through the acquisition of European art. This further encouraged discussion of the international context of Austrian artistic development. With the purchase of a number of cloud studies by Caspar David Friedrich and Johann Christian Claussen Dahl, three further works by Friedrich (two window pictures and a view of the rock formations along the River Elbe near Dresden), the Österreichische Galerie could claim to possess outstanding examples of North German Romantic painting. Two works by Carl Blechen — the *Forum Romanum* and the *Marina Grande* — complemented several works already in the Imperial picture gallery from the early nineteenth century: Neapolitan views by Josef Rebell and the *Waterfall at Tivoli* by Jacob Philipp Hackert. The careful selection of European work amassed by Haberditzl (its principal purpose being to better define the collection of Austrian art and to point up international connections) was extended by his successors. Their parallel attention to enlarging the national collection ensured that the Österreichische Galerie can now display a representative cross-section of art from the late eighteenth to the mid-nineteenth century.

The collection of Neo-Classical sculpture consists of a small number of valuable works, including Franz Anton Zauner's *Perseus and Andromeda*, Johann Nepomuk Schaller's *Philoctetes*, *Bellerophon Fighting with the Chimaera* and *The Youthful Cupid*, and Leopold Kissling's *Mars, Venus and Cupid*. Portraits in this part of the Österreichische

Galerie range from the Baroque or Classicizing work of the late eighteenth century influenced by English and French art — Angelika Kauffmann's *Lord John Simpson*, Friedrich Heinrich Füger's *The Actress Josepha Hortensia Füger* and works by Johann Baptist Lampi the Elder — through pictures by François Gérard (*The Family of Count Moritz Christian Fries*) and Eugénie Trippier-Lefranc, to leading examples of Austrian portraiture from the Biedermeier era, such as Friedrich von Amerling's *Rudolf von Arthaber and his Children* and Ferdinand Georg Waldmüller's *The Kerzmann Family* and *The Eltz Family*. The Biedermeier Realism evolved by Waldmüller around 1820 (*Frau Rosine Wiser, Portrait of a Young Man*) was further developed in the work of Franz Eybl.

In the painting of historical subjects, which was closely connected with the treatment of religious themes, artists generally clung to a rigid Academicism until well into the later nineteenth century. The leading Austrian figures in this area were Friedrich Heinrich Füger, Hubert Maurer and Anton Petter. The heroic deeds of the early Habsburgs were, however, treated more Romantically in the work of Ludwig Ferdinand Schnorr von Carolsfeld (*Rudolf von Habsburg and the Priest*) and Moritz von Schwind (*The Emperor Maximilian in Saint Martin's Wall*). Simultaneously, there emerged a concern with contemporary events. Among the Austrian artists taking their cue from French art in this respect — Jacques Louis David's *Napoleon on the St Bernard Pass* — were Johann Peter Krafft (*The Soldier's Farewell, The Soldier's Return, The Triumphal Entry of Emperor Franz I after the Peace of Paris*) and Peter Fendi (*Open-Air Mass on the Outer Burgplatz*). The event depicted in this last was a service of thanksgiving held in 1826 for the recovery from illness of Emperor Franz I.

The Romantically oriented Brotherhood of St Luke (also called the Nazarenes) rejected the Baroque-Classicist tradition inculcated at the Vienna Academy, as at other such institutions, moved to Rome and sought to return to the roots of 'Old German' painting. They are represented here largely with paintings of religious subjects (Johann Evangelist Scheffer von Leonhardshoff's *Saint Cecilia*, Josef von Führich's *The Virgin's Passage across the Mountains*

and Leopold Kupelwieser's *The Journey of the Magi*), but also with pictorial adaptations of Romantic tales (Moritz von Schwind's *The Fair Melusine* or *Rübezahl*).

Romantic landscape painting, informed by the sense of a harmonious union of man and nature as an expression of faith in the Creation, is seen at the Österreichische Galerie in the work of one of its leading representatives, Josef Anton Koch (*The Great Waterfall near Tivoli, The Berne Oberland*). In Ludwig Ferdinand Schnorr von Carolsfeld's picture *Spreading Pine in the Brühl near Mödling*, however, one can detect a later variant of Romantic landscape which already embraces elements of Biedermeier Realism. A realistic treatment of landscape got underway around 1830 and was evolved, through an objective treatment of nature, into simple compositions without any obtrusive sense of *mise-en-scène*. Examples in the Österreichische Galerie include the work of Friedrich Loos, Franz Steinfeld's *Hallstättersee* and Friedrich Gauermann's *Landscape near Miesenbach*. This approach was taken up and developed in mid-century in the poetic scenes of Adalbert Stifter, the soberly realistic depictions of Thomas Ender and the ambitious landscapes of Waldmüller (*Large Prater Landscape, Mödling with the Ruin of Schloss Liechtenstein*). A special position among landscape painters is occupied by Rudolf von Alt, who produced numerous topographically exact views of locations throughout much of Central and Southern Europe. Examples of his work in the Österreichische Galerie include *The Stephansdom, The Temple of Vesta in Rome* and *The Port of Naples with Vesuvius*.

During the Biedermeier period, still life enjoyed something of a Golden Age. Drawing on the model of Flemish and Netherlandish painting of the seventeenth and eighteenth centuries, artists such as Franz Xaver Petter, Josef Lauer and Josef Nigg produced splendid, and above all decorative, flower pieces. Other artists, however, testified to the increasing interest in botany (as in the case of the painstakingly exact record of flower, plant and fruit forms in Johann Knapp's *Jacquin's Monument*) or to a concern to convey the 'poetry' of a simple bunch of flowers (as, for example, in Waldmüller's *Roses by a Window*).

Viennese Biedermeier was, however, at its best in the realm of genre painting. Once again, Waldmüller is one of the leading names (works in the Österreichische Galerie collection include *Perchtoldsdorf Wedding, The Morning of Corpus Christi, Early Spring in the Vienna Woods* and *Collecting Brushwood in the Vienna Woods*). Like Johann Matthias Ranftl and Friedrich Gauermann, Waldmüller focused exclusively on rural communities in his genre paintings. The bourgeoisie, meanwhile, in particular its moral shortcomings, was the particular province of Josef Danhauser (among his engaging narrative paintings in the Österreichische Galerie are *The Rich Glutton, Reading of the Will*, and *Wine, Women and Song*). A touching record of the life of the lower classes is found in the work of Peter Fendi (*Eavesdropping, The Storm*). Fendi also sought to turn the attention of his wealthy patrons to the situation of those living on the periphery of society by showing the hard fate they often encountered (*The Attachment Order, The Impoverished Officer's Widow*). Three of Fendi's pupils — Carl and Albert Schindler and Friedrich Treml — are the most important exponents of the so-called 'soldier painting'. The scenes of daily life in the suburbs of Vienna by Michael Neder (*Coachmen's Dispute, Return of the Herd*) are valued for their directness. The collection also contains works by Johann Baptist Reiter, Franz Eybl, Erasmus Engert and Eduard Ritter.

The Österreichische Galerie owns the largest collection of paintings of the Biedermeier period in Vienna, including eighty-one works by Waldmüller, forty-six by von Amerling, twenty by Fendi, seventeen by Danhauser, seventeen by Gauermann and fifteen by Rudolf von Alt (of which six date from before 1850). Thanks to the wide range of the acquisitions of the former Imperial picture gallery, the present collection also contains a large number of works by less well-known figures. These serve to provide a fuller picture of the artistic production of this period.

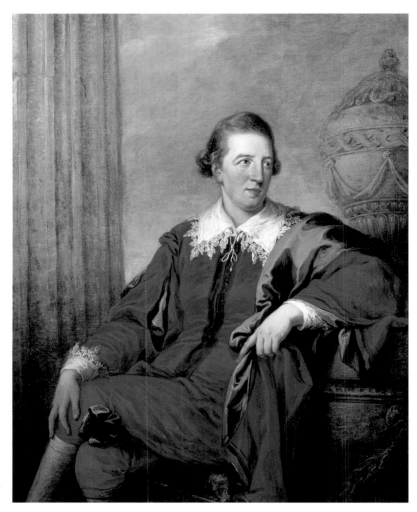

Angelika Kauffmann, **Portrait of Lord John Simpson**

Angelika Kauffmann (1741–1807)
Portrait of Lord John Simpson,
father of Maria Susanna, Lady Ravensworth,
1773
Oil on canvas, 127 x 101.5 cm
Inv. No. 8885

Angelika Kauffmann was born in
Chur, Switzerland, and brought up in the
Bregenzer Wald and in Milan. While
she was still young, her talent was rec-
ognized and encouraged by her father,
the painter Joseph Johann Kauffmann,
with whom she initially trained. Further
studies in Florence and Rome gave her
the chance to meet some of the most im-
portant artists and scholars of the mid-

eighteenth century. On a visit to Venice
she came to know Lady Wentworth
(wife of the British Consul), who invited
her to London. This visit led to a long
stay (1766–81), during which Kauffmann
formed a close friendship with Sir
Joshua Reynolds, one of the most im-
portant English portrait painters of the
day. In London she evolved a portrait
style of her own, notable for its lack of
artificiality of pose or sentiment.

Kauffmann's rendering of Lord
Simpson in the picture illustrated here
suggests a certain ambivalence between
formality and humanity in the sitter's
character because of the contrast be-
tween the architectural motifs in the

background and his unforced, comfortable pose. His pensive, slightly wandering gaze lends a relaxed expression to his face, thus allowing the man as such to dominate a sense of his social position. In its lack of stiffness or awkwardness and its reliance on 'natural' gestures, this work may be seen to stand at the beginning of a new type of portraiture that was to come into its own in French art only around 1800 and in the painting of Central and Northern Europe in the first decades of the nineteenth century.

Friedrich Heinrich Füger (1751–1818)
The Death of Germanicus, c 1789
Oil on canvas, 157 x 222 cm
Inv. No. Lg 47

Füger was born in Heilbronn and studied at the Academies of Stuttgart and Leipzig. After several years in Italy he settled in Vienna in 1783. In 1785 he became Director of the Vienna Academy and from 1806 he was Director of the Imperial picture gallery at the Belvedere. Although his work as a portrait painter was highly admired, he was himself most committed to large-scale history paintings. Both as a theorist and as a painter, Füger was close to Anton Raphael Mengs and Jacques Louis David (having come to know their work during his time in Italy). Füger's subjects were generally drawn from the history of Ancient Rome or Classical Mythology.

The Death of Germanicus is one of the key works from Füger's early Viennese period. The Roman commander Germanicus, who had made his name in the wars against the German tribes, is said to have been poisoned. Füger's composition follows the account by Cornelius Tacitus which the friends of Germanicus, gathered around his deathbed, swore to avenge his murder. The rendering of mood — ranging from subdued grief, through anger, to fierce resolution — reveals the artist's broad range of emotional expression without breaching the limits established by the traditions of academic propriety. In the treatment of space in which the expressiveness of the drapery is highly charged Füger reveals his continued dependence on the traditions of Baroque painting.

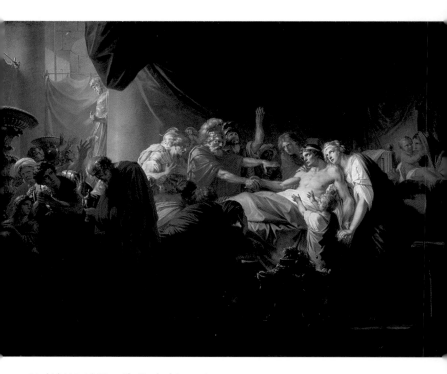

Friedrich Heinrich Füger, **The Death of Germanicus**

Jacques Louis David, **Napoleon on the St Bernard Pass**

Jacques Louis David (1748–1825)
Napoleon on the St Bernard Pass, 1301
Oil on canvas, 246 x 231 cm
Inv. No. 2089

The career of the French painter Jacques Louis David was closely tied in with political events in France in the late eighteenth and early nineteenth centuries. His *Oath of the Horatii* (Musée du Louvre, Paris), completed in Rome in 1785 and exhibited the same year in Paris, was immediately recognized as a 'revolutionary' work, thus contributing to the intellectual component of the developments that were to issue in the French Revolution. In 1789 David aligned himself with the Jacobins and started to treat contemporary events in his paintings. Within a decade David had attained fame all over Europe and was an obvious candidate for the commissions issued by Napoleon Bonaparte after the latter had seized power in France.

David's work on this picture of Napoleon crossing the Alps by the Great St Bernard Pass in May 1800 was strictly supervised by its subject. The picture was intended not only as a symbol of the glory of Napoleon's army and his country, but also as a symbol of his personal triumph. Napoleon's irresistible progress is conveyed by the pose of the horse as well as by the rider's upward pointing hand and his billowing red cloak. The resulting image, it has been said, might be understood as a painted

François Pascal Simon Gérard, **The Family of Imperial Count Moritz Christian Fries**

equestrian monument. The names of Hannibal and Charlemagne engraved on the rocks beneath the horse's hooves are intended to acknowledge Napoleon's conviction that his own place in European history was equal to that of such earlier leaders who had crossed the Alps. Despite the restrained, classically cool colouring and the uncompromising pose of the subject himself, the emotional excitement and dynamism in this work are testimony to David's keen attention to the Baroque treatment of such themes.

François Pascal Simon Gérard (1770–1837)
The Family of Imperial Count Moritz Christian Fries, c 1805
Oil on canvas, 223 x 163.5 cm
Inv. No. 3386

From 1786 Gérard studied portrait and history painting under Jacques Louis David and is generally regarded as one of his favourite pupils. After the great success attained by his 1801 portrait of *Madame Récamier* (Paris, Musée Carnavalet), he became one of the painters who were most sought

after by the nobility close to the French court.

The picture illustrated here, painted at the height of Gérard's fame, shows Count Moritz Christian Fries (1777–1826), who lived in Vienna, his wife, Maria Theresia, née Princess Hohenlohe-Waldenburg-Schillingsfürst (1779–1819), and their son Moritz (born in 1804). The young family is presented in a combination of unforced domesticity and formality, the riding costume and easy seated pose of the man contrasting with the generally more formal presentation of his wife and with the architectural elements in the background. The naked child in his bed invites us to see the group as an allusion to the Holy Family — a deliberate profanation of Christian iconography that is typical for this period.

As proprietors of the Viennese banking house Fries & Co., founded in 1766, the Fries family was one of the richest in the city. Moritz Christian Fries was also an important patron of the arts, but his careless and extravagant lifestyle eventually led to the collapse of the bank and, as a result, to the sale of the large art collection built up by his father.

Johann Nepomuk Schaller (1777–1842)
Philoctetes, 1808/09
Lead, h. 67 cm
Inv. No. 2287

After working for many years as an embosser at the Viennese Porzellanmanufaktur [Porcelain Factory], while also studying under the sculptor Johann Martin Fischer at the Vienna Academy, Schaller created his first independent work — this figure of Philoctetes shown drawing the poisoned arrow out of his foot. Schaller was encouraged to produce this work by Count Johann

Johann Nepomuk Schaller, **Philoctetes**

Caspar David Friedrich, **Sea Shore in the Mist**

Philipp Cobenzl, who was curator of the Academy's own art collection. The figure was made in plaster in 1808, and the lead cast in 1809. Although this is such an early work, the artist's skill is immediately apparent in its composition. Its success assured the young sculptor of extensive patronage.

Here, Schaller has based his figure on the so-called *Cincinnatus* or *Jason*, a sculpture from Antiquity (now in the Musée du Louvre in Paris) that had been copied by Wilhelm Beyer for the park at Schloss Schönbrunn. He has, however, intensified the forward-leaning pose and has attained a compact outline by means of the slight sideways turn of the upper body. Moreover, the positioning of the figure's helmet and the armour at his feet, as also the cloak placed over his bent right leg, provide the necessary stability. The quiver with its arrows had been given to Philoctetes by Hercules, with whose help, according to the legend, the Greek hero killed the Trojan hero Paris, thus ultimately bringing about the Fall of Troy.

Caspar David Friedrich (1774–1840)
Sea Shore in the Mist, c 1807
Oil on canvas, 34.2 x 50.2 cm
Inv. No. 3700

This scene, a bleak shore covered with rough stones and a ship disappearing like a phantom into the mist, is one of the best of Friedrich's early works and, on account of its simplicity, its sense of great calm and its suggestion of immensity, was already praised by Friedrich's contemporaries.

Friedrich, who emerged as a mature artist in the Dresden circle of Early German Romantics, was principally a landscape painter. Nonetheless, despite carrying out detailed studies directly from landscape motifs, he rarely sought to capture in his paintings the landscapes he had observed in reality. His subject was, rather, the 'universal landscape' as an expression of human moods.

Here, in opposing the mist with the almost tangible stones in the foreground, he is able to convey a compelling mood of melancholy. The implied significance of the mist is intensified by a suggestion of the dissolution of all that is material: Friedrich thus hints at a transcendental infinity. He is, in fact, employing a form of symbolism already

familiar in painting in the eighteenth century, in which mist could be understood as an allusion to man's distance from God and his succumbing to temptation, but also to the darkness of human life (Werner Sumowski). The small boat carrying a number of figures towards a ship lying further out has been interpreted by Helmut Börsch-Supan as an allegory of death. The same scholar has seen the cropped image of the abandoned anchor (a motif also to be found in other sea shore pictures by Friedrich) as a symbol of victory over the drudgery of mortal existence.

Josef Rebell (1787–1828)
The Port of Granatella near Portici, 1819
Oil on canvas, 98 x 137 cm
Inv. No. 2148

During Rebell's period as a student of landscape painting at the Vienna Academy, his interest in Italy was aroused by one of his teachers, Michael Wutky. After completing his studies in 1810, Rebell travelled, via Switzerland, to Milan and then south to Naples and eventually north again to Rome, where

he stayed until 1824. Impressed by the work of Claude Lorraine and Josef Anton Koch, and for a time also further advised in artistic matters by Wutky (who had himself moved to Italy in 1805), Rebell completed his development as an artist quite removed from all the Late Baroque influences that continued to mark Viennese landscape painting into the second decade of the nineteenth century.

The impact of the southern light on Rebell's imagination is clearly reflected in his charming view of the port of Granatella near Portici. The picture follows one of the Classical principles of composition, according to which the various strata lying above or behind each other, as well as features located to the left or the right (here, respectively, the wall jutting into the picture and the cloud of smoke issuing from Vesuvius), contribute to the overall chromatic and material balance. Rebell does more here, however, than simply provide a conventional *veduta*: by means of introducing into the foreground the figures shown engaged in their work, he seeks to grasp the subject in its totality. The picture is also notably refined in its treatment of the reflections in the

Josef Rebell, **The Port of Granatella near Portici**

Johann Evangelist Scheffer von Leonhardshoff, **The Death of Saint Cecilia**

water surface and of the colouring of the sky as it fades towards the horizon.

Rebell was among those to be included in the exhibition organized by German artists in Rome in the spring of 1819. The work he showed there aroused the interest of the Austrian Emperor Franz I, who acquired *The Port of Granatella near Portici*, along with three other views of the environs of Naples, for the Imperial picture gallery. In 1824 he appointed Rebell to the post (then vacant for six years) of director of the gallery. In Vienna Rebell also taught landscape painting at the Academy.

Johann Evangelist Scheffer von Leonhardshoff (1795–1822)
The Death of Saint Cecilia, 1820/21
Oil on canvas, 149 x 195 cm
Inv. No. 2244

Scheffer von Leonhardshoff, one of the most important Austrian artists of the Romantic era, had already become a deeply sensitive and devout painter during his travels in Northern Italy and Venice in 1812. Like the artists of the Brotherhood of St Luke (or Nazarenes), who were in Rome at this time and who had abandoned contemporary artistic

ideals and conventions in favour of those of German and Italian painting before 1500, Scheffer, too, found a beauty of which he could approve in the work of Raphael, Giovanni Bellini and Perugino. In 1815, when Scheffer first met the Nazarenes, he had already established a style of his own and only needed to consolidate it. Because he died so young, his total surviving oeuvre is not large: in addition to portraits, he principally painted religious subjects. These last had an important influence on Austrian and German religious painting until the early twentieth century.

The Death of Saint Cecilia (of which the Österreichische Galerie possesses two versions) is without doubt Scheffer's masterpiece. The first version (shown here) was painted in Rome and surpasses the second, painted in Vienna, in terms of both formal precision and technical perfection. Scheffer shows Saint Cecilia reclining on the grass, having been felled by the three sword strokes in her neck. Her oddly held right hand alludes to the legend that the dying saint, no longer able to speak, bore witness to the Holy Trinity by extending her three fingers. Scheffer's direct model for this reclining figure was Stefano Maderna's marble figure of the same saint in the church of Santa

Cecilia in the Trastevere district of Rome. Scheffer had already come to know this work during his first stay in the city. He claimed that he had selected the lunette form for his painting so that the composition would be tightly enclosed by its frame, its sense of peace thus remaining undisturbed. Shortly after Scheffer's death (on 12th January 1822), this picture was acquired for the Imperial picture gallery in the Belvedere. Here, on the orders of the Emperor Franz I, it was hung in a place of honour for public viewing.

Leopold Kupelwieser (1796–1862)
The Journey of the Magi, 1825
Oil on canvas, 33 x 41.5 cm
Inv. No. 3768

Alongside Josef von Führich, Leopold Kupelwieser was the most important painter of religious subjects active in Vienna in the first half of the nineteenth century. Kupelwieser was still too young when admitted to study at the Vienna Academy (in 1808) to become a member of the Brotherhood of St Luke. During a trip to Italy, however, he met up with the artists of the Brotherhood

in Rome. As a result, his subsequent work was strongly influenced by theirs. Kupelwieser also belonged to the 'Romantic' circle of Franz Schubert and Moritz von Schwind, finding in their concern with emotion a confirmation of his own literary and poetic understanding of art. This subsequently led him to enrich the content of his pictures with strong elements of narrative, even fantasy.

The Journey of the Magi was painted in 1825, shortly after Kupelwieser's return to Vienna. The principal figures, all on horseback and posed almost identically, are placed parallel to the picture plane and occupy most of the foreground. Kupelwieser's interest in the work of the painters of the Florentine Quattrocento is reflected both in his compositional devices and in his use of saturated colours. At the same time, the silhouetting of the main figures against the evening sky and the uncanny glow of the 'manger' in the shadow of the surrounding palm trees bestow on the picture a dream-like quality that dominates the religious significance of the subject.

Leopold Kupelwieser, **The Journey of the Magi**

Johann Peter Krafft (1780–1856)
**The Triumphal Entry of Emperor Franz I after the
Peace of Paris on 16th June 1814**, before 1828
Oil on canvas, 38.5 x 65 cm
Inv. No. 6247

This picture served as the presentation model of one of the three enormous wall paintings in the Audience Hall in the Hofburg in Vienna. The three are regarded as the high points of Krafft's work. This painting shows the festive reception that greeted the Emperor on his return to Vienna after the Peace of Paris, which had formally brought an end to the Napoleonic Wars. The choice of an event from recent history (the subjects of the other two paintings are *The Return of the Emperor from Pressburg in 1809* and *The Excursion after the Emperor's Recovery from Severe Illness in 1826*) was fully in accordance with Krafft's understanding of history painting. This, in his view, only had a future if the events it depicted had a clear connection to the present.

In terms of composition, Krafft's work for the Hofburg is reminiscent of French painting in the circle of Jacques Louis David, under whom Krafft (a native of Hanau in Hesse) had studied during his two-year stay in Paris (1802–04). Nevertheless, the device of incorporating the populace (which in French history painting had assumed an anecdotal character by about 1800)

introduces an element of genre painting, with each individual rendered clearly and individually in his or her activity. It is, indeed, the rejoicing of this populace, the picture's true subject, that establishes the Emperor as its central figure. This approach was, in fact, in accord with the contemporary idealization of the ruler (shared and encouraged by the Emperor himself) as close to, and beloved by, his people. In Krafft's use of pure, unmixed colours and sharp contours — these drawing attention to a certain stiffness of form, above all in the drapery folds — his relation to French Neo-Classicism is evident. However, his very precise rendering of individual figures already reflects the influence of the emerging Realism of Viennese Biedermeier.

Johann Peter Krafft, **The Triumphal Entry of Emperor Franz I after the Peace of Paris on 16th June 1814**

Ludwig Ferdinand Schnorr von Carolsfeld, **Rudolf von Habsburg and the Priest**

Ludwig Ferdinand Schnorr von Carolsfeld
(1788–1853)
Rudolf von Habsburg and the Priest, 1828
Oil on canvas, 140 x 190 cm
Inv. No. 4825

A politically inspired interest in the Middle Ages and, above all, the ideological stabilization that occurred in the period 1804 to 1806 (during which the Austrian Empire formally assumed a new status) were decisive factors in encouraging Austrian painters towards a much stronger engagement with national history during the early nineteenth century. The aim of strengthening a sense of nationhood had prompted the court historiographer Baron Joseph von Hormayr to publish his *Momente aus der vaterländischen Geschichte* [Episodes in the History of the Fatherland] between 1807 and 1814, a work recounting the most important events in the history of the House of Habsburg from its beginnings to the present day. Hormayr's insistence that 'love of the fatherland' should find expression not only in literature but also in the visual arts was a crucial spur to the emergence of Austrian history painting. Although Hormayr's views found hardly any re-

flection in the curriculum of the Vienna Academy, a number of leading painters did treat themes from Austrian history. These included Carl Russ (who submitted a total of thirty history paintings to the 1822 exhibition held at the Academy), Anton Petter and Johann Peter Krafft, and also the Nazarenes Franz Pforr and Ludwig Ferdinand Schnorr von Carolsfeld.

Among the historical figures favoured by artists were the Emperor Maxmilian I and, above all, the founder of the Imperial succession, Rudolf von Habsburg. The episode illustrated by Schnorr von Carolsfeld had been treated in a ballad of 1803 by Friedrich von Schiller: Rudolf offers his horse to a priest so that he can cross a stream swollen by rain to administer the Last Rites to a dying man. This remained a popular subject in Austrian painting beyond the mid-nineteenth century. In addition to implying a connection between national history, religion and humanity, the picture is also intended to show the close connection of the House of Habsburg and the Roman Catholic Church.

Carl Blechen, **Early Afternoon on Capri**

Carl Blechen (1798–1840)
Early Afternoon on Capri, c 1829
Oil on canvas, 91 x 130 cm
Inv. No. 1996

While the young Carl Blechen was still a student at the Berlin Academy (1822–24) he was significantly influenced by the works of his contemporaries Caspar David Friedrich and Johan Christian Claussen Dahl. The decisive factor in the evolution of his style of *plein-air* painting was, however, his encounter with the southern light of Italy during his travels there in 1828–29. From Rome, where he soon came to know the colony of German-speaking artists, he set out on a long excursion to Naples and then on to Capri.

This view of the island, which shows Monte Castiglione with the Cliffs of Tiberius, the Marina Grande in the bay and the village of Capri itself on the mountain ridge, vividly conveys the noon heat that in summer renders this region almost lifeless for several hours each day. Blechen's extraordinary gift for observation is apparent in his rendering of the colours drained of their intensity by the dazzling southern light yet set off against the strongly contrasting shaded areas. When this picture was shown at the autumn exhibition of 1832 at the Berlin Academy, however, the critics did not appreciate these qualities. They were baffled, above all, by the loose brushwork tending to hint at, rather than clearly convey, objects and by Blechen's endeavour to construct his pictures as far as possible through colour alone.

Friedrich Gauermann (1807–62)
Landscape near Miesenbach, c 1830
Oil on canvas, 32 x 45 cm
Inv. No. 2815

Gauermann grew up in Miesenbach, a village on the Schneeberg to the south of Vienna. While still very young, he started to produce sketches of his immediate surroundings under the guidance of his father, the painter Jakob Gauermann. After studying at the Vienna Academy (1824–27), Gauermann soon established himself as one of the representatives of a new generation of painters whose realistic treatment of landscape was to pave the way for later developments (others in this group were Franz Steinfeld, Friedrich Loos and Ferdinand Georg Waldmüller).

By the time Gauermann painted the picture illustrated here, this form of landscape painting had attained its high point, and not only in Gauermann's own work. The simplicity of the composition (in which the subject is shown in 'normal' daylight without any obtrusive *mise-en-scène*) reveals an objectivity in the observation of nature that is not to be found in Gauermann's later work. Eventually Gauermann started to broaden the scope of his landscapes by introducing elements of narrative.

Initially, his added figures were nothing more than staffage; but they gradually became central to the meaning of his pictures (fighting animals and episodes from peasant life were among the subjects he most favoured). The observation of nature, however, remained his starting point.

Friedrich Gauermann, **Landscape near Miesenbach**

Rudolf von Alt (1812–1905)
The Stephansdom, 1832
Oil on canvas, 46 x 57.5 cm
Inv. No. 2081

Although Rudolf von Alt studied at the Vienna Academy (1825–32), his most important teacher was his father, Jakob von Alt. From 1824 they went together on sketching trips throughout Austria and Italy and produced innumerable landscapes and city views in watercolour. After the death of his father, Rudolf von Alt continued making such trips until very late in life, and by this means he came to know virtually every part of Austria-Hungary.

Rudolf von Alt is notable not only on account of the enormous number of watercolours he produced (his oeuvre embraces some five thousand) but also because of the quality of his work: during the course of his career he reached a level previously unknown in this medium. His few oil paintings were largely produced in his studio during the winter months. Towards the end of his life, Rudolf von Alt became an admired model for the artists of the Vienna Secession and served until his death as its Honorary President.

This view of the south side of the Stephansdom (one of his favourite motifs) was painted in 1832, the artist's final year at the Academy. A degree of uncertainty in the treatment of perspective is explained above all by the difficulty of obtaining a sufficiently full view of the Stephansplatz from the adjoining Stock-in-Eisen-Platz. A few years later the artist was to solve this problem by slightly compressing the image of the Stephansdom.

Peter Fendi (1796–1842)
Eavesdropping, 1833
Oil on board, 31 x 23.2 cm
Inv. No. 2092

On account of his extraordinary capacity for the observation of people, and the high quality of his painterly record of the observed, Fendi occupies an un-

Rudolf von Alt, **The Stephansdom**

Peter Fendi, **Eavesdropping**

equalled position among the Bieder-meier painters of Vienna. The 'illicit' subject of the servant girl looking through the keyhole is rendered in so natural a manner that it does not shock us; rather, it endearingly draws our attention to a particular human failing. Fendi's subtle rendering of everyday events ensured that he soon became a great favourite with his contemporaries. As a result of commissions received from the Imperial family, above all from the Empress Carolina Augusta and the Archduchess Sophie, Fendi became the most important witness to the Bieder-meier domesticity cultivated by the Im-perial family. Fendi was especially cel-ebrated for his outstanding paintings of children. Through pictures such as *The Attachment Order* (1840) or *The Impover-ished Officer's Widow* (1836), he also drew attention to the fate of people on the periphery of society. Fendi worked predominantly in watercolour, a tech-nique that he brought to a very high level through his sensitive use of colour and his readiness to leave some of the painting surface uncovered. Fendi's work in oils too is notable for a thin, often only 'glazing', application of paint, through which under-drawing often re-mains visible — in the picture illustrated here this is the case with the outline of the door.

Friedrich von Amerling, **Rudolf von Arthaber and his Children**

Friedrich von Amerling (1803–87)
Rudolf von Arthaber and his Children, 1837
Oil on canvas, 221 x 155 cm
Inv. No. 2245

For decades during the early and mid-nineteenth century, Friedrich von Amerling remained the most famous and most sought-after portrait painter in Austria. His patrons were principally members of the Imperial family, of the aristocracy and of the wealthy upper-middle classes. Amerling owed his great sensitivity in the use of colour and in the treatment of the picture surface to the short time he spent in London studying

with the important English portrait painter Sir Thomas Lawrence. Although Amerling was not allowed to observe Lawrence at work, he nonetheless absorbed the English artist's distinctive quality through technical advice and the careful study of Lawrence's portraits.

Amerling painted his large-scale family portraits in the mid-1830s, thereby assuring himself of an important place not only in the history of Austrian art but also in that of nineteenth-century art as a whole. This group of pictures is distinguished by the unconstrained poses of the sitters and thus the absence of any sense of artifice. While

Waldmüller, in his own family portraits of this period, sought to establish both a formal integrity within the picture and a relationship between subject and viewer by means of an invisible network of gestures and glances, Amerling gave his compositions the character of something incidentally glimpsed.

This portrait shows Rudolf von Arthaber, an industrialist and patron of the arts, with his children. Two of the latter are looking at a picture of their dead mother — a device enabling Amerling both to increase the notion of the familial and to introduce an element of genre. The fact that this picture was posed and painted in the artist's studio shows Amerling's brilliance in evoking intimate interiors and establishing an inner connection between space and figures.

Josef Nigg (1782–1863)
A Bunch of Flowers, before 1838
Oil on canvas, 61.3 x 49.5 cm
Inv. No. 3629

As a result of the close co-operation between the Vienna Academy and the Vienna Porzellanmanufaktur, and the study of Netherlandish flower painting of the seventeenth and eighteenth centuries encouraged by Johann Baptist Drechsler, head of the Academy's Flower Painting School, Viennese flower painting between the late eighteenth century and 1850 attained a quality unequalled elsewhere in Europe. Painters took as their models the works of Jan van Huysum, Willem van Aelst or Rachel Ruysch to be found in the gallery of the Vienna Academy and in various private collections. As the development of this genre was dependent above all on the

Josef Nigg, **A Bunch of Flowers**

Ludwig Ferdinand Schnorr von Carolsfeld, **Spreading Pine in the Brühl near Mödling**

requirements of fashion and a growing public demand, it did not evolve as a 'purer' art form might have done but generally adhered to time-tested formal devices — in this case the presentation of a bouquet in a niche in a wall.

The most important among Nigg's fellow practitioners of this genre were Johann Baptist Drechsler, Sebastian Wegmayr, Franz Xaver Gruber and Franz Xaver Petter. Their pictures recorded artfully arranged bouquets, sometimes with a strong imaginative element — the combination, for example, of the finest flowers from quite different seasons and very diverse environments. In addition to his flower pieces in oils, watercolour and pastel, Nigg (who held the post of chief painter at the Viennese Porzellanmanufaktur) also painted floral arrangements on porcelain vases and trays. This work embraces some of the most important examples of porcelain painting to be produced in Vienna.

Ludwig Ferdinand Schnorr von
Carolsfeld (1788–1853)
Spreading Pine in the Brühl near Mödling, 1838
Oil on canvas, 67 x 114 cm
Inv. No. 3167

Although Ludwig Ferdinand Schnorr von Carolsfeld first emerged as an artist in the German Romantic artists' circle in Vienna, he neither took part in the protest of the Brotherhood of St Luke of 1809 against the artistic ideals embraced by the Vienna Academy, nor did he follow this group to Rome. Nonetheless, he was not offered the teaching post he desired at the Academy vacated by his own teacher, Friedrich Heinrich Füger, because, from the Academy's point of view, he still appeared too close to the Brotherhood. Schnorr von Carolsfeld was subsequently employed by the Archduke Johann to provide decoration for the 'Brandhof' near Mariazell; he also supplied drawn designs for the Neo-Gothic 'Franzenburg' at Laxenburg. During the 1830s, Schnorr von Carolsfeld painted portraits and religious, historical and literary subjects, but he also increasingly produced landscapes. In their 'veneration' of nature, these were clearly influenced by the Romantically attuned landscape views produced by Ferdinand Olivier and Joseph Anton Koch.

In the picture illustrated here — the precise record of the geological forms around a favourite excursion spot in the Vienna Woods — both the drawing of the plants and the play of light and shadow reveal the painter as a careful observer of nature. The commitment to realistic detail remains, however, subordinated within a fundamentally

lyrical approach, thus distinguishing this view from the landscapes painted by Waldmüller or Steinfeld. The figures, which are rather more than mere staffage, recall the treatment of landscape subjects in the work of the Brotherhood, although the religious content is limited to the figure of a wayfarer absorbed in prayer.

Josef Danhauser (1805–45)
Wine, Women and Song, 1839
Oil on canvas, 143 x 190 cm
Inv. No. 8860

The merry group of men, women and children who have gathered to eat and drink in front of a country tavern, and are now ending their meal with music-making, offers a vivid record of the country excursions so beloved in the Biedermeier era. The excursions undertaken by the Schubert circle, for instance, have entered into legend. Joy in life is here conveyed through an emphasis on the seemingly trivial objects that enrich the scene through their artful arrangement in a series of virtual still lifes. The maxim from the writings of Martin Luther being painted on the wall at the right, and giving the picture its title ('Whoever loves not wine, women and song, remains a fool his whole life long'), serves to guide the viewer's reading of the depicted scene, for the 'fool' of whom Luther speaks is to be found at the left end of the table. Seated awkwardly with his gloves still on, he drinks only sugared water, resisting all offers of food. He is not even to be persuaded, by the invitation to sing from the woman on his left, to join the company in its merry-making.

Josef Danhauser, son and heir of the founder of the celebrated Danhauser furniture factory, was the most important genre painter of the Biedermeier period in Vienna. Drawing on the example of pictures by Dutch artists such as Jan Steen or Acrian von Ostade, or on the moralizing genre paintings of William Hogarth and others, he evolved in his own work the ability to convey situations effectively in a compressed form. But while the *vanitas* symbols of his Dutch models allude to the transience of mortal life, Danhauser in this painting speaks up for the joy to be found in human existence, taking conviviality and cheerfulness as his golden mean and denouncing excessive austerity or renunciation.

Josef Danhauser, **Wine, Women and Song**

Ferdinand Georg Waldmüller, **The Morning of Corpus Christi**

Ferdinand Georg Waldmüller (1793–1865)
The Morning of Corpus Christi, 1857
Oil on board, 65 x 82 cm
Inv. No. Lg 63

Waldmüller was one of the most versatile and important artists of Viennese Biedermeier, producing portraits, landscapes, still lifes and genre paintings. With his gift for the precise observation of people and his direct study of nature, he evolved a style that enabled him to produce works of exceptional quality in every category. It is for his genre scenes, however, that Waldmüller has become so widely known. Always set in peasant communities, these record both traditional festivities and incidental everyday events that Waldmüller had encountered in the Vienna Woods or the Salzkammergut. In terms of content, his pictures are focused less on the harshness of work on the land than on peasant life as such. Old people, mothers and especially children were his preferred models: in contrasting figures from different generations, he was able vividly to show the passage of life.

Here, as a result of his attempt to render sunlight as truly as possible (a concern in his work from the 1840s),

Waldmüller is able to emphasize the festive character of the childrens' preparations for the celebration of Corpus Christi. The deliberate contrast of light and shade and the exaggerated intensity of local colour bestows an almost tangible plasticity on the figures. Throughout his life, Waldmüller sought to capture 'true form' in his pictures; the problem of the rendering of sunlight therefore represented the greatest challenge, although his endeavours in this respect only baffled the majority of his contemporaries.

Realism — Impressionism

In his continuous search for an ever more truthful rendering of nature, Ferdinand Waldmüller was convinced that it was necessary to increase the intensity of depicted light and so he always painted under a blazing sun. It was, however, a later generation of Austrian painters that was finally able to succeed in conveying atmosphere in its pictures. These painters certainly built on the *plein-air* landscape style evolved by Waldmüller and his Austrian contemporaries. Nonetheless, an impulse from abroad was also needed.

Emil Jakob Schindler, a contemporary of Wilhelm Leibl, Claude Monet and Auguste Renoir, was the leading figure in a movement that, in its finest achievements, may be regarded as a distinctively Austrian variant of the international vogue for *plein-air* painting in the mid-and later nineteenth century. Schindler's treatment of landscape had been anticipated by Albert Zimmermann, who was Professor of Landscape Painting at the Vienna Academy. While, in his own work as a painter, Zimmermann still partially adhered to a Romantic and idealizing attitude towards mountain scenery, he offered his pupils a perfect starting point for a new approach to landscape through his consistent emphasis on painting *en plein air.*

Accordingly, for Schindler, as also for fellow pupils such as Ditscheiner, Jettel, Ribarz and Russ, the encounter with the work of the Barbizon painters at the First International Art Exhibition, held in Munich in 1869, proved to be a further spur towards their definitive adoption of *plein-air* painting, inspired by the French painters Corot, Daubigny, Harpignies, Millet, Rousseau and Troyon. A few years later, at the Viennese Weltausstellung [Universal Exhibition] of 1873, works by artists of the 'School of Barbizon' were again on show, and the Viennese Kunstverein [Artists' Association] mounted an exhibition of the work of Gustave Courbet.

Barbizon, in the Forêt de Fontainebleau, had been 'discovered' by painters in France during the 1830s. In 1832 examples of recent English landscape painting had been exhibited at the Paris Salon and four years later the French painter Théodore Rousseau had settled at Barbizon. He was followed by other painters such as Constant Troyon, Charles-François Daubigny, Virgilio Narcisso Diaz de la Peña, Charles Émile Jacque and Jean-François Millet. Fontainebleau offered not only a plethora of charming motifs, but also the seclusion and the rural setting these painters desired, while its relative proximity to Paris made it easy for the artists settled there to show the results of their experiments at the annual Paris Salon and thereby to reach a sufficiently wide public.

In stark contrast to the supposedly 'important' themes of history painting, the Barbizon artists were concerned with an unassuming record of the observed; and they started to lay great store by the notion of 'honesty' in their work. Alongside straightforward scenes of landscape, they paid particular attention to the life of the simple folk who lived in the forest. Many of the oil studies were painted *en plein air.* Camille Corot, who was in close contact with the Barbizon painters, exhibited the first picture he had painted entirely *en plein air* in 1852. (Waldmüller had, of course, painted landscapes entirely *en plein air* decades before that).

Eugen Jettel and Emil Jakob Schindler were the first Austrian painters to focus on distinctively modern motifs. In this they were following the example of the 'paysages intimes' of the Barbizon artists. Schindler, for example, painted a series of suburban landscapes, including several views of the landing stage of the Danube steamers. While the French painters had largely remained faithful in their use of colour to the canon of tone-on-

tone painting, Schindler's precise observation of nature led him to go further: he was able to convey dazzling sunlight in pure, bright and sharply contrasting tones, thus abstracting the depicted objects into flat zones of colour. Schindler always took particular interest in the evocation of various states of weather and light, and in conveying atmosphere and its continuous changes. In doing so he often selected very simple or unpretentious subjects. Especially favoured were scenes of morning or evening, with light mist or overcast skies. Schindler finally started to produce landscapes in series showing the same motif, or a group of very similar ones — for example, an avenue of poplars — in the various light and weather conditions associated with the different times of day and each of the seasons. Atmospheric setting thus effectively replaced the ostensible motif as the picture's true subject. Schindler even planned a cycle of pictures representing each of the months, but this was never completed.

Schindler and the painters of his circle became increasingly concerned with the mood that a landscape might encourage in the observer, over and above its purely optical appearance. A landscape, he believed, was not merely perceived optically but also appealed to a painter's emotional sensibility and, in turn, to that of his audience. Just as inconspicuous, 'unexciting' landscape motifs now became more common, so also did inconspicuous objects — flowers and vegetation in gardens and fields were incorporated within pictures in unprecedented close-up, thus appearing to take on a secret life of their own.

The pictures of Schindler's maturity are of an exceptional subtlety in terms of composition. They have an altogether lyrical mood, an air of calm and contemplative observation; and it was this aspect of his work that, according to Carl Moll, Schindler was most concerned to pass on to his pupils.

Commentators have sought to characterize the work of Schindler's students as 'Atmospheric Realism' or 'Atmospheric Impressionism', in order to convey the quality that their paintings share; this should not, however, blind us to the fact that many of those influenced by Schindler subsequently went their own way. Schindler himself called his approach 'Poetic Realism'.

The work of the painters of Schindler's circle may be understood as a transformation of what had been achieved by the Barbizon artists. They went beyond the 'real', demonstrated a particular gift for observing the changes in, and qualities of, the weather, and sought to convey that which could, in turn, evoke emotional response in the observer of their pictures. Schindler and his contemporaries did not seek a dissolution of solidity in their pictures — for example by eschewing definitive outline in favour of regular short brushstrokes. Nor did they go so far as to favour the use of pure colours, yet the spirit of their approach to landscape painting may be described as truly 'Impressionistic', whether on account of the sense of the immediacy they so often achieved by the use of cropping, or because of their ability to capture the transitory, or their penchant for series of linked images intended to convey the various moods determining the perceived character of a landscape. Optical sensation, however, was of less importance to them than emotion, and it was the latter that was the true subject in their work.

Over time, Schindler established himself as the central figure among the Austrian artists approaching landscape in this way. He had a great many pupils, among whom were Tina Blau, Olga Wiesinger Florian, Marie Egner, Marie Louise von Parmentier and Carl Moll. The autodidact Theodor von Hörmann also regularly sought Schindler's advice. Hörmann, who was one of the most eager seekers after reality in art and who painted *en plein air* in all possible weather conditions, even at the risk of his own life, went beyond Schindler's chromatic restraint in the direction of an emphatic luminism. His mature work combines glowing colour with very bold, loose brushstrokes.

In the case of August von Pettenkofen, another great landscape painter (who had started as a painter of military subjects), it was the encounter with the shimmering light of the Great Hungarian Plain in 1851 that prompted a shift to much freer brushwork. During repeated trips to France, he had had the chance to study in some detail the works of the Barbizon painters. Pettenkofen himself produced innumerable scenes of the life of the peasants, their daily work, customs and villages, employing earthy but increasingly glowing colours, and above all a sometimes bold suppression of detail. In the case of Leopold

Carl Müller, one of the most prominent Orientalists (and thus known to his colleagues as 'Orientmüller'), it was the experience of the light and air of Egypt that encouraged the use of ever more luminous colour.

Landscape painting was always of some importance in Austria, and especially so in the second half of the nineteenth century, when the landscapes produced easily outshone the still lifes or the genre paintings in terms of quality, yet the art of Schindler and his colleagues was valued less by the public, and especially by 'official' taste, than was the superficial drama of the Alpine views painted by artists such as Halauska, Hansch, Hasch, Peithner-Lichtenfels, Selleny or Zimmermann, or the society portraits, historical and mythological subjects and genre pieces of the artists most celebrated at this time in Vienna — Hans Makart, Hans Canon or Franz von Defregger.

Just as the work of the Barbizon painters had a notable effect on painting throughout Europe, so too was the work of Gustave Courbet to become a model and an inspiration for many young artists. Courbet, who regarded himself as an autodidact, wished to paint only what he could see. Nonetheless, the 'Realism' to which Courbet himself laid claim, was itself markedly determined by the specific choice of motif, its sometimes monumental and painterly broad treatment, and the often striking use of cropping. A large number of painters followed Courbet, however, in turning to modern subject matter.

In 1869 Courbet stayed for a while in Munich, and got to know Wilhelm Leibl. Soon a group of similarly minded painters had gathered around Leibl — the so-called 'Leibl Circle'. These were committed to achieving a genuine renewal of painting through the integrity of their treatment of reality. Crucial factors, in their view, were the technical perfection and the quality of *facture* [painterly finish]. They disapproved of over-painting — as far as possible a picture was to be painted in one session. While Wilhelm Trübner was subsequently to develop this approach into a moderate form of Impressionism, Leibl himself retreated to the country around Munich to live among rural folk, who then became the principal subject of his work as a figure painter.

For Carl Schuch — alongside Waldmüller and Anton Romako one of the most important Austrian painters of the nineteenth century — meeting Leibl and his circle had a decisive influence on his subsequent artistic development, coming to know the work of Courbet and the new Realism and encountering convictions and ambitions that corresponded fully with his own. Like the other members of the Leibl circle, Schuch preferred undramatic subjects, landscapes and figures at rest that allowed extensive studies to precede the production of a finished painting. It was particularly as a painter of still lifes that Schuch was to attain fame after his death (he hardly ever exhibited his work during his lifetime, having no need to sell because he was financially independent). In a manner comparable to what we find in the case of Cézanne, Schuch was conscious of the two-dimensionality of the painted picture surface and the associated necessity of attending primarily to the relationships between forms and colours. Schuch, indeed, attained solutions comparable to those found in the work of Cézanne, even though he remained more strongly tied to tradition in his use of colour. Schuch did, however, understand what the Impressionists were attempting to achieve; and he reflected on the theoretical basis of their, and his own, use of colour. He also understood that, in order to present objects, these must be translated into an appropriate 'language' and thus subordinated to the autonomous arrangement of the picture. For Schuch, however, light was of even more importance than colour, though he understood light to be a constituent, rather than merely a modifying element. For this reason he made great use of chiaroscuro, believing that he was thus able to express more clearly the essential character of objects.

The achievements of the Barbizon painters were to prove the spur for a whole series of developments, whether proto-Impressionistic or genuinely Impressionistic. Only the salient works are mentioned here, in particular as represented in the collection of the Österreichische Galerie. (The influence of the Barbizon painters is also reflected in the work of the Italian *Macchiaioli*, of the Dutch 'Hague School', of the Austro-Hungarian artists' colony at Szolnok or of the Geman painters of the 'New Dachau School' established by Adolf Hoelzel and Fritz von Uhde).

August von Pettenkofen, **Casualty Transport**

Just as the art of Daubigny, Diaz de la Peña, and in particular the late work of Corot, was of great significance for the painting of Monet, Pissarro and Renoir, so, at a later stage, the emerging characteristics of each of these Impressionists was to be further developed by the following generation: in the work of Van Gogh, for example, colour became increasingly autonomous, while in that of Segantini the search for ever more intense light effects led to a form of Pointillism or Divisionism.

Combined with the vogue for Old Netherlandish painting, French developments also issued in the Late Impressionism of artists such as Max Liebermann, Max Slevogt or Lovis Corinth (this last is especially well represented in the Österreichische Galerie collection, with ten pictures). These artists combined a generally earthy colouring with virtuoso brushwork, its subjectivity so marked as to allow a smooth transition into forms of Expressionism. In Austrian painting, meanwhile, French influence was most significant for providing the impetus for the 'Atmospheric Impressionism' that, as we have seen, drew very strongly on Austrian tradition.

Austrian painting of the mid- and later nineteenth century should not, therefore, be assessed, as was previously so often the case, by the parameters established by the study of French art. It should, rather, be recognized and ad-

mired for its own qualities and achievements. For all the significance of outside influence, the evolution of Austrian art in this period had a certain autonomy; it drew on Austrian traditions, and it took from outside inspirations those parts it deemed useful in the realization of a new approach. In this development, the sensitive rendering of atmosphere was to prove more important than the treatment of light and the use of pure colour that, even today, we tend to regard as the signs of true progress in nineteenth-century European art.

August von Pettenkofen (1822–89)
Casualty Transport, 1869
Oil on board, 29.6 x 44.7 cm
Inv. No. 1861

Pettenkofen, who lived for years in Paris and was one of the first Austrian landscape painters to become interested in capturing the phenomena of light and atmosphere, discovered in the Great Hungarian Plain a landscape that corresponded perfectly with his own artistic endeavours. He persuaded a number of painter friends to join him there, and established with them at Szolnok an Austro-Hungarian artists' colony with aims very close to those of the Barbizon painters (which had indeed served as an inspiring example). Pettenkofen, however, did not only paint landscapes; he

also turned his attention to the inhabitants of the Szolnok region and to the soldiers stationed there. The paintings based on studies made at Szolnok are among his most impressive works.

The subject of the picture of 1869 illustrated here was one of those Pettenkofen treated most frequently. On this occasion, however, he has increased its implicit drama. As a result of the 'tattered' appearance achieved through loose, rough brushwork, the inherently depressing qualities of the motif are very effectively exaggerated. Two oxen drag the cart through the muddy ground, while two soldiers push it along from behind. Above the group, heavy rainclouds roll across the sky. Pettenkofen here offers a very personal and entirely unheroic view of the soldier's life — the opposite of what might have been imagined as they enthusiastically set out for the campaign, cheered on by the watching crowd. All that awaits the soldiers now is dull trudging, further hauling or exhausted waiting on the cart. It is to this relentless insistence (to which every formal aspect of the composition contributes, though without undue didacticism) that Pettenkofen's picture owes its fame.

Emil Jakob Schindler (1842–92)
Steamer Landing Stage near Kaisermühlen in Dazzling Sunlight, c 1871/72
Oil on canvas, 56 x 79 cm
Inv. No. 3338

After completing his studies at the Vienna Academy under the landscape painter Albert Zimmermann, Emil Jakob Schindler became one of the first Austrian artists to start working entirely *en plein air* and to focus on contemporary motifs. Taking his cue from the 'paysages intimes' of the Barbizon artists, Schindler painted a series of landscapes in the suburbs of Vienna, including many views of the steamer landing on the Danube near the Prater. In contrast to the work of the Barbizon painters, however, Schindler did not seek chromatic harmony in his pictures. As in the case of the work illustrated here, Schindler was prompted by the dazzling sunlight to simplify details into coloured planes; indeed, in as far as he drastically simplified their appearance, he went a significant step further. The light too attains an unprecedented harshness that makes possible exciting chromatic contrasts. Schindler has here already moved very far from the tonal

Emil Jakob Schindler, **Steamer Landing Stage near Kaisermühlen in Dazzling Sunlight**

integrity he had imbibed at the Vienna Academy. Starting from the observation of nature, he recognized the significance of the unfiltered light and the unrestrained colour, then 'translated' these effects accordingly.

In his later work, Schindler attained an unprecedented subtlety in the rendering of the atmosphere of landscape and came to be recognized as one of the most outstanding Austrian painters of his age. His significant influence on both contemporary and younger artists ensured that he retained his reputation as the key figure in Austrian 'Atmospheric Impressionism'.

Eugen Jettel (1845–1901)
Evening Landscape, shortly before 1895
Oil on board, 29.5 x 48.4 cm
Inv. No. 878

Like Emil Jakob Schindler, Jettel studied under Albert Zimmermann; but it was essentially his friendship with August von Pettenkofen that introduced him to a new approach to landscape painting in the manner of the Barbizon artists. In 1870, probably encouraged by Pettenkofen, Jettel set off on his first sketching trip — to Normandy and to Holland. Later (1874–97) he lived in Paris and other parts of France. After his return to Vienna, he became a member of the Secession. Jettel's pictures have been admired for their sensitive capturing of atmosphere and their attentiveness to the impulses of nature in the most inconspicuous contexts. He is rightly counted among the leading representatives of Austrian 'Atmospheric Impressionism'.

This *Evening Landscape* is among the most appealing examples of its type and captures its subject perfectly: the atmosphere of evening is evoked not only through motifs such as the calm sheet of water or the flock returning home, but also through the sovereign use of colour — beneath the trees and in the sunken path there are already passages of great darkness and cooler tones, while along the horizon, where the sunlight is fading, we find the glow of yellow and red. The emotional impact of this evening sky is intensified through the positioning of the trees silhouetted against it.

Eugen Jettel, **Evening Landscape**

Tina Blau-Lang, **Spring in the Prater**

Tina Blau-Lang (1845–1916)
Spring in the Prater, 1882
Oil on canvas, 214 x 291 cm
Inv. No. 2233

Tina Blau first trained under the landscape painter August Schäffer in Vienna and then under Wilhelm Lindenschmidt in Munich. She first encountered the work of the Barbizon painters at the international exhibition held in Munich in 1869. After returning to Vienna, she completed further studies under Emil Jakob Schindler, in whom she found not only a like-minded teacher but also a good friend.

Spring in the Prater is a work of great importance within Blau's oeuvre as well as in the context of late nineteenth-century Austrian landscape painting as a whole. In contrast to the detailed naturalistic approach of her earlier work, Blau here moves forward decisively, and apparently not only in response to outer influences but also as a logical consequence of her own inner development, in particular her strong commitment to the observation of nature. In the picture illustrated here it is no longer graduated tonal values that determine the character of the image, but rather the bright, glowing (albeit mixed) colours that evoke a shimmering atmosphere through their application in short, close-ly packed brushstokes. Travel in both Italy and Holland certainly helped Blau to reach such artistic maturity. It was only after completing this picture, however, that she visited Paris. There she found ample confirmation of the artistic path she had chosen.

On account of the brightness of its colouring, this picture was not initially accepted for inclusion in the international exhibition held at the Vienna Künstlerhaus in 1882, the complaint being that it would have the effect of a 'hole in the wall' alongside the other works. Interestingly, no less influential a figure than Hans Makart found it to be the best of all the pictures submitted to the exhibition, so ensuring that it was, after all, included, albeit in an unfavourable position. Nevertheless, when the French Minister of Culture, Antonin Proust, visited the Viennese exhibition, he too recognized the picture's quality. When it was shown the following year at the Paris Salon it received a *mention honorable*.

Carl Schuch (1846–1903)
Still Life with Pumpkin, Peaches and Grapes, 1884
Oil on canvas, 62.2 x 81 cm
Inv. No. 1358

Alongside Waldmüller, Carl Schuch may be regarded as one of the most important Austrian painters of the nineteenth century. Schuch made innumerable oil sketches for each finished painting, intending the end result to appear as if it had emerged swiftly and fluently, its good *facture* quite apparent, and the image as a whole possessed of a timeless value. For this reason, Schuch produced rather few finished oil paintings. As a landscape painter, Schuch made only sketches *en plein air*: these were intended to be worked up into finished paintings in the studio. This recognition of the artifice essential to painting was at the heart of Schuch's endeavours and of his achievements; and these did, indeed, bring about a revival in Austrian painting. Schuch was a contemporary of Cézanne (though he did not know the French artist's work), and like the French artist he understood that a painting was a plane upon which colours should be arranged according to their relationship to one another.

This approach to the construction of pictures out of colours and planes, this meticulous attention to tonal values, is especially apparent in Schuch's still lifes. Schuch was also a keen theorist and one who was able to articulate his conclusions clearly. More importantly, he was able to apply theoretical considerations to his work as a painter. He sometimes wrote out 'palettes' as part of his preparations for particular paintings. In the case of the still life illustrated here, there survives, in a sketchbook Schuch kept in Paris in 1884, a composition sketch with notes on the colours Schuch planned to use, these being selected according to complementarity and contrast: 'Pumpkin cut open, orange / on blue plate / greenish grapes and peaches.' The finished painting differs slightly from the sketch, the blue tone of the grapes serving as a complementary contrast to the orange and yellow of the pumpkin.

Carl Schuch, **Still Life with Pumpkin, Peaches and Grapes**

Carl Moll, **The Naschmarkt in Vienna**

Carl Moll (1861–1945)
The Naschmarkt in Vienna, 1894
Oil on canvas. 86 x 119 cm
Inv. No. 252

Moll was the most faithful of the pupils of Emil Jakob Schindler. He was also a steadfast member of his circle, taking care of many practical matters on his behalf (including the organization of exhibitions of Schindler's work), and he later married Schindler's widow. Moll was also one of the most prominent founder-members of the Vienna Secession (established in 1897) and in this capacity was responsible for ensuring that international modern art was exhibited in Vienna. He arranged important exhibitions of the work of Van Gogh, Gauguin and Munch and also encouraged and supported the work of young Austrian artists such as Klimt and Schiele.

Carl Moll took the Naschmarkt as his subject on several occasions. The picture illustrated here is not only one of the best known views of Vienna but also one of the last and most perfect works to be informed by the spirit of strongly atmospheric Realism that Schindler encouraged in his pupils. Nonetheless, the bright colouring and, in particular, the dominant role of light reveal a concern to go beyond Schindler's approach. The light-flooded atmosphere, the filigree of the foliage, the gleam on roofs and sunshades bestow a calm magic on the scene. Only the persistence of earthy tones betrays Moll's artistic provenance.

Theodor von Hörmann (1840–95)
Field of Cock's Head near Znaim, 1893
Oil on canvas, stuck down on to board,
22 x 48 cm
Inv. No. 1202

Hörmann's picture of a field of cock's head plants near Znaim [now Znojmo, Czech Republic] is among those works in which he was closest to Impressionism. He was one of the first Austrian painters of the nineteenth century to gradually abandon the even tonality of 'Atmospheric Impressionism' in favour of the use of brighter colours, as seen in this and other pictures from the later part of his career. The elongated format of the works of this group, painted only a few years after Hörmann's stay in Paris, recalls that favoured by the French artist Charles-François Daubigny. In their use of pastose brushwork to characterize the landscape. however, these pictures approach the style of Van Gogh.

There is nothing petty about Hörmann's *Field of Cock's Head near Znaim*: every element of detail has been

Theodor von Hörmann,
Field of Cock's Head near Znaim

absorbed into the planes of colours built up with broad strokes of the palette knife. By means of their varied, but also very consciously selected, directions, the picture as a whole becomes a tangle of colour, an impression — a colouristic, optical equivalent of what the artist has observed. By this means, Hörmann is able to convey not merely the shading and gradation of the colours in the fields, but also the changes these colours undergo as the wind blows across the land.

Hörmann makes do without any staffage, showing the entirely unpeopled, slightly rising landscape in all its expanse and, indeed, its melancholy. The path, meanwhile, draws the viewer's gaze into the depth of the composition. Atmosphere is conveyed here by a landscape reduced to its basic elements. This simplicity is underlined by the apparent emptiness (of what was, after all, a heavily cultivated area). Under a boundless sky, across which the wind chases the clouds, even the few trees on the horizon seem to approximate the role of individual figures.

Olga Wiesinger-Florian (1844–1926)
Poppies in Flower, c 1895–1900
Oil on canvas, 70 x 98 cm
Inv. No. 8139

The term 'weed and beet picture' has been used to designate a genre specific to Austrian painting in the second half of the nineteenth century, and especially to be found in the work of painters in the circle of Emil Jakob Schindler, including Eugen Jettel, Rudolf Ribarz and Marie Egner. These artists selected closely viewed and unobtrusive motifs for their landscapes, even while the themes they thereby addressed were no less profound. Works of this sort usually adopted an entirely novel perspective: the crops in the foreground, viewed from below appeared large and significant while the 'real' landscape became a relatively subordinate background.

Wiesinger-Florian's *Poppies in Flower* is an example of this approach. The flowers occupy the foreground as in a still life, while the edge of the forest on the horizon is now merely suggested by a distinctly coloured band. The concentration on a detail results in an intensified vitality of the whole, and it allows for an entirely new insight into a flower-strewn meadow.

Along with Carl Moll, Marie Egner and others, Wiesinger-Florian was

Olga Wiesinger-Florian, **Poppies in Flower**

Marie Egner, **In the Pergola**

among Schindler's private pupils and profited greatly from his teaching; at the same time, however, she was a very strong personality and consistently went her own way, concerned above all with the most precise rendering of reality. This led her eventually to a use of glowing colour that went some way beyond her teacher's interest in capturing atmosphere.

Marie Egner (1850–1940)
In the Pergola, 1912
Oil on paper, stuck down on to cardboard,
68 x 86.7 cm
Inv. No. 1546

To begin with, Egner was strongly influenced by her teacher Emil Jakob Schindler, to whose inner circle she belonged for five years and under whose encouragement she turned to the treatment of landscape motifs from the Vienna Woods. From around 1890 she began to shake off Schindler's influence and to evolve a style that employed stronger colouring. Egner's form of Impressionism, as illustrated in the picture shown here, always remained closely tied to the observation of nature and to a concrete subject. In her pictures a

sense of depth and perspective is never abandoned for the sake of achieving a shimmering network of colour across the canvas.

In the picture illustrated here there is, nonetheless, evidence of great skill in the way local colours are allowed to come into their own and, in particular, in the artist's attention to the variety in the play of light — as illumination, translucence, sparkle or shimmer. Egner was consistent in painting *en plein air*, always bringing great spontaneity to her work, as is very evident in this picture, painted during a trip to Italy. (The painting surface appears to have been enlarged by the addition of a strip of canvas at the right.)

Eugène Delacroix (1798–1863)
Still Life with Flowers, 1834
Oil on canvas, 74 x 92.8 cm
Inv. No. 2455

Delacroix's still life is an image of abundance, of the richest possible display. It also shows how extravagant Nature can be — in the motif of the fruits strewn, as if haphazardly, around the broad vase. The artist's principal interest here is in the play of colours and tones. This was a concern that persisted throughout Delacroix's oeuvre, being constantly further refined through the help of the artist's renowned colour circle. In this work Delacroix intensifies the effects of each colour by using multiple nuances arranged to enhance complementary harmonies or contrasts. In order to show the colours of the flowers at their most powerful, the fruits are left almost colourless and even the background becomes a unified, subdued foil, entirely subordinate in chromatic terms.

There is disagreement regarding the date of this picture. Delacroix refers to it in his journal in 1844 as a 'tableau de fleurs, à Nohant'. Scholars have therefore concluded that Delacroix painted the picture during one of the occasions on which he stayed at Nohant with the novelist Georges Sand (who subsequently owned it) — in 1842 or 1843. Adolphe Moreau, however, in his volume *Eugène Delacroix et son oeuvre* (Paris 1873), dates the picture to 1834. A number of factors speak in favour of this earlier dating, above all the greater simplicity in relation to Delacroix's later flower paintings. The loose brushwork, with the paint barely covering the canvas in some passages, appears related to works painted around 1833, as does the attention to colour at the expense of plasticity, and the neglect of the background in favour of emphasis on the play of colour in the flowers.

Eugène Delacroix, **Still Life with Flowers**

Camille Corot, **Portrait of a Young Woman (Madame Legois)**

Camille Corot (1796–1875)
Portrait of a Young Woman (Madame Legois),
c 1840–45
Oil on canvas, 55 x 40 cm
Inv. No. 2413

Corot's *Portrait of a Young Woman* marks a turning point in his approach to figure painting. His earlier detailed portrait style gradually assumed elements of genre painting in which the subjects would be very generalized or mythicized. The women in Corot's pic-

tures — and his figures now are nearly always female — became less naturalistic in appearance and more expansively treated. Corot deliberately selected robust types from among the peasantry or urban lower classes, feeling these to be full of undiminished life and true simplicity. Very often they are shown looking out at the spectator; but their glance is not an intent, active one; rather it is a pensive gaze that falls, as if by chance, on an arbitrary object while the thoughts turn inwards. Pure being

presents itself to us here, blooming, un-folding, but pausing as it unfolds. The flow of life is interrupted, held up for an eternal moment, in which meditation or reflection occurs. Yet there is no sense of earnestness in these activities; the sitters are simply lost in reverie. Corot's figures are always alone; they are exemplary and yet not anonymous. They are concrete people, concrete models that the artist has invested with a universal significance.

In the picture illustrated here, the evocation of detached, entirely calm observation underlines the 'purity' of the act of sitting on the part of one who has abandoned every further activity. The young woman simply *is*, but her existence is perceived as beautiful in itself. This beauty finds its pictorial equivalent in the refined juxtaposition of chromatic values — the *valeurs*, of which Corot so often spoke and in which his mastery consisted.

While the art historian and critic Julius Meier-Graefe was right to refer to an inner connection between the work of Corot and that of both Vermeer and Chardin, it is probable that Corot knew very little of the former. In the case of both of these earlier artists, one finds a tenderly graduated tonality that itself gently establishes formal transitions. In the case of Chardin, the real subject of his pictures could be said to be the calm existence of objects as they are, the charm of the ordinary. The pictures of Vermeer, meanwhile, tell us of the inner stability of the world; they are full of the same sense of a pause, of the 'sheen' of the fleeting moment, in which everything remains poised in perfect harmony.

Gustave Courbet (1819–77)
The Wounded Man, c 1854
Oil on canvas, 79.5 x 99.5 cm
Inv. No. 3276

This is the second version of a self-portrait that is now in the Musée du Louvre in Paris. X-radiography exam-ination of the picture in the Louvre has revealed a series of superimposed images. The now visible self-portrait is painted over two others: a female figure without any apparent connection to the self-portrait, and a couple lying be-neath a tree with the young woman resting her head on the shoulder of her beloved. There is no doubt that this last image served as a basis for *The Wounded Man*.

Gustave Courbet. **The Wounded Man**

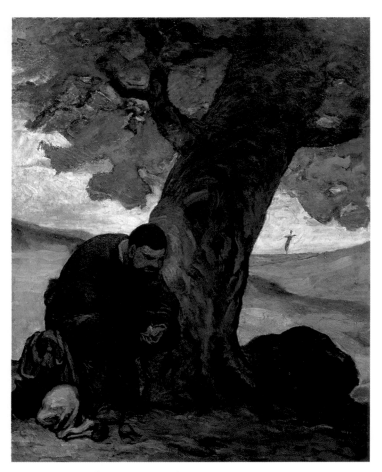

Honoré Daumier, **Sancho Panza Resting under a Tree**

Courbet, who often addressed in his work the question of his own identity as a man and as an artist, painted himself in a great many guises according to his mood and his concerns. It is possible that *The Wounded Man* was prompted by the painful experience of the end of a love affair that occurred at some point during the period 1851 to 1854. The image appears to evoke his sense of having been wounded by the pain of love and abandoned in an evening landscape.

One should not, however, ignore the similarity between this image and traditional presentations of the dead or dying Christ. Identifying with Christ offered the artist the possibility of describing his status as that of an ideal inspired outsider, as an insightful challenger of society, whose misunderstanding was

the cause of his sufferings. At the fall of the Vendôme Column in Paris, Courbet explicitly acknowledged this connection: 'I stand here at this column, this monument to infamy, like Jesus Christ when he was carrying the Cross.'

Honoré Daumier (1808–79)
Sancho Panza Resting under a Tree,
c 1860–70
Oil on canvas, 100 x 81.5 cm
Inv. No. 1056

From the mid-nineteenth century, Daumier produced over twenty works based on Cervantes's novel *Don Quixote*, one of his favourite books. He saw the two principal figures — Don Quixote and Sancho Panza — as endlessly suggestive embodiments of human charac-

teristics, ideals and cosy superficialities, and he saw the danger of their risibility; he probably recognized something of each character in himself as well.

Daumier repeatedly treated the theme of the divergence of two strong wills — Don Quixote storming out feverishly towards ever new adventures, followed only reluctantly by Sancho Panza, or Don Quixote as a chivalric figure stirred by ideals, while Sancho Panza thinks only of his own peace and quiet.

Above all, however, Daumier (who had always wanted to be a painter and whose work was not intended for public exhibition) was interested in the problem of light and shade, of opposing brightly glowing colours to homogeneous dark tones. One repeatedly finds compositions that lead the eye from a dark, enclosed foreground into a light-filled expanse. This contrast ensures a very powerful pictorial arrangement. It condenses the figures to their simplest forms, reduces them to their essence; it also exaggerates the power of the dark continuous outlines Daumier so readily employs. The result is an imposing monumentality and a high degree of expressivity. This is apparent in the compact, rounded form of the seated Sancho Panza in contrast to the towering, gaunt figure of Don Quixote. In this respect, Daumier is extraordinarily modern. His work was one of the strongest influences on the evolution of the style of Jean-François Millet.

Charles-François Daubigny (1817–78)
Meadow in Autumn, 1867
Oil on canvas, 85 x 150 cm
Inv. No. 4467

Towards the end of the 1850s Daubigny abandoned the practice of making sketches *en plein air* in preparation for finished paintings to be executed in the studio, and started to paint in oils *en plein air*. At the same time he started painting the broad, balanced river landscapes with which he has since been associated and that remain his most appealing subjects. In 1857 he in fact fitted up a floating studio (in a small boat) in which he would drift along various rivers, most frequently the Oise, until he found a view worth painting.

In the picture illustrated here the brushwork is already very loose, with the brushmarks short and delicate and very free, especially in the region of the clouds. It is clear that the artist is already more interested in a general impression than in an exact record of nature. The predominantly grey-green colouring is characteristic of this period of Daubigny's career.

Daubigny, without doubt the most modern of the Barbizon painters, was far in advance of his contemporaries, above all in his large *plein-air* oil studies.

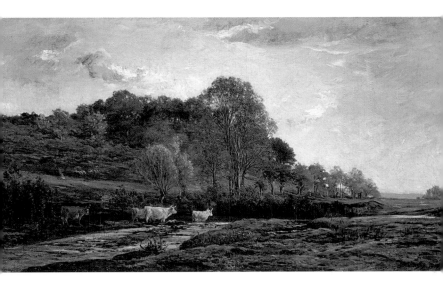

Charles François Daubigny, **Meadow in Autumn**

Jean-François Millet (1814–75)
**The Plain of Chailly with Harrow
and Plough**, 1862
Oil on canvas, 60.3 x 73.6 cm
Inv. No. 2450

In comparison with the other Barbizon painters, Millet was always concerned to infuse his pictures of peasant life with a deeper meaning of a generalizing and often symbolic nature. This characteristic first made itself felt around 1847, in the change that occurred both in Millet's style and in his subject matter. In the following years Millet was essentially a figure painter, with landscape appearing to retreat in significance behind the monumental figures in his work. It was only in the late 1860s, and above all in the 1870s, that Millet really became a landscape painter.

The *Plain of Chailly with Harrow and Plough* is an image of winter, of the season in which nature appears to stand still. Summer, and all the life associated with it, has gone — the harrow and plough are the silent witnesses to this absence. Nor is there any hint of human life here. We see only the plain, uninterrupted, appearing almost endless in its expanse, leaving the eye

seeking instinctively for a landmark, for boundaries. Before Millet, there had hardly ever been a picture like this, so uncompromising an image of flat landscape.

The harrow in the foreground (its spars leading the eye into the depth of the picture) and the ravens in the vast grey sky also contribute to the impression of utter desolation felt by the spectator in front of this picture. Nevertheless, Millet himself would not have welcomed too melancholy an interpretation of this work (for example that it was a form of *memento mori*). His deep religious faith allowed him to see the hand of God the Creator in the beauty of nature, even in the simplest things, and he was thus deeply moved by these.

Auguste Renoir (1841–1919)
After the Bath, 1876
Oil on canvas, 92.4 x 73.2 cm
Inv. No. 1055

In 1876, at the second Impressionist exhibition, Renoir showed his celebrated picture *Le Moulin de la Galette*, which was painted in a garden in the rue Cortot where Renoir had also produced

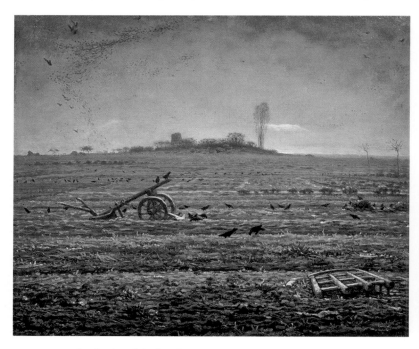

Jean-François Millet, **The Plain of Chailly with Harrow and Plough**

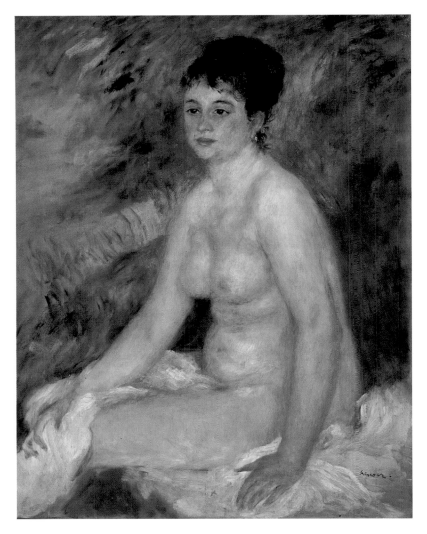

Auguste Renoir, **After the Bath**

two nudes of his model 'Anna'. It is fascinating to compare the nude illustrated here with the two others by Renoir, painted from the same model in the same year, and to note how it mediates between them.

The study for *Nude in the Sunlight*, now in the Musée d'Orsay in Paris, was painted *en plein air* and is essentially a study of the play of dappled light and colour over the model's soft skin. The lustrous body seems made up entirely of distinct tones; it is captured as a momentary impression of the effects of the light and appears to consist of these alone. In the picture of Anna now in the

State Pushkin Museum in Moscow we can already detect the beginnings of a development that was to lead Renoir, during the 1880s, to produce solidly constructed, firmly drawn nudes. The picture in Vienna, also painted *en plein air*, occupies a mid-point between the two others; yet it is clearly a work from the late phase of Renoir's Impressionism. It also points to future developments, with the velvety lustre of *plein-air* painting, but its corporealit is already perceptibly 'sculpted', showing Renoir's striving towards greater generalization, towards the absorption of the individual within an ideal of womanliness.

Edouard Manet (1832–83)
Lady in a Fur Wrap, c 1880
Pastel on canvas, 55.8 x 45.8 cm
Inv. No. 3867

During Manet's last years his ability to work was increasingly limited by illness. No longer able to embark on large compositions, he produced a great many portraits, working mainly in pastel. The figure shown in *Lady in a Fur Wrap* is a fashionable creature who looks self-confidently out at the spectator, her head charmingly balanced on a slender neck. Her alert gaze has something spontaneous about it, an engaging freshness, as if the whole portrait recorded a single fleeting moment. As in other pictures by Manet, the image consists entirely of planes 'slotted' together; the artist has no interest in real space, being much more concerned with the play of colour. In a manner typical of Manet's work, the picture contains sharp contrasts, exaggerated clarity and flat colour planes. By means of dark 'framing' elements around both the face and the breast, the flesh appears even more lustrous and precious, and is especially smooth where it shows through the fluffy fur. Particularly refined is the achievement of such a variety of soft tones employed in the rendering of the skin. The lush green of the background

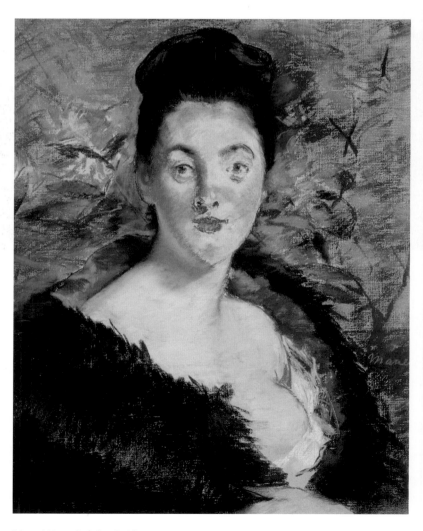

Edouard Manet, **Lady in a Fur Wrap**

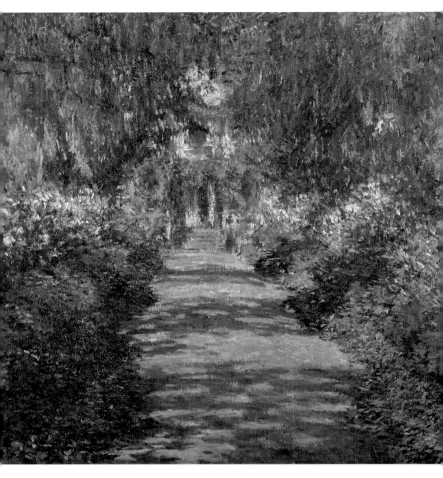

Claude Monet, **Path in the Artist's Garden at Giverny**

with its few precious flowers creates a mellow harmony that complements the warm flesh tones, the red lips, the pink cheeks and the brown tones of the fur.

Manet was committed to depicting the life of his contemporaries, albeit not in so radical a manner as was Henri de Toulouse-Lautrec. For Manet, modern man and woman were infinitely worthy of record. In his work we can find his painter colleagues and poet friends as well as the refined ladies and high-society mistresses in all their 'poses', their gestures, their fashionable clothes, even their exaggerated or false elegance. Above all, though, Manet conveys his great delight in the sheer painterliness of their appearance.

Claude Monet (1840–1926)
Path in the Artist's Garden at Giverny, 1902
Oil on canvas, 89.5 x 92.3 cm
Inv. No. 3889

In this *Garden at Giverny* the liberation of the brushstroke from the reality of the depicted subject has become even greater than in earlier Monet paintings. Surface qualities are here almost insignificant; the artist intends to record only a pure optical impression, the play of colours. What is of importance here is not how things really are, but how they appear. For this reason Monet does everything to 'forget' what he kno about them so as to render their pearance entirely in terms of colou

Monet's Giverny pictures repre the end of such a process. Every

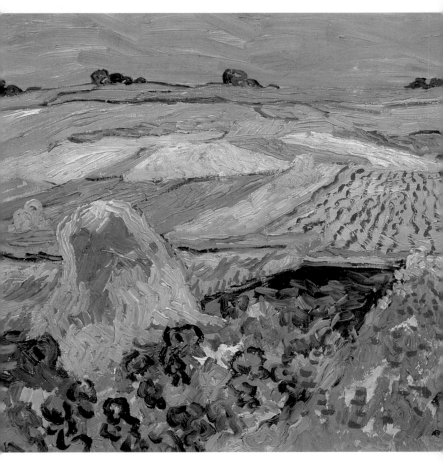

Vincent van Gogh, **The Plain at Auvers-sur-Oise**

beyond this point signifies an abandoning of the objective and a move in the direction of pure painting, a move soon to be made by Monet, and especially by his younger contemporaries. In this view of his garden, painted in 1902, everything 'solid' is dissolved into lustrous points of colour that serve to convey the shimmering light and the heat of an early afternoon in late summer. It is the time when the light is at its most blazing: where it falls directly on the flower-beds the colours glow with a deep splendour, elsewhere they are more subdued. The spruces cast their shadows vertically onto the gravel path that leads to the house with its climbing roses. Both the door and a window are open.

Monet's mastery is here apparent above all in the modulation of the lu-minosity of the colours: whether shimmering with concentrated power or more subdued in effect, they are never broken in their chromatic values or impure or darkened by the admixture of black. They are always colours that simply appear to have had more or less light extracted from them.

Monet moved to Giverny in April 1883 and invested a great deal of effort in laying out his garden — a testimony in particular to his love for blue flowers, above all for irises. 'What I need above all else are flowers, again and again,' he declared. The picture in the Öster-reichische Galerie collection was painted at a time when Monet's water-lily pond had just been enlarged. While he was still prevented from painting his water-lily pictures, he preferred to paint near the house.

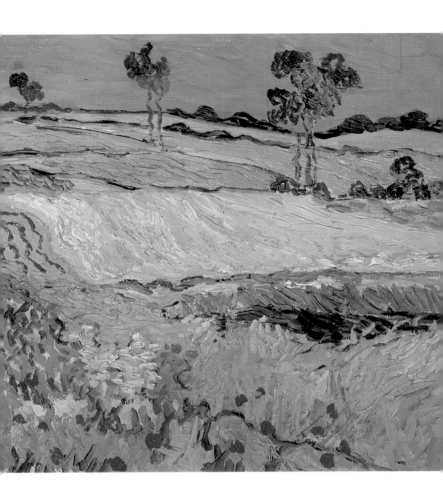

Vincent van Gogh (1853–90)
The Plain at Auvers-sur-Oise, June 1890
Oil on canvas, 50 x 101 cm
Inv. No. 1007

This picture is one of a total of twelve by Van Gogh that make up a cycle of rural scenes that are chromatically attuned to each other. Van Gogh wrote to his brother Théo that 'this picture works extremely well alongside another one — *The Wheatfields* — for that is a picture with a vertical format with pink [tones], the other pale green and yellowish green, colours that are complementary to pink.'

The Plain at Auvers-sur-Oise conveys very impressively the expansive quality of the landscape. This appears as if reduced to a few generalized forms indicating features characteristic of the region. The blue-grey sky does not convey the glow of clear weather but rather the mood one finds after rain or on a dull day. The strong sense of recession into depth, the high horizon line and the sense of space obtained by means of overlapping segments of the composition convey, with the simplest of means, the impression of the rolling countryside around Auvers-sur-Oise. The use of colour perspective here also makes an important contribution: towards the horizon the tones tend to a uniform blue-green, while in the foreground they glow full of freshness, setting each other off in their saturated variety. Both in terms of *facture* and colouring this is one of Van Gogh's greatest achievements, with more subtlety and refinement than many of the other paintings completed in the last weeks of his life.

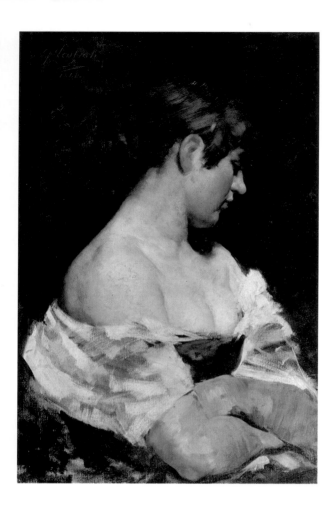

Franz von Lenbach,
**Study of a
Female Model**

Franz von Lenbach (1836–1904)
Study of a Female Model, 1861
Oil on canvas, 73.3 x 48 cm
Inv. No. 8066

Lenbach poses his model, a young woman, in three-quarter view with her head turned away from the spectator, her profile just legible, and her shoulders bared. She is clearly a sturdy person, perhaps of peasant stock, with muscular shoulders and lower arms. Her pale flesh tones are set off against a dark background and attain a great luminosity through this contrast. The skin is rendered in a manner suggestive of the model's warm vitality and the artist's careful observation; it is darker — tanned by the sun — on her face and lower arms, paler on the shoulders, and very pale on the breast. The naturalistic treatment of such details,

as also of the effect of light, is characteristic of Lenbach's work following his trip to Rome in 1858–59, where his principal aim was to attain an exact record of nature. As he later observed, at the time he was gripped by a sort of fanaticism for the sun and its blazing light.

The study is close to the records of shepherds and peasants painted by Lenbach in these years, though it goes rather further than these. The background is already darkened and the modelling of the figure is no longer achieved through the harsh alternation of light and shade provoked by the midday sun, but emerges, rather, through soft gradations of tone. The swift brushstrokes obtain an effect of greater openness. While those used for the body are firm and closely packed, the background is painted quite thinly, and in certain

passages the canvas remains visible. Throughout, there is a speckled quality to the paint. Here, and in the vague rendering of the blouse with an almost casual brushstroke, one detects a freedom of touch that is not to be seen in Lenbach's later work. Nor does the artist again attain the same degree of freshness in the treatment of flesh tones in his later prolific production of increasingly Salon-style portraits. This picture comes, in fact, from a period during which Lenbach's style was changing. It is among the most significant examples of German Realism.

Wilhelm Leibl (1844–1900)
Portrait of Countess Rosine Treuberg, 1877
Distemper on board, 88 x 66.8 cm
Inv. No. 1497

When Leibl had painted the portrait of Count Ferdinand Fischler von Treuberg, he was invited to the Count's house — Schloss Holzen, between Augsburg and Donauwörth — in order to paint the portrait of his wife Rosine (née Poschinger). Leibl stayed at Schloss Holzen from June to October 1877 and painted two portraits of the Countess: a smaller one in distemper on board

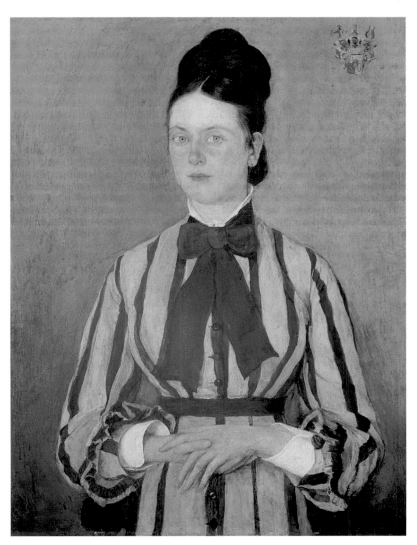

Wilhelm Leibl, **Portrait of Countess Rosine Treuberg**

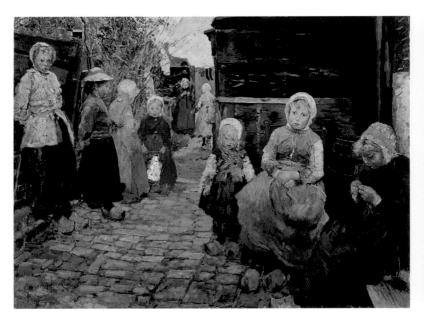

Fritz von Uhde, **Fishermen's Children in Zandvoort**

showing the Countess standing (illustrated here) and a larger one in oil on canvas that remained unfinished (now in Hamburg). In a letter to his mother, Leibl described the portrait: 'I only hope that the portrait of the Countess goes all right, but that will require a lot of work; it will be very difficult, for ladies are always somewhat vain and are seldom satisfied merely with a true reflection of their appearance....'

This rather stiffly composed picture offers very clear evidence of Leibl's mastery of colour. In adddition to the flesh tones, there are dominant shades of grey, brownish grey and a very dark blueish grey, all these being modelled and imbued with inner luminosity in the most refined manner. At the same time, the subject's distant expression, her stiff pose and the cool colouring convey something of her reserve (this comes rather more to the fore in the second portrait). Leibl also exploits the traditional device of the slightly turned head with the gaze directed towards the spectator from the corners of the eyes in order to suggest the calmly observing aspect of the subject's character. Her pose is not to be understood as evidence of clumsy composition but rather as the record of a somewhat withdrawn personality addressing the world with careful consideration.

Fritz von Uhde (1848–1911)
Fishermen's Children in Zandvoort, 1882
Oil on canvas, 60.2 x 80.2 cm
Inv. No. 537

It was due to his meeting with Max Liebermann in 1880 that Fritz von Uhde abandoned the sombre chiaroscuro painting he had learnt from Mihaly Munkácsy in favour of a light-filled *plein-air* manner. It was Liebermann who persuaded Uhde to work *en plein air*, not only sketching but also painting directly from nature. Liebermann also urged Uhde to go to Holland and paint there. Uhde, accordingly, spent the summer of 1882 in Zandvoort and also followed Liebermann in the local subjects he chose to paint. Uhde's work from this period shows that this experience opened his eyes to the effects of light; it also reveals his independence in the use of colour. For all their painterly freshness and general brightness of tone, these pictures employ a more earthy tonality, stronger contrasts and a wider range of colours than does Liebermann in his treatment of comparable subjects.

The picture illustrated here served as a preparatory study for the *The Hurdy-Gurdy Man*, painted after Uhde's return to Munich. In his Dutch scene, Uhde shows us an almost incidental view into

a back yard, a moment in the everyday life of the children of the local fishermen as they go about their daily tasks and play their usual games. The little girls appear as if they had been painted by someone they knew very well and whose presence did thus not bother them. There is nothing posed about them; they are shown as personalities in all their individuality. As a result of this, the picture has enormous vitality. In the distance the details are painted less and less firmly and precisely. This bestows on the picture an Impressionistic character. Light has already assumed an important role; where it enters the composition it brightens the colours and so picks them out, even though (with the exception of the girls' aprons) Uhde continues to use earthy tones.

Lovis Corinth (1858–1925)
**Lady with a Goldfish Tank
(The Artist's Wife)**, 1911
Oil on canvas, 74 x 90.5 cm
Inv. No. 1829

Corinth's picture exudes spontaneity, both in the quality of its *facture* and as an exercise in capturing a moment of happiness. It is the record of an instantaneous impression. The artist's wife frequently spoke of his sudden decisions to capture in a picture as soon as possible situations that had appealed to him.

It was Corinth's directness of approach, and perhaps also his deep love for his wife, that enabled him to show this corner of the house — so unobtrusive, but for both of them so precious — exactly as it was, purely as a fragment of reality but with such freshness and luminosity in the colouring. The picture is striking for the bold structure of this particular corner, precisely defined through the presence of the window lintel in the background.

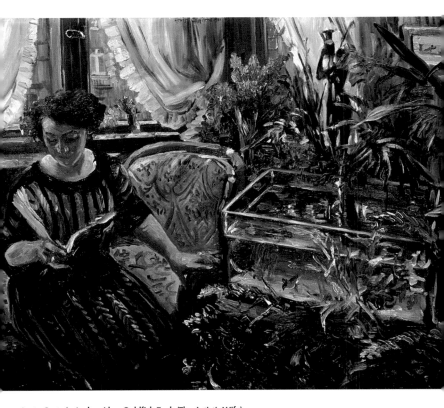

Lovis Corinth, **Lady with a Goldfish Tank (The Artist's Wife)**

Corinth's concentration on the immediate, on the foreground, allows everything outside the window to become flat, unfocused, a mere foil. The view down on to the foreground is affectionate, and not only toward the artist's wife: the fish tank and the plants appear just as important here as is the figure of the woman. Every detail is insistently rendered — the wallpaper, the pattern on the cover of the sofa, the many flower vases in the window. Everything in the scene is significant in itself, but it gains in significance through being shown in the glow of a beautiful afternoon. Light cascades into the room, is entangled in the curtain, lies along the window sill, plays over the smooth surfaces, and — where refracted by glass — scatters multiple highlights.

Max Slevogt (1868–1932)
Boys Bathing, 1911
Oil on canvas, 80.2 x 101.7 cm
Inv. No. 2826

In 1909 Slevogt moved to Godramstein in the Palatinate, where his wife's family had a country house (Slevogt referred to it as 'the villa'), and spent several years there. During this time he painted a great many Impressionistic pictures which are among the most successful and balanced of his entire career.

Boys Bathing is one of many pictures painted by the pond there. In contrast to other works by Slevogt, those showing his garden are always calm, poised, almost motionless. While the light remains an active force within them, the world is otherwise in happy silence. In its strict, symmetrical construction, infused with brightness, *Boys Bathing* tends in this direction. The tones used recur almost throughout the composition, creating the impression of overall luminosity. In the background, the sun plays across the meadow that lies beyond the pond: here two of the boys are sitting while a further two recline drowsily. This passage is so bright that their figures are hardly distinguishable from their surroundings. The reflecting water surface, set into circular ripples through the action of the fountain at its centre, throws back glowing colour out of its dark depths in the form of a hundred reflections. Two further boys stand here, apparently engaged in a game, the water reaching their hips; the alternating reflection and shadow of their bodies thus emphasize the dark gloss of the water surface.

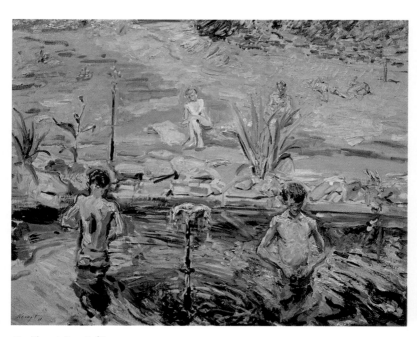

Max Slevogt, **Boys Bathing**

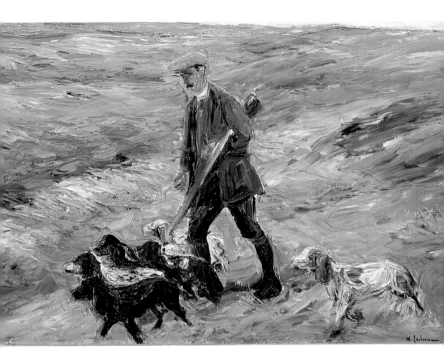

Max Liebermann, **Hunter in the Dunes**

Max Liebermann (1847–1935)
Hunter in the Dunes, 1913
Oil on canvas, 70.6 x 100.4 cm
Inv. No. 1638

A hunter strides forcefully over the pale green of the dune grass with his dogs, his cap pulled down over his forehead, his shotgun under his arm. The colours are earthy and cool and closely interrelated; even the sky is a light greyish blue. While the hunter and the dogs are painted with the brush, the pastose paint used for the dunes is applied with a palette knife in brisk strokes that run diagonally across the picture. Through these relatively simple means, the atmosphere of a cool, windy day by the sea is evoked, its bracing freshness captured in the picture's tonality. The parallel palette knife strokes, made up out of related yet always distinct colours, serve to indicate the long grass bent by the wind. They are typical of the dune scenes Liebermann painted at this period.

Liebermann made his first trip to Holland in 1871, and from 1875 he went there almost every year. He was very much inspired by his encounters with Dutch painting of the seventeenth cen-

tury. In addition to this, he found that the landscape of Holland offered him a great number of motifs and posed ever new problems. Over the years there thus came about a long series of landscapes showing the dunes and the shore. In the dune pictures in particular many basic constituents and devices recur again and again: the presence of a rising, foreground slope extending almost to the picture's upper edge and leaving only a narrow strip of sky, for instance, or the inclusion of only a few, isolated figures.

In 1913, when the picture illustrated here was painted, Liebermann made what was to prove his last trip to Holland. In Noordwijk he discovered the motif of the hunter with his dogs and made a series of sketches. These served as the basis for three oil paintings of this subject.

Historicism

The demolition of the old defence wall surrounding the city of Vienna was decreed in 1857 by the Emperor Franz Joseph I. The significant expansion of the city that followed on this event — intended to link the old core with the suburbs — introduced a period of lively building activity. During the 1860s and 1870s there arose on the grounds of the former fortifications and the now superfluous glacis a circular boulevard, the Ringstrasse, with imposing public buildings all along it. In the process of seeking an appropriate appearance for the use designated for each of these, a multifarious co-existence of various revival styles (based on both physical and documentary evidence of the originals) evolved, from which the term 'Historicism' derives. In the spirit of a Baroque Gesamtkunstwerk, such buildings and their interior decoration and fittings required the collaboration (on an equal basis) of architects, sculptors and painters.

The most important artist in the realm of 'official' sculpture was Anton Dominik Fernkorn. Among his most significant works are the equestrian monuments to the Archduke Carl and to Prince Eugene of Savoy that stand in the Heldenplatz in Vienna, in addition to the *Lion of Aspern*. Reduced versions of all three are to be found in the collection of the Österreichische Galerie. Further models in the collection, of works by Caspar von Zumbusch (*Monument to Maria Theresia*), Viktor Tilgner, Rudolf Weyr and Edmund von Hellmer, give an impression of the large number of monuments decorating the Vienna Ringstrasse and its parks. In addition, the collection holds portrait busts and painted portraits and schemes of painted decoration, all attesting to the great need for display felt at this time by members of the ennobled upper middle classes. These had risen to wealth and social standing largely on account of their own achievements in technology and business and wished to decorate their newly erected houses and offices.

The person who had the most influence on artistic and social life in Vienna from the later 1860s to the early 1880s was Hans Makart. He influenced not only painting but also the styles of decorative arts and fashion through the luxurious fittings and extraordinary costumes adopted for the legendary celebrations organized in his studio. In addition to large decorative schemes in the style of the Venetian painters of the sixteenth century or of Peter Paul Rubens (*Modern Amoretti, The Five Senses, Venice greets Catherina Cornaro, Bacchus and Ariadne*), he also produced charmingly intimate genre paintings (*Lady at a Spinet*). Makart was very much sought-after as a portrait painter as well, in particular for his ability to flatter society ladies by bestowing on them an idealized eternal beauty (*Magdalena Plach*).

After 1873, Makart had a great rival in the virtuoso portrait, the history and genre painter Hans Canon, who returned to Vienna in that year. Working in the style of Anthony van Dyck and Peter Paul Rubens (*The Lodge of Saint John, Midday Rest*), Canon painted his masterpiece for the ceiling of the main staircase of the Naturhistorisches Museum, *The Cycle of Life*. The sketch for this work is in the collection of the Österreichishe Galerie.

Anselm Feuerbach, originally from Speyer and initially trained in Düsseldorf, was called to Vienna from Rome to provide painted decoration for the Ceremonial Hall of the newly completed building of the Academy. At the Österreichische Galerie he is represented by five major works, including *Orpheus and Eurydice, Medea at the Urn* and the portrait of his stepmother *Henriette Feuerbach*. Munich painters with pictures in the collection include Franz von Stuck (*Lost*) and Carl Spitzweg (*The Confirmed Bachelor*). The Swiss German

Arnold Böcklin, who was a member of Feuerbach's circle of friends in Italy, is represented by two works: one (*Portrait of the Painter Franz von Lenbach*) that is testimony to his engagement with the painting of the Italian Renaissance and another (*Marine Idyll*) that reveals his love for the allegorical symbolism of Classical Mythology.

The Viennese painter Anton Romako also spent many years in Italy, above all in Rome, where he mainly painted portraits and rural genre scenes based on life in the Campagna. After his return to Vienna, he evolved a style of painting distinguished by a selective exaggeration of real details and characteristics (*Tegetthoff at the Naval Battle of Lissa*, *The Two Friends*, *Girl Picking Roses*, *Countess Maria Magda Kuefstein*), and this generally baffled his contemporaries. Romako's series of views in the Gasteinertal taken from the same position but at different times of the day and the year, reveal an approach close to that of French Impressionism.

In comparison with the situation in England and France, an interest in material progress and technology was relatively slow to take root in Austria, and such an interest is reflected in only a very few examples of Austrian painting. Karl Kager's *View of the Nordwestbahnhof* in Vienna pays tribute to the development of the railways. August Schaeffer von Wienwald's *Return from the Weltausstellung* records the great cultural, economic and social event of 1873.

Viennese landscape painters were already confronted with examples of the *plein-air* work of the Barbizon artists at this exhibition; but, alongside Austrian exponents of 'Atmospheric Impressionism', there were conservatively oriented painters whose work remained faithful to a naturalistic treatment of landscape subjects until well into the last quarter of the nineteenth century. Artists from this group represented in the Österreichische Galerie collection include Anton Hansch (The *Stubai Glacier in the Tyrol* and *The Palü Glacier*), Carl Hasch and Ludwig Halauska. Interest in the Orient arose around 1850 and is reflected in the works of Alois Schönn, Emanuel Stöckler and, above all, Leopold Carl Müller. Müller's numerous prolonged stays in Egypt enabled him to outshine all his Austrian rivals in capturing local life (*The Market in Cairo*, *The School in Algiers*, *Nefusa*).

The era of Historicism is especially notable for the readiness of large numbers of artists to spend years travelling and living abroad. The Austrian Romako spent nearly two decades living in Rome. Hans Makart, a native of Salzburg, and the Germans Anselm Feuerbach and Anton Dominik Fernkorn were called to Vienna from Munich and Rome to work on the decoration of public buildings, while the Austrians Hans Canon and Moritz von Schwind spent many years in Germany before returning to Vienna for the same purpose. The painters commissioned to decorate the Vienna Arsenal, Carl von Blaas and Carl Rahl, also spent many years abroad.

The momentum of art life in Vienna during the 1860s, 1870s and 1880s derived a substantial boost from the enormous amount of new building taking place in the city during this period. Another event of great importance was the founding, in 1861, of the Genossenschaft bildender Künstler Wiens — Künstlerhaus [Association of Viennese Artists — Künstlerhaus]. Through organizing important exhibitions and other events, the Künstlerhaus became a major supporter of artistic activity alongside the now well-established Academy. An earlier foundation that came to assume an important role in the following decades was the Ministerium für Cultus und Unterricht [Ministry for Culture and Education], established in 1848, which was able to offer practical support to contemporary art through granting stipends, making acquisitions and through offering commissions for new work. This institution served, in effect, as a second art-collecting body in addition to the existing Imperial picture gallery. From 1851, with a view to the eventual founding of a 'modern gallery', a programme of acquiring works by living artists was implemented. These were temporarily deposited at the Vienna Academy and eventually transferred as long-term loans to the Österreichische Galerie.

Anton Dominik Fernkorn (1813–78)
**Equestrian Monument to Archduke Carl
with a Flag**, c 1860
Bronze, h. 60 cm
Inv. No. 4781

Fernkorn studied at the Munich Academy but largely acquired his expertise in bronze casting at the Royal Bavarian Bronze Foundry. In 1847, seven years after settling in Vienna, he was commissioned by the Emperor to provide a design for an equestrian monument to the victor of the Battle of Aspern (1809), the Archduke Carl. Fernkorn's progress towards the streamlined form he eventually evolved can be traced by reference to numerous sketches, the artist's principal concern being to achieve clarity of exposition. The dynamic movement of the Archduke is based on reports of the battle itself, according to which he had fired the soldiers to great efforts by seizing the flag and had thus been ultimately responsible for the defeat of Napoleon's army.

Fernkorn also, however, drew on the example of celebrated earlier works — Jacques Louis David's painting of 1801 *Napoleon on the St Bernard Pass* (Österreichische Galerie) and Johann Peter Krafft's picture of 1819, *Archduke Carl with his Retinue at the Battle of Aspern* (Heeresgeschichtliches Museum, Vienna). Especially notable in Fernkorn's statue from the technical point of view is the use of only two principal load-bearing points, a solution seldom achieved by any sculptural work since Leonardo da Vinci's *Equestrian Monument to Francesco Sforza*.

Although the final version of Fernkorn's model for the statue was ready by 1848 and had formally been accepted, the commission for the full-scale work was only granted in 1853 because of the political disturbances of the intervening years. The execution of the finished work also prompted the founding of the

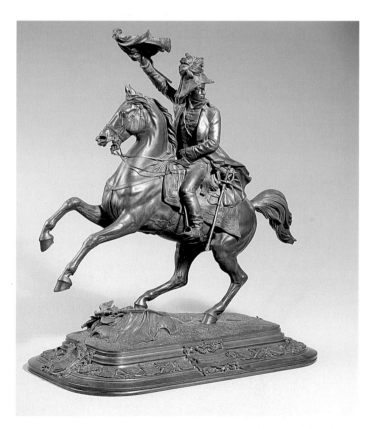

Anton Dominik Ritter von Fernkorn, **Equestrian Monument to Archduke Carl with a Flag**

Imperial Bronze Foundry in Vienna. in the former Imperial and Royal cannon foundry in what is now Gusshausstrasse. In 1856 Fernkorn was granted sole use of the new foundry for three years. The equestrian monument was formally unveiled on 22 May 1860 in its assigned position in the Heldenplatz in Vienna. The version illustrated here is a reduction.

Hans Canon (1829–85)
The Lodge of Saint John, 1873
Oil on canvas, 320 x 208 cm
Inv. No. 2083

The painter Hans Canon was one of the most important representatives of Viennese Historicism. Drawing on Baroque pictorial traditions, he was an especially keen exponent of allegorical painting and was clearly influenced here by the work of Peter Paul Rubens. Canon was also greatly admired as a portrait painter.

The original inspiration for Canon's painting *The Lodge of Saint John* came to him during the period of many years that he spent in Southern Germany (Munich, Stuttgart, Karlsruhe), where he became much more strongly aware of the widely supported movement towards greater tolerance in matters of religion. His picture shows the figures of Moses and the Christ Child with the representatives of the various denominations of the Church before them. Submissively, both the Pope (as 'Vicar of Christ' in Rome) and the Metropolitan of the Greek Orthodox Church lay down their symbols of leadership, while the

figure symbolic of the Lutheran Church points to the biblical text 'Love one another' and the representative of the Anglican Church offers up a scroll as the sign that he forgoes his own privileges. The title of this picture alludes to John the Baptist, who here plays a mediating role, drawing attention to the shared root of all the Western religions and thus inspiring their representatives to contrite reflection. Alongside the demand that the various confessions be granted equal status, Canon's picture also acknowledges the desire for reconciliation between Christianity and Judaism.

When this picture was shown in 1873 at the Weltausstellung in Vienna, it attracted considerable attention and, at the Emperor's request, it was acquired for the Imperial collection as *The Union of the Sects of the Church*.

Hans Makart (1840–84)
Bacchus and Ariadne, 1873/74
Oil on canvas, 476 x 784 cm
Inv. No. 2097

Alongside Hans Canon and Carl Rahl, Hans Makart is the best-known painter of the Viennese 'Ringstrasse Period', the era characterized by substantial urban expansion and an economic boom. Makart's importance lies in his more general cultural influence as much as in his role within Viennese art life. Of prime importance were the legendary 'historical' festivities Makart organized in his studio in Gusshausstrasse (formerly part of the Imperial Bronze Foundry used by the sculptor Fernkorn) and the Jubilee procession to mark the silver wedding of the Emperor and his Consort in 1878, for which the artist designed the costumes and decoration.

Makart, who trained as a painter at the Munich Academy, was especially highly admired as a portrait painter; he knew very well how to respond to the need for display felt by members of the wealthy upper middle classes. Makart is also readily associated with large-scale paintings of historical, literary or mythological subjects. These proved to be popular with all classes of society because they offered such a feast for the eyes. Although a certain eclecticism is evident in Makart's work, he was nonetheless very able to unite elements from Venetian art of the sixteenth century — the work of Titian or of Paolo Veronese — with those associated with Peter Paul Rubens, and to subordinate both to his own virtuoso painting style within homogeneous and powerful compositions.

This provenance with regard to subject matter is also clear in the Dionysian celebrations seen in *Bacchus and*

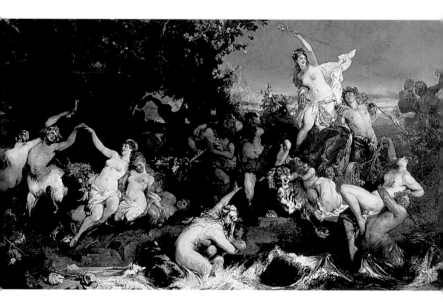

Hans Makart, **Bacchus and Ariadne**

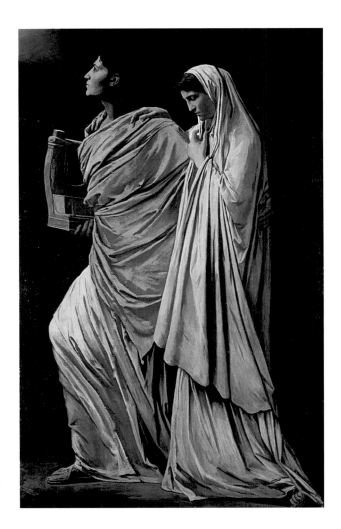

Anselm Feuerbach,
**Orpheus and
Eurydice**

Ariadne, illustrated here. The inherent exuberance of the subject is conveyed through the ever renewed flow of movement within the various figural groups, a movement culminating in the pose of Ariadne, who triumphantly brandishes a thyrsus. The composition was originally devised as the central section of the curtain for the newly opened Komische Oper on the Ringstrasse. Because the surface of the oil painting proved too reflective, however, the picture was never used for this purpose.

Anselm Feuerbach (1829–80)
Orpheus and Eurydice, 1869
Oil on canvas, 200 x 126.5 cm
Inv. No. 1719

Feuerbach was the son of an archaeologist and thus, from his childhood, familiar with stories from Ancient Greek and Roman history, literature and mythology. After training at the Academies of Düsseldorf, Munich and Antwerp, he turned repeatedly to such subject matter. He first treated the legend of Orpheus in 1866. The divine poet of the Greeks was able to enchant animals and plants with his singing. After his beloved Eurydice had died from the bite of a snake, he went, lamenting and singing, to Pluto, King of the Underworld.

Anton Hansch, **The Stubai Glacier in Tyrol**

Impressed by the singer's lament, Pluto allowed Eurydice to return from the Kingdom of the Dead on condition that Orpheus did not turn to look at her during their journey towards the light. In Feuerbach's picture, Orpheus is seen hastening towards his goal. Only in the faltering steps of Eurydice is the outcome of the story hinted: we know that soon Orpheus, in his concern, will turn back towards her and thus lose her forever.

This subject is not rare in nineteenth-century art. In contrast to the usually more dramatic treatment of the episode, Feuerbach sought to make visible the inner spiritual tension of both Orpheus and Eurydice and to convey the story through the presentation of the figures alone. The use of monochrome, the solidity of the figures and the strict rendering of the drapery folds (these almost entirely negating the underlying body shapes) bestow on the picture the character of a painted copy of a stone relief. During his long stay in Rome (1857–72), Feuerbach is known to have been especially interested in Ancient Greek and Roman sculpture. This would also account for details such as the cithara with a Marsyas relief held by Orpheus: this is a visual quotation from a statue of Apollo

in the Vatican Museums. The close connection of the Orpheus story with the myth of Apollo encouraged Feuerbach to regard Orpheus as a symbolic embodiment of the artist.

Anton Hansch (1813–76)
The Stubai Glacier in Tyrol, c 1875
Oil on canvas, 95 x 126 cm
Inv. No. 3084

Hansch, who trained as a landscape painter at the Vienna Academy, discovered what was to prove his preferred range of motifs in the mountains during the 1830s and 1840s. Over the years he evolved a naturalistic landscape style for the representation of steep mountain ranges, wild waterfalls and deep ravines. The dramatic exaggeration of given motifs — in this case the powerful glacier rendering the figures of the climbers all but insignificant — became a regular feature of Hansch's paintings. During long working trips in the Bavarian, Austrian and South Tyrolean Alps, Hansch made innumerable sketches that he then used as the basis for the large-scale paintings he subsequently produced in his studio. Hansch's oeuvre offers no reflection of the contemporary prevalence of *plein-*

air painting in France, even though examples of such work would have been known to him at the latest by 1873 when they aroused the interest of both public and artists at the Weltausstellung in Vienna.

Leopold Carl Müller (1853–92)
Market in Cairo, 1878
Oil on canvas, ˉ37 x 216 cm
Inv. No. Lg 353

There was an Orientalist strain in Viennese painting from the mid-nineteenth century. Nonetheless, only a small group of artists devoted themselves to this fascination; and the local market for such paintings was also rather small, with the result that only a few examples are to be found in Viennese collections today. In France and England, however, there were many keen buyers for such works, the best Orientalist painters generally coming from these two nations.

Leopold Carl Müller was the most important of the Viennese Orientalists. The picture illustrated here was commissioned by the Austrian Ministerium für Cultus und Unterricht. The surviving correspondence relating to the commission reveals that the artist expressly resisted the imposition of a particular subject: the illustration of a specific event would, in Müller's view, reduce the atmosphere of the setting to merely secondary importance, and Müller was more concerned to convey the general impression made on him by the city of Cairo. The picture was partly painted on the spot and partly in Müller's studio in Venice. The canvas accompanied him on his many journeys between Italy and Cairo, allowing figures added in the studio to be corrected under the impact of the Egyptian sun. This record of daily life in Cairo is a penetrating study of the variety of human types, their gestures and their costumes, and notable above all for the vault of light and haze and its impact on the colouring of the city. All these characteristics make *Market in Cairo* one of the chief examples of realistic Orientalism in European painting as a whole.

Leopold Carl Müller, **Market in Cairo**

Anton Romako (1832–89)
Tegetthoff at the Naval Battle of Lissa
(first version), c 1878/80
Oil on board, 110 x 82 cm
Inv. No. 5032

This work by Anton Romako is one of the most unusual 'history paintings' of the nineteenth century. Its subject was the naval battle fought near Lissa in 1866, in which Admiral Wilhelm Tegetthoff, commander of the Austrian fleet, defeated the Italians. Romako eschewed the traditional manner of presenting battles: both action and drama are concentrated on the bridge of the Austrian flagship. The moment shown is just before the decisive ramming action, when all the crew are tense with anticipation. This moment is identified by means of the flying splinters of the exploding grenade at the left above the wheel; the ship itself is enveloped in steam and gunsmoke.

Such concentration on a purely psychological rendering of those taking part in a battle was found unacceptable by contemporary critics. They were also puzzled by the all too human, and thus 'unheroic', pose of Tegetthoff himself. For Romako, however, it was Tegetthoff the man (who was uneasy about the outcome of his plan of attack) that mattered. It was only thus that he felt able to do sufficient justice to the commander's inspired achievement.

Anton Romako (1832–89)
Countess Maria Magda Kuefstein
(née Krueger), 1885/86
Oil on canvas, 79 x 63 cm
Inv. No. 3803

After his long stay in Rome (1857–75) Romako found it difficult to settle down in Vienna. The Viennese public, which had developed a taste for the flattering portraits of Hans Makart, felt Romako's expressive painting too taxing. Thanks to the support of Count Karl Kuefstein, however, the painter was able to continue working. During one of Romako's stays at the Count's home — Schloss Greillenstein in Lower Austria — he produced this portrait of Countess Maria Magda Kuefstein. Romako's honest attitude towards his subject is recorded in a letter to the Count: 'As you see, the portrait pleased the Countess although I didn't flatter her.'

Romako's sitter does not fascinate us on account of her youth or her beauty, but rather through the dignity and refinement of her pose. The finely painted head with its almost supra-realistic blond curls is surrounded by a delicate veil that appears to stiffen in front of the breast, thus masking the outlines of the dress. Together with the portrait's cool colouring, this blurring of the body's shape bestows on the image an ideal character, almost that of a devotional image. This impression is strengthened through the almost too 'sculpturally' rendered bouquet at the lower right corner.

Anton Romako, **Countess Maria Magda Kuefstein**

Art around 1900

The character of the art world and the cultural climate in Vienna around 1900 owed a great deal to Gustav Klimt and the Secession founded by him and his colleagues. Klimt, with his calm appearance and firm manner, was a dominant presence in the city at this time of exciting and important change, like the withdrawal of the Secession from the Künstlerhaus exhibitions in 1897, and the withdrawal of the 'Klimt-gruppe' from the Secession itself in 1905, an event followed three years later by the organization of the Kunstschau [Art Show]. Throughout this time, works by Klimt repeatedly formed the focal point of exhibitions in Vienna.

At the time of the founding of the Vereinigung bildender Künstler Österreichs — Secession [Association of Austrian Artists — Secession] in 1897, Klimt was one of the strongest spokesmen, and the moving force, in support of the idea of the association's having its own exhibition building. This was eventually designed by the architect Joseph Maria Olbrich. The Secession also put forward new ideas in its own art journal *Ver Sacrum* [Sacred Spring].

It was a time of awakening in all the arts, a blossoming in creativity that was to bestow on Vienna a great many important artists and works of the highest interest and quality. Among architects, Otto Wagner was the leading figure of the movement for reform: he called for a new ethos in the language of architecture. Among his pupils were many who were themselves to have a considerable impact on architecture in Vienna and elsewhere. After Wagner came Adolf Loos with his much more radical demands and his now celebrated condemnation of meaningless ornament. The ideas of the Gesamtkunstwerk and the formal organization of all aspects of life according to a single impulse — both ideas advocated by the Secession — led to an enormous boom in the realm of the applied arts. In 1903

the Wiener Werkstätte [Vienna Workshop] was founded: its largely handmade products were based on designs by artists, architects and designers such as Josef Hoffmann, Koloman Moser, Bernhard Löffler, Carl Otto Czeschka and Dagobert Peche. A markedly stylized manner of painting — *Stilkunst* — as in the work of Max Kurzweil, Carl Moll, or Broncia Koller-Pinell, became very widespread.

It should not be forgotten that it was through the efforts of the Secession (above all those of Klimt, Moll and Joseph Engelhart) that there arose many of the impulses towards the *Stilkunst* embodied in Viennese *Jugendstil* [the Central European equivalent of *art nouveau*] and also towards the new art of early Austrian Expressionism. Through the well-planned programme of exhibitions mounted by the Secession, modern and sometimes contemporary art from across Europe was brought to Vienna, thus providing the essential precondition for the younger generation — artists such as Schiele, Kokoschka, Faistauer, Gütersloh and Harta — to make their own discoveries and so take Austrian art boldly forward into the twentieth century.

Gustav Klimt, the first President of the Secession, and his comrades-in-arms felt a real need to free Vienna from its cultural confinement within the Danube Basin and the Imperial provinces and to bring it face to face with European Modernism. It is true that certain Viennese collectors had for some time taken an interest in the work of the Barbizon painters and in Early Impressionism, and that the Künstlerhaus had very occasionally mounted exhibitions of European art. Nonetheless, there was a great deal of catching up to be done, in particular as far as an interested public was concerned. The demands of the members of the Secession were also supported by renowned critics, including Ludwig Hevesi

(without whom Viennese *Jugendstil* would never have acquired such a following), Berta Zuckerkandl and Hermann Bahr.

In the catalogue for the first exhibition of the Vienna Secession the following claim was made: 'Considering that the majority of the [Viennese] public has been left in blissful ignorance regarding the powerful artistic developments abroad, we have been concerned, especially in our first exhibition, to offer an image of modern art in other countries, so that the public may be granted a new and higher standard against which to measure local artistic production.' In this exhibition, which took place in 1898 in rooms lent by the Gartenbaugesellschaft, the works of Austrian members of the Secession were shown alongside those of Arnold Böcklin, Eugène Carrière, Fernand Khnopff, Alphonse Mucha, Auguste Rodin (fifteen items), Franz von Stuck and James McNeill Whistler. Shortly after this event, in April 1898, the usually quite conservative Künstlerhaus reacted — very much to the indignation of the Secession — by mounting a 'jubilee exhibition' with work by many of the same artists and also that of Claude Monet and Giovanni Segantini.

At the second Secessionist exhibition held later in 1898, which also marked the inauguration of Olbrich's Secession Building, the foreign artists represented included Anders Zorn and Fernand Khnopff. In 1899 the Secession showed work by Walter Crane, Eugène Grasset, Max Klinger, Constantin Meunier, Félicien Rops and Théo van Rysselberghe. Significantly, many essentially conservative Salon painters were also included — these having superficially (and, as it was to prove, lucratively) adapted their style to the new currents. Nonetheless, the names mentioned show how concerned the Secession was to present to the Viennese public, within the shortest possible time, a broad panorama of artistic innovation and stylistic development.

The range of artists also reveals that Viennese interests were quite eclectic and by no means limited to art from Paris. As has rightly been observed, at the time of the first Vienna Secession exhibitions the artistic vanguard in Paris no longer consisted of the Impressionists, but rather of those Symbolists who followed the lead of artists such as Puvis de Chavannes, Odilon Redon, the members of the *Nabis* group or the painters of Pont-Aven. A key role was resumed by Paris with the important retrospective exhibitions of the work of Van Gogh, Gauguin and Cézanne; but these did not take place until after 1900, until which point these artists were known to few outside well-informed artistic circles.

While an exhibition of Japanese wood-block prints was held at the Österreichisches Museum für Kunst und Industrie in 1899, the Sixth Secession exhibition, in 1900, was entirely devoted to Japanese art, in acknowledgement of its importance as one of the foundations of European Modernism and also of the linearity and decorative planarity of *Jugendstil*. Klimt's work, for example, would have been unthinkable without the example of Japanese wood-block prints — whether with regard to its insistence on idiosyncratic cropping, its banishing of a sense of depth, its emphasis on ornamental planes, or its beauty of line in the treatment of contour. Egon Schiele too, drew greatly on Japanese art (albeit sometimes indirectly, through the work of Klimt). Its influence can be found in his expressive use of outline, the isolation of figures and objects within his compositions and their reduction to powerfully expressive forms, and the eschewing of pictorial depth. Of all Austrian artists of this period, Schiele was to go the furthest in developing what he had learnt from Japanese art.

As part of the ninth show mounted by the Secession, in 1901, a memorial exhibition for Giovanni Segantini was organized. Among the works included was the painting *The Evil Mothers* (1896), and this was acquired by the Secession in order to present it to the modern gallery which was about to be established by the state. The Secession's commitment to presenting the most important contemporary artistic developments in Europe had always embraced the idea of a new gallery devoted to exhibiting Austrian art in the context of international art. As its contribution to the new Moderne Galerie, which opened in 1903 in the Unteres Belvedere, the Secession donated to the state a series of paintings and sculptures, including Van Gogh's *Plain at Auvers-sur-Oise* (1890), the work by Segantini mentioned above, and a plaster cast of Rodin's *Portrait Bust of Henri de Rochefort-Lucay* (before 1897). It thus became

possible for the Viennese public to encounter outstanding modern works in a permanent collection within the city. Segantini's picture was to be one of the works that later drew Schiele's attention to new forms of expression.

Like the Secession exhibitions, the Secession journal *Ver Sacrum* was also committed to supplying and encouraging new ideas. In 1901, for example, a whole issue was devoted to Jan Toorop, whose symbolic pictorial language was to prove of considerable importance for Klimt, both in his Beethoven Frieze (1902; see pp. 124–127) and in pictures such as *Water Snakes* (1904–07).

The didactic pretensions of the Secession were very evident in the large exhibition mounted in 1903 entitled 'The Evolution of Impressionism in Painting and Sculpture'. Selected and organized by three famous champions of modern art — Octave Maus, Julius Meier-Graefe and Richard Muther — this traced a 'tradition' that connected works by El Greco, Velázquez, Rubens. Vermeer, Tintoretto and Goya to those of the French Im-pressionists and Post-Impressionists, not forgetting to acknowledge the contribution of Japanese wood-block prints. Representatives of the 'shift towards stylization' — including Vincent Van Gogh, Henri de Toulouse-Lautrec, Pierre Bonnard, Edouard Vuillard and Maurice Denis — were also included. Works exhibited on this occasion were acquired for the Moderne Galerie, including Monet's *Portrait of the Cook Paul Antoine Graff.* By means of such exhibitions, a definitive change in taste was effected among the Viennese public.

At the nineteenth Secession exhibition, in 1904, the artists represented included Cuno Amiet, Axel Gallén, Hans von Marées, Edvard Munch and Ferdinand Hodler. For the young Schiele, the encounter with the work of Munch must have been the confirmation of his own will to expression. The Secession had already introduced Munch's prints to Vienna in an exhibition held in 1902, and Schiele (though only twelve years old at the time) may well have seen these. Schiele's *Portrait of Eduard Kosmack*, with the sitter holding his hands between his knees, certainly recalls the pose and facial expression adopted by the figure of the girl in the two versions of Munch's *Puberty* (1893–95). Munch's, and especially Hodler's work thus became familiar in

Vienna, and for the latter it was a critical and financial success at what proved to be one of the most popular Secessionist exhibitions ever held.

Not only were the members of the Secession concerned to bring foreign art to Vienna, they were also to be strongly influenced by this art in their own work. Klimt offers one of the best examples of the retroactive effect of this confrontation with the achievements of other great European artists. In the portraits he painted around 1900, for example, the influence of Whistler is detectable, while his landscapes from this period reflect the influence of Monet. Paintings from the early 1900s such as *Judith and Holofernes* clearly reveal Klimt's interest in the Late Impressionism of artists such as Théo van Rysselberge or Segantini, while the 'painted mosaic' that extends across the surface of Klimt's landscapes like a tightly worked carpet of individual coloured forms was adapted out of French Pointillism (the work of Paul Signac was shown by the Secession in 1900). Klimt's endeavour to achieve an ornamental, planar arrangement of the picture surface was in part encouraged by the brightly coloured patterned planes that tended to abolish a sense of space in the work of Bonnard and Vuillard. Later the encounter with the work of Toulouse-Lautrec led to a change in Klimt's approach to portrait painting, while the brilliantly coloured, simplifying backgrounds in the paintings of Matisse ensured that colour in Klimt's work assumed greater importance in its own right.

In 1905 the Vienna Secession split into a group favouring greater stylization and another preferring to retain a greater element of Naturalism. The first of these, the 'Klimtgruppe', consisted of architects such as Josef Hoffmann and Otto Wagner, painters such as Carl Moll and designers such as Koloman Moser. In 1908, on an empty building site (later the site of the Konzerthaus), Hoffmann erected a temporary exhibition building in which a show of new Austrian art could be held. This was the Kunstschau, and Klimt's *Kiss*, was exhibited there before being acquired for the Moderne Galerie. A year later an Internationale Kunstschau was held in the same location with work by foreign artists.

The Secession continued to mount exhibitions even after the departure of

the 'Klimtgruppe'. Nonetheless, other important exhibition venues now emerged, notably the gallery of H. O. Miethke. The shows mounted here were generally organized by Carl Moll and were to prove of particular importance in the presentation of international Modernism. In January 1906 the first significant Van Gogh exhibition was held here (with forty-five pictures); in March 1907 seventy-two works by Gauguin were shown; and in 1909 one hundred and seventy-eight works by Toulouse-Lautrec were presented.

The influence of Gauguin was reflected only in Oskar Kokoschka's work, and only for a while. Kokoschka's drawing style was more strongly marked by the emaciated and angular youths and gaunt figures of the sculptor Georg Minne. It was, however, the work of Van Gogh that had the strongest impact on artists in Vienna. The exhibition of 1906 had already aroused Klimt and his circle (including, by this time, Schiele) to paint sunflowers. At the Internationale Kunstschau of 1909, organized by the 'Klimtgruppe', pictures by Van Gogh were shown to even greater effect alongside works by Cuno Amiet, Ernst Barlach, Pierre Bonnard, Maurice Denis, Paul Gauguin, Henri Matisse, Edvard Munch, Félix Vallotton, Maurice de Vlaminck and Edouard Vuillard.

The qualities of the late work of Van Gogh are very clearly reflected in a picture such as Klimt's *Avenue at Schloss Kammer*, in its dense application of paint, its characterization of individual forms and its clearly outlined foliage. For Schiele, Van Gogh's painting offered an expressive art that closely corresponded to what he was himself striving for. Like Van Gogh, Schiele saw symbolic self-portraits in landscapes, trees or other objects. The expression of psychological states through the manner in which objects or figures were rendered (as found in the work of Van Gogh) offered the young Schiele the exciting challenge of a possible means of freeing the inner pressure of his own anxieties by addressing these through art. Schiele also drew on Van Gogh's work in terms of the motifs commonly found there.

For Kokoschka, too, the encounter with the work of Van Gogh was of crucial significance. It provided Kokoschka with a sense of direction for his new mood of insistence, for an as yet undefined sense of revolt, even for the ideas he had derived from Adolf Loos. As a

result, the paintings of Van Gogh may be said to have triggered the radical change in Kokoschka's style that occurred in and after 1909. What Kokoschka drew from Van Gogh was a new form of expression achieving its effects by means of impetuous brushstrokes that attested to the undiminished vehemence of the inspired artist in a fury of creation. Gustav Klimt, meanwhile, was prompted by the example of the work of Toulouse-Lautrec (also included in the Internationale Kunstschau of 1909) and by impressions gathered on a trip to Paris to adopt a more spontaneous approach to contemporary reality and to reflect this in his work (c.f. *The Mauve Hat* of 1909). Of greater importance during Klimt's later years, however, was the renewed encounter with the work of the *Nabis* artists and with Matisse, which called forth an unprecedented brightness of colouring and emphasis on patterned background, as in the case of the second *Portrait of Adele Bloch-Bauer*. (It is probable that Klimt was encouraged to show Japanese wood-block prints or paintings in the background of this picture by the example of Van Gogh's portrait of *Père Tanguy*). The figures' outlines in Klimt's later work remain of significance but the colours (deeper and more luminous than before) take on greater importance in relation to these. At the same time the brushstroke becomes freer and looser and the transitions more subtle.

The Österreichische Galerie collection of work from around 1900 presents both Viennese art and a group of important examples (necessarily selective but of extraordinary quality) that constitute the contemporary European context for Viennese developments. In the years following the foundation of the Moderne Galerie, a systematic collecting policy was implemented in the attempt to continue the original aim of encouraging international comparison, in as far as funds allowed. Since the foundation of the Museum Moderner Kunst [Museum of Modern Art] in 1962, however (which one could indeed regard as a new state-sponsored Moderne Galerie), the Österreichische Galerie's collecting activity in the realm of international art has concentrated on enriching its nineteenth- and earlier twentieth-century holdings.

The Sufferings of Weak Humanity　　　The Knight in Armour,
Ambition, Pity

The Longing for Happiness

Gustav Klimt (1862-1918)
Beethoven Frieze, 1901-02
Casein-based paint, stucco work, pencil, appliqué work in various materials (glass, mother-of-pearl etc.), gold-leaf on plaster.
Oveall length 34.14 m
(longer walls ecch 13.92 m
shorter wall 6.30 m), h. 2.15 m
Inv. No. 5987

Provenance: Initally in the collection of Carl Reininghaus, Vienna; from 1913 owned by August Lederer, Vienna; from 1960 owned by Erich Lederer, Geneva. Acquired in 1975 for the Österreichische Galerie through the Bundesministerium für Wirtschaft und Forschung; installed in the Secession building in Karlsplatz.

The Three Gorgons;
above Sickness,
Madness and Death

The Giant
Typhon

The Hostile Powers
Impurity, Desire, Excess

The Longing for Happiness

Poetry

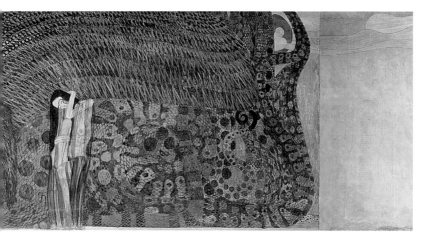

Nagging Care

The Longings and Desires of Mankind fly
above and beyond the Hostile Powers

The Arts

The Choir of Heavenly Angels
Joy, beautiful divine Spark

For the whole world this kiss

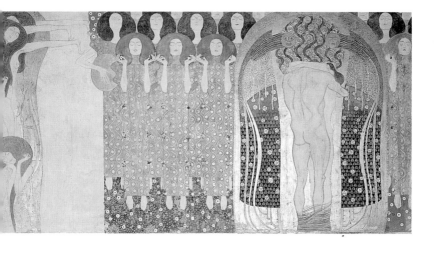

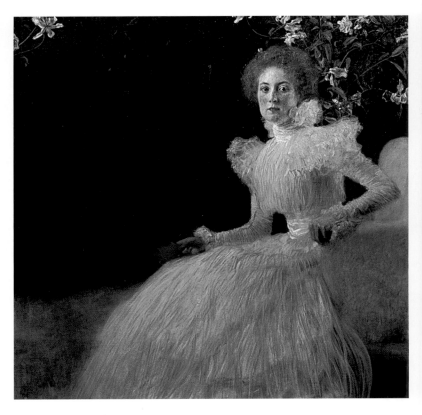

Gustav Klimt, **Portrait of Sonja Knips**

Gustav Klimt (1862–1918)
Portrait of Sonja Knips, 1898
Oil on canvas, 141 x 141 cm
Inv. No. 4403

Sonja Knips (1873–1959), née Baroness Potier des Echelles, was the wife of the Viennese industrialist Anton Knips, who owned many pictures by Klimt and also commissioned a house and its fittings from Josef Hoffmann. In Klimt's portrait she sits in an armchair at the right of the composition, her upper body turned towards the viewer. A bold spot of colour is provided by the red sketchbook in her hand, which had in fact been given to her by Klimt. To the right of her slender neck there is a naturalistically rendered floral structure (we know, from one of Klimt's preparatory drawings, that he had originally intended to place a shadowy human figure here).

The frame — designed by Klimt's youngest brother George (1867–1931), a goldsmith — deliberately crops the image and, together with the square format itself, draws attention to the fact that the picture is an extract from a larger whole. Until 1898 Klimt had exclusively employed a vertical format for his paintings. Together with *Pallas Athene*, the portrait of Sonja Knips is among the first of his works to have this new square shape — a format with which he was to become associated and that, as an embodiment of perfect proportion, was fully in accord with Secessionist taste.

A further characteristic of Klimt's later work — the antagonism between fully modelled and naturalistically rendered face and hands and a stylized treatment of the rest of the picture — is also to be found here. Only the sitter's face and a few of the flowers in the background are recorded in detail; the rest of the image dissolves into softly shimmering, partially translucent zones of colour, with no sharply defined outlines.

Gustav Klimt (1862–1918)
The Kiss, 1907/08
Oil, silver- and gold-leaf on canvas,
180 x 180 cm
Inv. No. 912

In Klimt's most celebrated painting, *The Kiss*, we encounter the perfect realization of the Secessionist endeavour to aestheticize every act, to imbue every realm of life with art. The man and the woman we see here are placed on a meadow glutted with brightly coloured flowers, as if they were standing on a carpet: it is a Garden of Paradise, or *hortus conclusus*. The precarious placement of the lovers at the very edge of this patch of meadow and in front of the vibrant gold tonality of the background is offset through the framing and protecting aureole of gleaming gold that surrounds the two figures, in particular the woman.

Klimt attempts to raise the lovers' kiss to an act of universal significance.

Oblivious to everything around her, the woman sinks to her knees before the demonstration of love offered by the ivy-crowned, dominant figure of the man. She seems to lose herself entirely in him as she offers up her face and mouth, her facial features regular and yet generalized. The image of the couple avoids any detraction from the 'artistic' in favour of the realities of human pose, movement and gesture. The image is one of premonition: it hints at sensuality and yet remains removed from it. The kiss is chaste and full of promise, not frenzied and already drawing the lovers towards an abyss of passion.

The man's cloak, with its insistently rectangular ornamentation, and the woman's dress, decorated with softly flowing lines and a brightly coloured flower pattern, embody the opposed principles that merge in the kiss. The picture attempts to assuage the desire for happiness and to evoke a world of perfect harmony which has banished

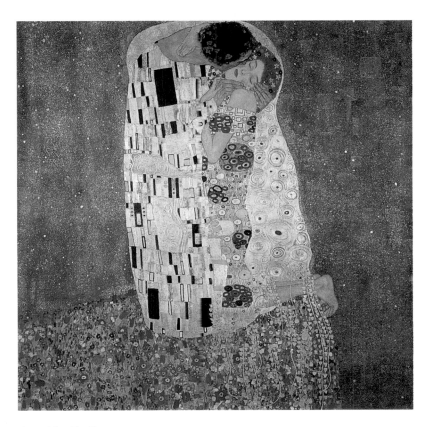

Gustav Klimt, **The Kiss**

Gustav Klimt, **Avenue in the Park at Schloss Kammer**

the notion of opposites — and not only the opposition of man and woman. To this end, Klimt isolates his figures, removing them from any three-dimensional context and bestowing on them an air of timelessness. Equally important here is the beauty of the ornamentation and the implied luxury of the materials. The deep impression made on Klimt by the mosaics of Venice and Ravenna is reflected in these aspects of his painting.

The kiss shown here is understood as a form of redemption. In the same way its earlier incorporation within the Beethoven Frieze (there, in relation to all the arts; see illustrations on pp. 124–127) and its later use in the frieze for the Palais Stoclet (in an entirely ornamental world) signified the fulfilment and the goal of all human striving.

It has rightly been observed that as an expression of physical desire Klimt's *Kiss* is more readily associated with the realm of suffering than with that of paradisiacal harmony; but this element of the physical, and thus of susceptibility to suffering, is offset through the complete and precious ornamentation. The kiss is thereby released from the constraints of its humanity. At the same time the painting unfolds, in all its luxuriance, a parallel, metaphorical form of sensuality.

After its exhibition at the Kunstschau in 1908, *The Kiss* was acquired by the Moderne Galerie. The work may be seen as both the high point and the culmination of a particular phase of development within Klimt's oeuvre. The antagonism between the naturalistically treated and delicately painted flesh and the planar, ornamental treatment of the rest of the picture was subsequently to play hardly any part in Klimt's images. Similarly, the use of gold was completely abandoned in favour of an increasingly bold use of colour.

Gustav Klimt (1862–1918)
Avenue in the Park at Schloss Kammer, c 1912
Oil on canvas. 110 x 110 cm
Inv. No. 2892

In the period 1908 to 1912 Klimt spent the summer months at the Villa Oleander in Kammerl near Kammer on the Attersee. Here he painted five views of Schloss Kammer, of which the picture illustrated here was the last. The first three images, painted between 1908 and 1910, show the Schloss as viewed from across the lake, while the last two show it as viewed from the land. In the picture illustrated here, the lake is just detectable at the left of the composition. We see the avenue leading to the Schloss with the entrance to the building in the background. Though the Schloss is placed at a certain distance, it retains a characteristic frontality, and the architectural details are recorded very faithfully. The arrangement of the composition as a whole is strikingly asymmetrical and it is precisely through this that it attains its formal tension.

The space-shortening presentation of the trees, staggered in the gradually narrowing avenue, is opposed to the planar network of the foliage (rendered in consistent, evenly large dabs of colour) and the flattened, almost stylized tree trunks. Here too the sense of depth is largely achieved by means of the overlapping of forms, and not through any sculptural development of individual motifs. The glowing yellow of the facade of the Schloss creates, as it were, a beacon for the path with its arched foliage and thus also for the picture as a whole. The strong spots of colour, and above all the incisively outlined trunks and branches, are testimony to Klimt's reaction to the work of Van Gogh.

Gustav Klimt (1862–1918)
Adam and Eve, 1917/18
Oil on canvas, 173 x 60 cm
Inv. No. 4402

Like a number of other pictures from the last year of Klimt's life, *Adam and Eve* is unfinished. The treatment of a biblical subject is an exception in his oeuvre. Although the composition clearly derives, in terms of its construction, from a woodcut by Hans Baldung Grien (and probably in part from Klimt's knowledge of Grien's painting *Death and the Maiden*, 1500; Kunstmuseum,

Basle), the picture is effectively removed from traditional biblical iconography. Despite its conventional title, it appears to focus not on the Fall of Man, but rather on the Creation of Eve.

The naked figure of Eve here masks that of Adam who, according to the biblical account of the Creation (Genesis ii, 21–25), is shown still deep in the sleep during which God made Eve out of one of his ribs. Eve's feet are placed in anemones, so as to emphasize the youthful freshness of her body. The softness of the naked female figure is opposed to the man's bony shoulders and sunken cheeks and temples; her gleaming luminosity and tender skin contrast with his dark and mottled appearance. The picture is especially striking for the chromatic refinement and transparency of Eve's skin, which Klimt has painted using innumerable related tones to achieve the required appearance of freshness and youth. The treatment of Adam's body, on the other hand, includes cold, dull tones.

It is, however, possible that, as in Albrecht Dürer's *Adam and Eve* in the Prado, Klimt is also concerned to convey aspects of the essential characteristics of man and woman, the distinct ways in which they experience the world and grasp reality. While man invests much more strongly in measuring, counting, classifying and organizing, woman progresses intuitively, absorbing knowledge into the totality of her being. In the juxtaposition of such implied distinctions with the similarity of pose — both Adam and Eve have their heads inclined to one side — Klimt perhaps also intended to express the ultimate interrelatedness and solidarity of man and woman.

The contrasts of life and death, of growth and decay, also find their echo in this picture, as is above all suggested through the contrasting character of the two figures. As in other late works by Klimt — *The Baby*, *The Virgin*, *The Bride* — so too in *Adam and Eve* the stages in the cycle of life are acknowledged.

Gustav Klimt,
Adam and Eve

Max Kurzweil (1867–1916)
Bettina Bauer, 1908
Oil on canvas, 66 x 52 cm
Inv. No. 6516

Although Max Kurzweil was one of the founders of the Vienna Secession in 1897, later formed part of the 'Klimt-gruppe' and was always a good friend of Gustav Klimt, the ideals of *Stilkunst* and the symbolism partially linked with it were ultimately to prove of only limited appeal for him. Relatively early in his career, Kurzweil's approach was informed by his encounters with French painting. His work reveals him to have been strongly inspired both by Impressionism and by the work of Bonnard, Vuillard and the other *Nabis* painters.

In Kurzweil's portrait of Bettina Bauer, the artist's skill is especially evident in the delicate, 'light-hearted' colouring and in the skilful use of cropping. The shifting of the figure away from the centre of the composition bestows an air of spontaneity on the image. While the sitter's direct gaze and upright sitting posture underline her childlike curiosity and the first hint of vanity, the pastel tones play up the girlish and spring-like character of the portrait. There is, however, no element of the ornamental in this composition: it concentrates entirely on the girl's pretty face. Bettina Bauer, later a print-maker and wife of the sculptor Georg Ehrlich, was five when this portrait was painted.

If we compare this portrait with Kurzweil's record of Bettina's elder sister Mira, the artist's capacity for empathy with his subject is even more evident. While the younger child, as befits her youth, still poses as a princess, the elder appears relaxed and looks out at us vaguely, as if lost in a day-dream. At the same time, the portrait of Bettina Bauer shows how effectively Kurzweil was able to merge two distinct influences on his work: the Japanese-inspired Secessionist cult of planarity in the treatment of the background, and the Impressionistic application of paint in the treatment of the planes and, above all, of the face.

Max Kurzweil,
Bettina Bauer

Broncia Koller-Pinell (1863–1934)
The Harvest, 1908
Oil on canvas, 110 x 130 cm
Inv. No. 5458

Broncia Pinell, wife of the physician, physicist and later industrialist Hugo Koller (c.f. Egon Schiele's *Portrait of Hugo Koller* in the Österreichische Galerie) was one of the few successful woman painters at work in Vienna around 1900. In addition to being very interested in the work of Van Gogh and the *Nabis* painters — both determined the direction of her development for some time — she became increasingly drawn to the painting of Gustav Klimt. In 1908 she exhibited her work at the Kunstschau and the following year at the Internationale Kunstschau. Among the pictures included here was *The Harvest*. While the influence of French artists is apparent in this work, the painting also provides evidence of Pinell's re-working of the decorative planarity of the exponents of *Stilkunst*. Broncia Koller-Pinell here concentrates forms into compact, boldly coloured planes and distributes these, as if to form a pattern, and without concern for plasticity or depth, across the picture surface.

Giovanni Segantini, **The Evil Mothers**

Broncia Koller-Pinell, **The Harvest**

134

Giovanni Segantini (1858–99)
The Evil Mothers, 1894
Oil on canvas, 105 x 200 cm
Inv. No. 485

This painting, one of those that the Vienna Secession donated to the state in 1903 for the collection of the newly established Moderne Galerie, is one of Segantini's series of 'Nirvana pictures'. In these the artist took his theme from Luigi Illica's poem 'Nirvana', which speaks of the fate of women who have willingly undergone abortions. For Segantini, who saw the essence of woman to lie in her capacity for motherhood, the women discussed in Illica's poem had surrendered to lust without being prepared to endure the pregnancy and motherhood that were the result of their actions. In his view, such women were doomed to suffer in purgatory. In an article in *Ver Sacrum*, Segantini wrote of the 'vain and unfruitful voluptuaries' whose 'punishment in purgatory' he had painted. In *The Evil Mothers* he shows, however, not only their suffering but also their purification and their redemption.

In the left background we find one of the women chained to a tree, desperately struggling to free herself so that she can suckle the child she hears approaching through the snow, and to whom she is tied by means of a branch as if by an umbilical cord. In the foreground we see a mother suckling her child. In the background, in front of the already shaded mountains, we see women dancing with their children in their arms, and looking up to the heavens.

Segantini increases the impact through the inclusion of striking naturalistic detail. For, despite the striking symbolic content of this work, its dominating subject is the light of the mountain region that provides the setting. Segantini's Divisionism allows him to render in all its luminosity every modulation of the light as it plays over the surface of the snow, the crown of mountains and the evening sky, and as it shimmers on the skin of each woman or shines through the thin fabric of her drapery. In a most striking manner, the opposed impulses of tree and human body merge into a single arabesque — a form both symbolic and strongly expressive.

Ferdinand Hodler (1853–1918)
Profound Emotion, 1901
Oil on canvas, 115 x 70 cm
Inv. No. 1942

Hodler first attempted to convey profound emotion in visual form in a smaller picture, of 1894. His concern for stylization and nobility of feeling here informs everything — the figure as much as the landscape. Crucial to this approach is the emphasis on expressive gesture. Hodler always sought out the beauty of fluent line, and an intensification and concentration of line is usually found in his work in the figures' outer contours. He also strove, however, to convey something of the life of the inner world through the use of pose and gesture, so that the human body might itself become an eloquent form.

The veneration of nature found throughout Hodler's oeuvre is here concentrated into the pose of a single figure. The lowered, spiritualized gaze and the sensitive hands placed solemnly across the upper breast contribute to the desired effect. The use of colour is of equal importance, with the natural green of the meadows opposed to a blue that signals transcendence. As so often in his work, Hodler here allows the landscape background to reach almost to the upper picture edge; the meadow, reminiscent of a carpet embroidered with crocuses, both protects and frames the figure as if it were a screen.

A Hodler exhibition mounted by the Vienna Secession in 1904 was enormously successful. The impact of Hodler's work was also to leave visible traces in Austrian painting, particularly in the work of Egon Schiele.

Auguste Rodin (1840–1917)
Design for a monument to Victor Hugo, c 1836
Reduced version of the second project for the
original design, terracotta, h. 74.5 cm
Inv. No. 8077

The Parisian church of Ste Geneviève
had been deconsecrated in 1885 in order
to become the Panthéon; and in 1889
Gustave Larroumet, an official in the
Ministère des Beaux-Arts, submitted a
programme for its sculptural decoration.
Rodin was asked to provide a monument
to Victor Hugo for the right transept.
Although he did not receive a formal
commission until 16th September 1889,
he had already started work on this
monument. Rodin planned to show
Hugo in exile on the island of Guernsey,
seated on the cliffs with the muses of
Youth, Maturity and Old Age swirling in
a wave over his head. After completing
a first, not very compelling project, he
embarked on a second, the plaster
model of which is now in the Musée
Rodin in Paris. The terracotta group

Auguste Rodin, **Design for a monument to Victor Hugo**

now in the Österreichische Galerie is a reduced version of this. Hugo rests his head contemplatively in his hands, while his other arm is outstretched, as if to grasp at a phrase. The three muses (or personifications of Hugo's three most celebrated poems, 'La Légende des siècles', 'Les Châtiments' and 'Les Voix intérieures') rise up over his body, each set off against the other.

At this point disagreements arose between Rodin and the commission with regard to the character of the proposed monument. It was objected that the group of figures evolved by Rodin would merge into a barely legible mass when viewed from a distance, and he was required to alter his design. He therefore embarked on an entirely new concept, an 'Apotheosis of Victor Hugo', in which the poet was to be shown standing at the top of a cliff, with sirens at his feet listening to him reciting his poetry while Iris, the messenger of the Gods, appeared above his head. This scheme also brought forth two versions; the examples now in the Musée Rodin are datable to about 1890/91.

In July 1890, however, Rodin returned to his original plan on learning that the group rejected by the Panthéon commission could certainly be erected in the Jardins du Luxembourg. He therefore re-worked it for this purpose, producing two further versions. The Österreichische Galerie's terracotta reduction of the second version of the original design is one of the most significant works by Rodin for this project: it records the original conception of the muses floating above the poet in a wave, and it approximates the figure of Hugo himself as this was to appear in the final version (accepted for the Panthéon), albeit in a more compact form.

Fernand Khnopff,
Vivien

Fernand Khnopff (1858–1921)
Vivien, 1896
Painted plaster on a gilt wood base, h. 99 cm
Inv. No. 4431

Sensuality is the dominant characteristic of Khnopff's half-figure of a fairy from the English tales of King Arthur. The seductively squirming body is shown from the mid-thigh upwards, its form all too evident through the clinging, indeed damply adhesive, shirt. With eyes half closed, red lips half open and face framed in thick red hair, Vivien seems to inspect the viewer coquettishly, sure of the triumph of her charms.

In the poet Alfred Tennyson's 'Idylls of the King', Vivien is the witch who ensnares the mage Merlin and steals his 'magic book'. Merlin's 'book' was written on a shell and Khnopff's figure of Vivien holds this to her breast. With her own magic powers, Vivien traps Merlin in the forest of Brocéliade. The figure illustrated here may, however, be said to embody the vampire-woman of the late nineteenth-century imagination,

the *femme fatale*, whose simultaneous allure and menace preoccupied artists such as Munch or Klimt and who is a recurrent theme in the work of Khnopff.

In order to increase the realism and sensual presence of this figure, Khnopff makes use not only of colour but also of the contrast of the rough surfaces of drapery or hair against the smooth areas of flesh. In his sculptural works of this period, Khnopff experimented with various materials in order to achieve the effect of morbidity he envisioned. Like his German contemporary Max Klinger, he resorted to the use of polychromy (by adding paint to completed figures and sometimes by creating these out of a number of different sculptural materials) in order to achieve both a strongly naturalistic effect and a sense of material luxury.

Max Klinger (1857–1920)
Crouching Figure, 1900/01
Marble, h. 80 cm
Inv. No. 8079

Klinger was already becoming established as a draughtsman, print-maker and painter when he also turned his attention to sculpture, in 1885. As a sculptor, he strove to attain the contemporary goal of the Gesamtkunstwerk in bestowing polychromy on his works by creating them out of variously coloured, precious materials. A similar intention is to be found in Klinger's paintings *Christ on Olympus* and *The Judgement of Paris*, where a very 'sculptural' painting style is complemented by the painted sculpture of the frames.

The plasticity of Klinger's figures is compact and always clearly defined, even though, like Rodin, Klinger saw the torso as capable of independent sculptural expression. In his *Crouching Figure*, a work preceded by a surviving oil study, the artist demonstrates his

Max Klinger,
Crouching Figure

Constantin Meunier,
The Hauler

mastery in the rendering of the 'tele-
scoped' body parts. The figure invites
one to walk around it, and from each
side it offers new, interesting views.
This in effect ensures that the space it
encloses becomes an integral part of
the work. In this respect, and despite
its classicizing precision in the rende-
ring of detail, it may be recognized as
more 'modern' than contemporary
works by Rodin.

Constantin Meunier (1831–1905)
The Hauler, 1905
Bronze, h. 225 cm
Inv. No. 764

Meunier did not evolve his sculpted
figures through the process of looking
at other sculptures but rather through
the observation of reality. As a young
man he had started training under a
sculptor who encouraged him to work
in a shallow, naturalistic style. He
soon abandoned this as too untruthful
and superficial, especially as painting
seemed to offer more scope for honesty.
It was only when he was commissioned
to produce illustrations for a book about
Belgium, however, that his eyes were
opened to a subject that was to pre-
occupy him throughout his career. The
commission took him to a mining area
— the Borinage — and here he came

into contact with the miners and learnt of the hard conditions in which they struggled to earn a living. The more he recognized the sculptural qualities of these figures, the more he felt drawn back to sculpture in order to attempt to capture what he had seen.

In contrast to the majority of sculptors active around 1900, Meunier's greatness lay in his ability to summarize, his simplification of form, and the combination of a number of large and unadorned parts into an expressive overall silhouette. The simple working people he had encountered assume in his work an unprecedented dignity without falling into pathos. The figure of the hauler conveys not only the exertion required by the work that has to be done, but also the beauty and dignity of those who do it. Ultimately, it speaks of the earnestness and the greatness of these working lives.

Aristide Maillol (1861–1944)
Action in Chains, 1905
Bronze, h. 215 cm
Inv. No. 2883

This bronze figure was made for a monument in Puget-Théniers in honour of Louis-Auguste Blanqui, a hero of the French Revolution. Maillol, who had painted and produced tapestries during the earlier decades of his career, turned to sculpture, almost by chance, at the age of forty. In his sculptural work, Maillol sought to achieve classical austerity and universal validity. He eschewed all superfluous detail and reduced his figures to clear, archaic forms. His sculptures became ever more emphatically structural and clear in their proportions. They consisted of self-contained masses, a few extremely simplified and emphatically solid forms with smoothly finished, compact planes.

Aristide Maillol,
Action in Chains

Edvard Munch, **Summer Night on the Shore**

Maillol drew on nature in evolving the basic principles for his approach to the figure: 'Nature is good and healthy and strong. One must live with it and heed its voice. Then one will produce good art. Yes, harmony in nature. I try always to express that in my work... In the composition as a whole I look for the great harmony of forms, so that these will emerge clearly in the figure's silhouette, without gaps and distortions; and in the details too I look for harmony. I place them one next to another, always comparing the part with the whole. Without copying nature, I work as nature does.'

Action in Chains, in spite of its strong suggestion of movement, corresponds to the type of female figure that Maillol always favoured: heavy, unemotional, very monumental and tending to generalized large forms. The figure adopts a straddling pose, twisting round from the shoulders, with the head turned to the side. The body is sturdy and incisively divided into distinct compartments. The act of stepping boldly forward here becomes a symbol of the will to freedom.

Edvard Munch (1863–1944)
Summer Night on the Shore, c 1902
Oil on canvas, 103 x 120 cm
Inv. No. 3772

There is no doubt that this picture is one of Munch's greatest achievements in landscape painting. During the 1890s Munch became increasingly concerned with the rendering of landscape. He transferred to this his experience of the treatment of the human figure (which he had learnt to condense to a few deeply coloured planes with undulating outlines). Landscape thus became the major expressive force in many of his works. Details were very often suppressed and topographical information omitted in order to convey only the mood that the experience of nature triggered in the observer. Individual forms were transposed into zones of colour, generating the true formal tension of each picture through their harmony and the interaction of their tones.

Although, from late 1892, Munch spent a great deal of time in Berlin, he generally spent his summers in Åsgårdstrand in Norway. Around 1900 he painted many fjord landscapes,

including scenes of the bright, moon-lit nights of the Nordic winter. Munch also recorded his experience of the long Nordic summer nights of this region. *Summer Night on the Shore*, illustrated here, was preceded, for example, by *Secret of a Summer Night* (1892) and *Moonlit Night* (1895). This sequence culminates in the picture in the Öster-reichische Galerie, where the mid-night sun forms a golden reflection in the blue and lilac water. In its con-struction, as in its softly undulating, un-interrupted forms, this picture conveys a sense of calm and perfect balance. These qualities do not only capture the peace of this summer night, they also impress the spectator with the evidence of Munch's skill in using relatively abstract forms to increase the scope for expression. Munch himself empha-sized: 'One cannot paint such pictures from nature, one must derive them from one's own innermost thoughts.'

This picture formerly belonged to Alma Mahler (widow of the composer), to whom it was given by her second husband, Walter Gropius, to mark the birth of their daughter Manon.

James Ensor (1860–1949)
Fantastical Still Life, c 1917
Oil on board, 16 x 21.5 cm
Inv. No. 3914

Like masks, skeletons and disguises, which were commonly the subject of Ensor's work, still lifes play a very sig-nificant part in the artist's oeuvre. These too are often impressive testi-mony to his unrestrained imagination. In them he is able to give subtle ex-pression to those preoccupations of which all his work speaks: the secret life, the unfathomable and the danger-ous lurking beneath superficial beauty, the animation of the seemingly static and inconspicuous. *Fantastical Still Life* hints at all of these through the ambiguous appearance of the sculpted figure of a nude girl (poised mid-way between cold materiality and the warmth of real life) and through the reaction of the curious creatures that inhabit the lower right corner of the picture and look up at her with gaping mouths and eyes widened in lust or anger. An inscription on the back of the picture — 'Sourire d'œillet, caresse de marguerite' [smile of the carnation, caress of the daisy] — points up the fre-quent element of charm in Ensor's embodiment of the bizarre.

James Ensor, **Fantastical Still Life**

Early Expressionism

In the Imperial Vienna of the years after 1900 the combination of boundless aestheticism and ambivalent premonitions of unavoidable decline produced an atmosphere unique in the world. One of its products was Early Austrian Expressionism. When the young Oskar Kokoschka exhibited in public for the first time at the Kunstschau in 1908 and the Internationale Kunstschau in 1909 his work disturbed a public that had only just come round to the innovations of the Vienna Secession. Most critics tore Kokoschka to shreds; but, as the critic Ludwig Hevesi observed, 'it cleared the air.' The 'chief savage' Kokoschka himself, however, had his head shaved and amused himself by provocatively displaying this stigma.

Kokoschka had already not minced his words as the author of a scandalous theatre-piece *Murderer, Hope of Women* which was performed on the garden stage of the Kunstschau. 'Discovered by Adolf Loos at that time, Kokoschka freed himself, under the influence of this fatherly mentor, from his previously decoratively oriented Wiener Werkstätte style, and produced portraits in which he embarked on a dark search for the psyche. With breathtaking directness the painter exposed the character behind the appearances of superficial reality, which often aroused the sitter's fury. According to a prior agreement, all those portraits that could not be sold were bought by Loos, who thus became the owner of the largest collection of Kokoschka's early work.

In the year of Kokoschka's first public exhibition, Richard Gerstl, aged only twenty-five, committed suicide in an especially gruesome manner. Gerstl had avoided contact with other artists and preferred to associate with the composer Arnold Schoenberg and the circle of his pupils. He had emerged with astonishing speed as a painter of shocking immediacy. His Late Impressionistic application of paint finally issued in an existential havoc of colour, of which his

Laughing Self-Portrait in the Österreichische Galerie is a troubling example. The merciless questioning of the painter's own existence in a self-portrait — achieved through an approach not merely anti-academic, but truly brutal — was far removed from the aesthetic ideal of the Secession; it also introduced a preoccupation that was to become characteristic of Early Austrian Expressionism.

Max Oppenheimer — or MOPP as he called himself — was born in Vienna but, until quite recently, has been all but ignored in Austrian art history. Though Oppenheimer decided to abandon Early Expressionist style (which he had evolved at the same time as Kokoschka) for a form of Cubism that made him an exception in pre-war Austria, he still occupies an important place in this context. Sadly, the Österreichische Galerie owns no examples of his early work to prove this adequately. In 1910/11 Kokoschka angrily claimed that Oppenheimer was merely a hanger-on and had copied his, Kokoschka's, pictures. The violent dispute in the 'Danube marshes' was about what Kokoschka (fearing the loss of his uniqueness) called the 'Faustian character and the grim laceration of oneself and others'.

Just as this dispute was gathering momentum there emerged from within the Secession yet another figurehead of Austrian Expressionism — Egon Schiele. The size alone of Schiele's oeuvre is striking: in the ten or twelve years of his effective career (he died aged twenty-eight in 1918), he produced about three hundred and thirty oil paintings and over 2,500 drawings, watercolours and gouaches. Schiele returned repeatedly to the interrogation of his own existence, which he saw poised between transience and sexuality. Despite the initial impression derived from many of his self-portraits, his work goes far beyond pure narcissism. The Österreichische Galerie's splendid Schiele collection, which is strongest in works from the artist's last

years, offers deep insights into Schiele's character both as man and as artist.

Although Early Austrian Expressionism was clearly perceived as such only in retrospect, contemporary Austrian art critics had already begun to refer to an 'Ausdruckskunst' [art of expression]. Alongside Richard Gerstl (whose work was never exhibited during his lifetime), Oppenheimer and Kokoschka were the first to aim at capturing what had, as early as 1908, been called the 'human psyche'. The vibrations of the soul, evoked in broken tones, became the true subject of the style of portrait painting they evolved. They found models in the work of El Greco, Edvard Munch, Ferdinand Hodler and the French Post-Impressionists, especially Van Gogh. Among Austrian artists, the idiosyncratic art of Anton Romako offered a fruitful starting point.

Austria — and in this context that means the metropolis Vienna — may be seen to have contributed its own, clearly distinct variant of Expressionism to a movement that art historical commentary has largely associated with Germany. Most of the Austrian Expressionists were half a generation younger than their German colleagues who established the artists' group *Die Brücke* in Dresden in 1905, or *Der Blaue Reiter* in Munich in 1911. It is true, of course, that Kokoschka collaborated significantly for a time with the Berlin publisher and gallery owner Herwarth Walden and was thus in close contact with Berlin Expressionism. Nevertheless, even while Kokoschka argued that Expressionism was a 'message from me to you', his artistic imagination and that of his Austrian colleagues always turned back to individual body-awareness. There is, for example, a marked contrast to the work of the German Expressionists, which invariably has a strong stress on content and usually revolves, directly or otherwise, around metropolitan life.

While the German Expressionists, like the Fauves (often regarded as their French equivalent), eagerly employed pure colours as the bearers of expression, their colleagues in Vienna tended to glaze, or modulate, refined planes of colour with zones of light and shade. It is also significant that the Austrians were only rarely found in ethnographic museums studying the art of 'primitive' peoples, in the way that their German and French contemporaries were, with such far-reaching consequences.

Generally speaking, in Vienna, with its morbid over-sensitivity, Expressionism evolved in a different cultural and political climate. It is significant that there was no strong local tradition of Modernism. After all, Viennese *Jugendstil* had itself been a tardy development within the general European ferment of the later nineteenth century. And the break with the Secessionist ideal in Vienna occurred within the fold of the Secession itself. It is notable that for the Expressionist innovators — above all, for Egon Schiele — Gustav Klimt remained throughout a humane and artistic point of reference. In the end, in Vienna there was no real commitment to championing the avant-garde; the anarchic euphoria of an iconoclastic free-for-all never occurred in the history-laden Danube metropolis.

During the final decade of the monarchical era, though above all in the difficult years after 1918, Austrian artists were reluctant to engage with Cubism and other Post-Expressionist innovations. At that period Austria distanced itself from the international avant-garde and for some time once again went its own way. Expressionism, however, understood in the most general sense as an emphatically gestural and strongly coloured expressive painting, therefore became the central current of Austrian painting during the inter-war years.

Richard Gerstl, **Laughing Self-Portrait**

Richard Gerstl (1883–1908)
Laughing Self-Portrait, 1908
Oil on canvas, stuck down on to cardboard,
40 x 30 cm
Inv. No. 4035

Richard Gerstl was overcome by a sense of total isolation when he made one last attempt, in front of his easel, at a defiant act of self-definition — the act of laughing, an act he no longer felt able to perform in the outside world. At the end of an unhappy love affair, Gerstl found himself completely alone:

Mathilde Schoenberg had gone back to her husband, but Gerstl himself had forfeited any right to return to the congenial circle of Arnold Schoenberg's pupils and friends. The man we see in the *Laughing Self-Portrait*, with his unshaven chin and shortly cut hair, suggests the 'outcast' character of a prisoner. The ambiguous nature of the light, the apparently nocturnal hour, and Gerstl's despairing and unrelieved instability deprive his laughter of its liberating capacity. Even the act of screaming, already contained within

the laughter, is fragmented, like the scattered spots of colour in the background, leaving only a nervous echo. Even more terrifying, however, is our recognition that, in spite of the raw application of paint, the disharmonious colouring and the sense of a man swiftly slipping out of control, Gerstl recorded his psychological descent in merciless detail, down to the very last highlight on his face.

Egon Schiele (1890–1918)
Man and Woman (Death and the Maiden), 19 5
Oil on canvas, 150 x 180 cm
Inv. No. 3171

A man in a short penitent's gown and a woman with a rouged face embrace each other while crouched, half-kneeling on a rumpled cloth that has been flung down on the ground in a dark, inclement setting. As so often in his work, Schiele gives his own facial features to the male figure, who is shown gazing into emptiness. While his companion (posed by his regular model Wally Neuziel) has placed her thin arms around him, she nonetheless appears to be slipping away from him. Her hands lack the strength to cling to him. Even the white cloth visually encircling the couple is unable to ensure their solidarity.

One is inevitably reminded of Klimt's celebrated picture *The Kiss*, though the distance could not be greater from Schiele's image to that of the complete union of two lovers in the Secessionist shelter of a golden aureole. In place of the perfect harmony sumptuously idealized by Klimt, we here find broken tones and harsh outlines that seem to anticipate the couple's parting. Every detail points disturbingly at the co-existence of love, sexuality and death. It is not only in its title that this work goes far beyond mere portraiture to emerge as an image of emphatic universal validity.

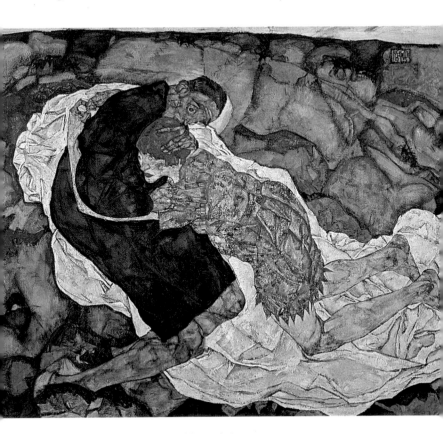

Egon Schiele, **Man and Woman (Death and the Maiden)**

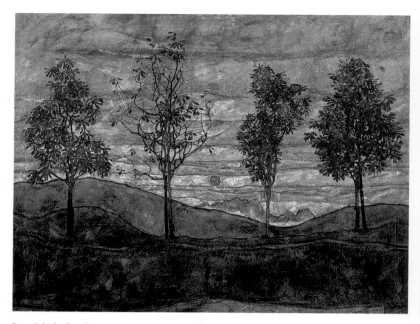

Egon Schiele, **Four Trees**

Egon Schiele (1890–1918)
Four Trees, 1917
Oil on canvas, 111 × 140 cm
Inv. No. 3917

In this picture the rich tradition of nineteenth-century Austrian landscape painting meets the nervous singularity of the oeuvre of Egon Schiele. The row of four small, partially bare horse-chestnut trees does not draw the eye into the depth of the picture but runs parallel to the picture plane. It is perhaps the most beautiful treatment of landscape to be found in Schiele's later work. The sky, heavy with evening, withdraws like the setting sun into the atmospheric depth of the composition, contrasting with the incisively rendered upright forms of the trees. Schiele's emphatically symmetrical repetition of the series of tree forms draws on the theory of 'Parallelism' evolved by the Swiss painter Ferdinand Hodler and illustrated in his work. After Klimt, Hodler was the artist that Schiele most admired. In the reddish evening light every strip of colour making up the landscape, and in particular the sky, comes into its own in all its detail. In spite of Schiele's expressive use of line and colour, the picture reveals its debt to the decorative principles of Viennese *Stilkunst*. After all, nothing is as characteristic of Viennese Jugendstil as the inclination to turn every picture element into part of the overall ornamental design. In Schiele's painting the autumnal landscape is intensified into a symbol of an elegiacal and melancholy state, one whose mystical spell is found in his famous Krumau town scenes as well.

Egon Schiele (1890–1918)
The Family (Crouching Couple), 1918
Oil, over chalk wash, on canvas,
150 x 160 cm
Inv. No. 4277

Schiele himself entitled the painting 'Crouching Couple'. It has always been seen as one of his greatest works, although it was left unfinished, especially towards the lower edges. As was so often the case, Schiele includes his self-portrait (as the male figure), but the features of Edith Schiele (whom he had married in 1915) do not match those of the depicted woman. Originally there were flowers between the woman's legs. It appears that Schiele replaced these with the figure of the child when he learnt that Edith was pregnant, the child's presence celebrating, in the words of the poet Franz Theodor Csokor, the end of impatient expectation in a 'sailing out into the stormy sea of life'. The child was, in fact, never born. Edith Schiele died on 28th October 1918 towards the end of her pregnancy, during the devastating influenza epidemic of that period to which Schiele himself succumbed three days later.

In the picture Schiele squats on a sofa, its outline barely distinguished against the dark background. With his drumstick arms and gaunt body, he forms a protective 'frame' around his family; but the distinct directions of the pose and gaze of man, woman and child undermine any real feeling of solidarity.

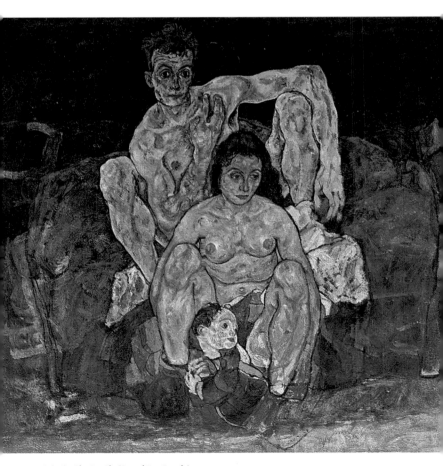

Egon Schiele, **The Family (Crouching Couple)**

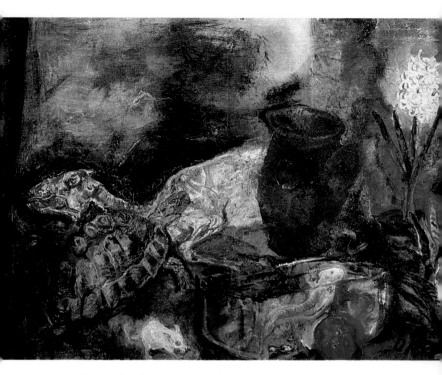

Oskar Kokoschka, **Still Life with Lamb and Hyacinth**

Oskar Kokoschka (1886–1980)
Still Life with Lamb and Hyacinth, 1910
Oil on canvas, 87 x 114 cm
Inv. No. 2358

This still life is one of the most im-
portant pictures that Kokoschka ever
painted and the most famous of his
works in the collection of the Öster-
reichische Galerie. It has usually been
seen as a *memento mori*, as a deeply
penetrating metaphor of a world that is
swiftly and recklessly falling apart. We
know that it was painted in the house
of the physician Dr Oskar Reichel, who
was one of the keenest collectors of
Kokoschka's early work. The already
skinned Easter lamb was brought from
the kitchen; the other components such
as the tortoise, the pink amphibian in
its tank and the white mouse were
found in the play-room of the doctor's
two sons, while one of the children
brought the hyacinth from the conserva-
tory by mistake. Kokoschka's visionary
power, however, draws this colourful
assembly of oddities into a compelling,
darkly animated whole, even though
every detail disturbingly adds to the

'emancipation of dissonance' (Werner
Hofmann). In its transparent 'beauty',
the naked flesh of the dead lamb, like
the picture as a whole, dissolves into
an iridescent play of colour, while the
white hyacinth shines out against a
mysterious blue like an 'eternal light'.
For all its obvious 'modernity', the pic-
ture has a clear connection with the
moralizing tradition of still life paint-
ing since the sixteenth century.

Oskar Kokoschka (1886–1980)
The Pensions Clerk, 1910
Oil on canvas, 74 x 59 cm
Inv. No. 2448

Throughout his career Kokoschka
was a superb portrait painter. His sub-
jects included numerous fellow artists
and bohemians, as well as scholars and
famous personalities from the grand
bourgeoisie. In the picture illustrated
here, however, his subject (according
to Kokoschka himself) was an otherwise
unknown Viennese pensions clerk. In
seeking to render the play of nerves
and the deep instinctual and emotional

processes, Kokoschka employs an unpredictable combination of brittle tones and makes use of brusque, nervous line. He scratches the paint layer with the end of the brush to set off swirling patterns across the black cloth of the man's suit or incisively trace the contour of the face. The awkwardness of gesture, meanwhile, becomes a bearer of almost painful expression, while the aura radiating from around the sitter's head suggests a certain spirituality though also (against the indifferent background) a rather forlorn mood. Kokoschka's way of allowing us to look 'behind the facade' not only recalls the hidden worlds revealed by Sigmund Freud, but also relates to the unornamented architecture promoted by Adolf Loos or to the writings of Karl Kraus.

Oskar Kokoschka, **The Pensions Clerk**

Oskar Kokoschka, **Portrait of the Artist's Mother**

Oskar Kokoschka (1886–1980)
Portrait of the Artist's Mother, 1917
Oil on canvas, 112 x 75 cm
Inv. No. 5840

Were it not for the calm pose of the sitter, here emphasizing the central axis of the picture, the canvas looks as if it might literally crack under the onslaught of nervous brushstrokes. Kokoschka has modelled the thick layers of paint with a broad, flattish brush, creating a pictorial 'web' within which the mildness of the sitter's expression gains in significance. Whereas linear forms scratched into the paint surface had been something supplementary in Kokoschka's earlier paintings, here there is absolute equality between 'line' and 'colour'. In 1916, after being invalided out of the army and convalescing for a while in Vienna, Kokoschka moved to Dresden. Under the influence of this first-hand knowledge of German Expressionist art, Kokoschka's style began to change: the formal and technical tumult found in this portrait eventually gave way to the use of smoothed planes of colour within clear, resolved compositions.

Max Oppenheimer (1885–1953)
The Klingler Quartet, 1916
Distemper on canvas, 71 x 80 cm
Inv. No. 2493

Around 1910, together with Schiele and Kokoschka (with whom he was often at odds), Oppenheimer created what we now regard as the works most central to Early Austrian Expressionism. Not long after, however, Oppenheimer's work started to reflect the new possibilities opened up by French Cubism. In Zurich in 1916 he took part in the first DADA exhibition, and it was at this time that he also produced one of his most celebrated compositions — *The Klingler Quartet*. This quartet, named after its founder, is still regarded as the most significant chamber music group in Germany during the first half of the twentieth century. In 1935 Karl Klingler (1879–1971) disbanded his ensemble because he was not willing to dismiss its Jewish cellist as the Nazi regime had demanded. Oppenheimer's picture is, however, not a portrait of the musicians — their heads, in fact, remain outside the composition. Nor is it a still life of musical instruments. Rather, it aims at illustrating the musical experience itself, one of Oppenheimer's central concerns being the attempt to render music with the means available to its sister art, painting. One can, indeed, imagine that one hears the sound of the music through the positioning of the instruments, the dynamism of the rising and falling lines, the interlocking of the Cubist-influenced motifs and the feeling of a composition so densely packed that it seems to push against the frame.

Max Oppenheimer, **The Klingler Quartet**

Emil Nolde (1867–1956)
Joseph Recounting his Dreams, 1910
Oil on canvas, 86 x 106 cm
Inv. No. 2409

Nolde's picture allows us, within the Österreichische Galerie collection of Early Expressionism, to compare the work of Schiele, Kokoschka or Oppenheimer with that of a painter who was one of the most important German Expressionists and also (albeit only from 1906 to 1907) a member of the legendary artists' group *Die Brücke*. *Joseph Recounting his Dreams* was painted in 1910 and is an early example of Nolde's treatment of biblical subjects (it illustrates the story told in Genesis 37:5–10). Such works are now seen as an outstanding part of his oeuvre. Nolde, the great loner, identified with the biblical figure of Joseph, who was not only an outsider and simple-minded like a fool (hence his costume recalling that of a harlequin) but also a chosen individual.

Thronging around the frail figure of Joseph are his brothers, rendered as enormous yellow, green and vermilion masks, their harshly outlined hands raised in threatening gestures. With lowered eyes, Joseph tells of his dreams of things to come — of how he will save the very brothers who now circle him distrustfully. The suggestive exaggeration of the garish colours (unthinkable among Viennese painters) here becomes the principal vehicle of expression. As Werner Haftmann has written, colour is inevitably brutal: 'in Nolde's work everything immediately becomes ecstatic, a current of images from an imagination attuned to the daemonic, the romantic and the primeval'.

Emil Nolde, **Joseph Recounting his Dreams**

Alexei Jawlensky, **Lady against a Blue Background**

Alexei Jawlensky (1864–1941)
Lady against a Blue Background, c 1908
Oil, paper, on canvas, 63.5 x 44.5 cm
Inv. No. 4027

While Nolde was a sometime member of *Die Brücke*, Jawlensky, a Russian who had settled in Munich in 1896, was a member of the artists' group *Der Blaue Reiter*. He was especially close to the leader of this group, Wassily Kandinsky. Jawlensky's *Lady against a Blue Background* is one of two female portraits by Jawlensky in the collection of the Österreichische Galerie, both dated 1908. Jawlensky's 'model' here was his wife, Helena Neznakomova. Her round face with large eyes and green shadow fills out the entire upper left corner of the picture. Nonetheless, in spite of the close view the individual forms were abstracted as colour planes and are set off against a scattering of decorative details such as the pattern on the lapels of her jacket. In his use of such powerful, barely mixed colours — yellow, red and blue — Jawlensky drew both on Russian folk art and on the work of the French Fauves. The most significant artist among these, Henri Matisse, had a strong influence on the Russian artist.

Art in the 1920s and 1930s

The Österreichische Galerie possesses an extensive and important collection of works dating from the two decades between the end of the First World War in 1918 and the Nazi *Anschluss* of 1938. Most of these are by Austrian artists, but they are supplemented by a small but important collection of international art. Vienna, until 1918 the capital of a multi-ethnic empire, was now no longer the only centre of Austrian art.

The work of Austrian artists during these years was notable for its diversity, and individuality was a central characteristic of those who produced their most important work at this time. In terms of style, too, there was no single predominant trend: Expressionism, a late form of Impressionism, Cubism, *Neue Sachlichkeit* [New Objectivity], Magic Realism and Fauvist tendencies existed side by side. In Paris Austrian artists discovered the work of Paul Cézanne and the other great personalities of 'Classical Modernism'.

Nonetheless, the various artists' associations were of considerable importance in art life during the 1920s and 1930s: in addition to the enduring Vienna Secession (established in 1897) and the later Graz Secession (established in 1923), one should note the moderately progressive *Hagenbund* (established in 1908). Austrian artists continued to train at the Vienna Academy, but the equivalent institutions in Munich, Stuttgart and Berlin were also important for them.

Most of the artists represented in this section were born in the two decades following the year 1885, so that the First World War occurred during their youth or early adulthood. This is true of Oskar Kokoschka (who in 1916 left Vienna for Dresden, where he taught at the Academy until 1924) and of Franz Wiegele, one of the leaders of the 'Nötsch Circle'. An equally decisive change in circumstances occurred with the rise of National Socialism in Germany and sub-

sequently in Austria. This provoked the wave of emigration beginning in the mid-1930s of which many artists formed a part.

These external events found little direct reflection in painting itself; rather, they encouraged a form of escapism, even Idealism, a cult of the idyll. We find, perhaps to our surprise, that in the most difficult periods of the world economic crisis, when the artists' associations were in especially straitened circumstances and painters themselves had to fight for their existence, the work that was produced is notable for Cézannesque landscapes, Arcadian idylls peopled with figures of an idealized beauty, paraphrases of Classical works of painting, and representations of a calm bourgeois world of the family as a solid, secure centre. The fragile and bizarre is expressed less in subject matter than in colouring — especially in as far as many artists rediscovered the primeval force of colour. Very few of the pictures of the 1920s and 1930s in the collection of the Österreichische Galerie are in any way critical of the contemporary political and social situation; though a striking exception is to be found in Oskar Laske's large *Ship of Fools*.

The year 1918 did, of course, mark an abrupt caesura in Austrian art in that it brought the deaths of so many important figures — Gustav Klimt, Egon Schiele and Otto Wagner among them. Viennese *Jugendstil* nonetheless continued to exert a strong influence on art and design in Vienna, in some cases into the 1920s; but in general it would be fair to say that the most varied styles existed alongside one another, often interacting with each other in a sort of symbiosis.

A number of important artists were associated with the Graz Secession, established in 1923 by the artists Wilhelm Thöny, Alfred Wickenburg and Fritz Silberbauer. Thöny, whose early

work was characterized by a melancholy Expressionism, turned after the early 1930s to visionary architectural landscapes especially appealing for their graphic qualities. Alfred Wickenburg was one of the few Austrian artists to adopt Cubist devices, although he adapted these into the 'Plastic Cubism' seen in works such as *Rinaldo and Armida* (1923). Fritz Silberbauer, whose paintings (for example, *My Son* of 1926) may be seen to exemplify *Neue Sachlichkeit*, played a crucial role in the art life of Graz after the First World War.

Rudolf Wacker, an artist from the Vorarlberg, was a pioneer of Magic Realism. His still lifes and landscapes from the mid-1920s onwards have a traditional, almost Old Masterly objectivity. Albert Paris Gütersloh is now widely known as the precursor and mentor of the 'Vienna School of Fantastic Realism'. His literary work is best described as Expressionist, but most of his small-scale paintings are close to Surrealism. A progressive association established after the war was the Salzburg artists' group 'Der Wassermann', founded by Felix Albrecht Harta and Anton Faistauer (an especially important figure in the art life of Salzburg, who died very young). Faistauer, a founder also of the 'Neukunstgruppe' in 1909, initially adhered to the approach of the 'Klimtgruppe'. In the years after the war, the work of Cézanne became of great importance to his art (*Ajaccio*, 1926).

Of particular importance during the inter-war period were the artists of Carinthia, in particular those of the so-called 'Nötsch School'. Franz Wiegele and Sebastian Isepp, who both came from Nötsch in the Gailtal, along with Anton Kolig from Moravia and Anton Mahringer, further developed independently the principle of space-evoking colour in the manner of Cézanne and combined strict composition with a sensual delight in colour. Also associated with this group was the Viennese painter Gerhart Frankl (*Church in the Meadow*, 1929). Among other artists from Carinthia were Arnold Clementschitsch, Felix Esterl and Jean (Hans) Egger. The expressive manner of Egger's early work assumed a light, easy elegance after 1925, when the artist moved to Paris. The leading figure in Austrian art of this period, and indeed, one of the best known figures internationally, was Oskar Kokoschka. Between 1924 and 1931 he travelled widely in Europe.

North Africa and the Near East and started to paint strikingly individual landscapes. Also dating from this period is one of his most vivid records of animals (*The Tiger-Lion*, 1926).

Vienna was significant at this time for the number of exceptional teachers to be found at its Academy and other institutions for training in the visual arts. Many of these teachers had reached early artistic maturity working in an Expressionist manner and had subsequently evolved their own variants of Late Impressionism. Among these were Josef Dobrowsky (who drew on Old Netherlandish painting in his use of subdued yet inwardly glowing colour), Ferdinand Kitt, Ernst Huber, Franz von Zülow (a painter of consciously unsophisticated rustic scenes, discovered by Josef Hoffmann) and Sergius Pauser (whose work of the 1920s and 1930s was close to *Neue Sachlichkeit*).

Among the leading figures in the *Hagenbund* at this time were Joseph Floch, Franz Lerch and Georg Merkel. Floch is most notable for the sense of timelessness, calm and isolation in his figure paintings. Lerch is known for the very controlled compositions of his architectural landscapes, figure paintings and portraits. Merkel remained deeply influenced by his trip to Paris in 1905, and his work continued to reflect his absorption in the imaginary Classical worlds evoked by Poussin, Claude Lorraine and Puvis de Chavannes. Another member of the *Hagenbund* was the sculptor Georg Ehrlich. Influenced by the work of Georg Minne and Wilhelm Lehmbruck, his figures are lyrical, sensitive and harmonious. Like Merkel, Ehrlich may be described as engaged on a quest for Classicity (*The Siblings*, 1933). After the end of the First World War, Austrian sculpture emerged from the shadowy existence it had led since the decline of Historicism. A key role in its rebirth was played by Edmund von Hellmer, whose teachings on 'truth to materials' led him to devise a new type of training for young sculptors. Among those influenced by Hellmer were Anton Hanak, Josef Müllner and Gustinus Ambrosi. Another pupil of Hellmer, Joseph Humplik, was indebted to the art of Antiquity. The most important pupil of Hanak (*Venus Vindobonensis*, 1924–31), in turn, was Fritz Wotruba. His early work is clearly influenced by Minne, Lehmbruck and Maillol, but his early torsos of youths are

also close to archaic Greek examples (*Torso*, 1928/29). Wotruba's only subject was the human figure and his preferred material was stone. He emigrated to Switzerland but returned to Vienna in 1945 when invited to teach at the Academy. Here, introducing a new sense of form and organization into sculpture, he cast a fruitful spell over a whole generation of young Austrian sculptors. Another artist also important as a teacher was the painter Herbert Boeckl: his most significant contribution lay in the discovery of the elemental aspect of colour (*Summer Evening at the Klopeinersee*, 1923). Through the work of his pupils, Boeckl's influence can be felt to this day.

Among the important non-Austrian artists represented in the Österreichische Galerie collection of inter-war art are the sculptors Ernst Barlach (*The Doubter*, 1931), Georg Kolbe (*Mermaid*, 1921), Alexander Archipenko (*Female Nude*, 1920) and Gerhard Marcks; and the painters Max Beckmann (*Reclining Woman with Book and Iris*, 1931), Erich Heckel, Carl Hofer (*Girl with a Plant*, 1923), Ernst Ludwig Kirchner (*The Mountains at Klosters*, c 1923) and Maurice de Vlaminck (*Houses*, 1920).

Herbert Boeckl (1894–1966)
Summer Evening at the Klopeinersee, 1923
Oil on canvas, 44 x 52 cm
Inv. No. 2444

Herbert Boeckl, a leading figure in Austrian art of the 1920s and 1930s, came from Klagenfurt in Carinthia. Influenced in his early career by Egon Schiele and Oskar Kokoschka, he became deeply interested in the work of Lovis Corinth after the end of the First World War. His encounter, during a trip to Paris in 1923, with the work of the great figures of Classical Modernism — Cézanne, Van Gogh and especially the Fauves — as well as that of Théodore Géricault, proved to be a turning point in his artistic development. Colour was the most important aspect of Boeckl's work of the 1920s: 'In [Boeckl's] oil paintings the colouring unfolds with enormous power, and, on account of the brutality of the application of paint, one tends at first to overlook the strong compositional arrangement and the subtle richness of chromatic nuance here serving to tame a temperament of great sensuality into artistic clarity' (Gerhart Schmidt, 1956).

Herbert Boeckl, **Summer Evening at the Klopeinersee**

Hans (Jean) Egger, **Landscape with Church Tower (St Martin am Silberberg)**

On returning to Austria from Berlin, Boeckl painted a number of small pictures that convey an unadulterated, vital joy in his homeland: 'The picture *Summer Evening at the Klopeinersee* presents a cheerful, carefree scene, and the colour accordingly radiates atmosphere, it conveys a vague but pleasurable feeling. . . . The great self-confidence with which the nudes and the reclining figures are placed, with a few powerful brush-strokes, against the green and blue, is remarkable. The red of the evening sky and the figures themselves strike us as self-evident, and we only gradually become aware of their luminosity' (Gerbert Frodl, 1976).

Hans (Jean) Egger (1897–1934)
Landscape with Church Tower
(St Martin am Silberberg), c 1923
Oil on canvas, 79 × 63 cm
Inv. No. 4388

In 1995, the year this guide was written, it was at last possible to mount a comprehensive retrospective exhibition of the work of Hans Egger at the Österreichische Galerie. Egger died young and some of his works remain untraced. A native of Carinthia, he trained in Munich; but Scandinavia was also of importance for him, above all on account of his response to the work of Edvard Munch. The most important period of

Gerhart Frankl, **The Church in the Meadow (St Jean Baptiste in Reims)**

Egger's career followed his move to Paris in 1925. His experience of the city and its art life was to prove decisive for his further development. The Expressionist landscape painting of Egger's earlier career (not dissimilar to the early work of Boeckl) gradually gave way to a very personal, more elegant and generally lighter style. Though painting landscape and nudes as well, he was best known in Paris as a portraitist and, as such, exhibited widely there and with great success.

The *Landscape with Church Tower*, painted before Egger's move to Paris, combines passionate expression with lyrical tenderness.

Gerhart Frankl (1901–1965)
**The Church in the Meadow
(St Jean Baptiste in Reims)**, 1929
Oil on canvas, 55.5 x 82.5 cm
Inv. No. 3172

Frankl originally studied chemistry but soon responded to his sense of a vocation for the arts. Naturally drawn to the 'Nötsch Circle', he studied in Nötsch (an important centre for painting in Austria in the inter-war years) in 1920–21. He became not only a painter but also a theorist, and throughout his life he was deeply absorbed in the art of the past — a preoccupation reflected in his painting and above all in his drawings. A particularly close connection with the Österreichische Galerie is established through Egger's drawings of sculpted figures by the Master of Grosslobming (see pp. 24–25).

Frankl's highly cultivated manner of painting is connected to his knowledge of French Post-Impressionism, in particular the work of Cézanne. This is especially true of one work of 1928, *Still Life with a Clay Pipe*, and of the almost monochrome landscape of 1929 illustrated here. Painted during a stay in France, this record of the church set in the landscape also reveals parallels with the work of Frankl's contemporary Herbert Boeckl. In its subdued tonality and its atmospheric values, however, it is close to the work of Maurice Utrillo.

Albert Paris Gütersloh (1887–1973)
Torbole, 1926
Oil on canvas, 58 x 70 cm
Inv. No. 2596

Gütersloh, born Albert Konrad Kieh-treiber, was a self-taught painter. He is known in Austria as one of the 'Fathers of Modernism', and his works from the 1920s and 1930s were to prove of considerable influence on the emergence and evolution of certain developments in Austrian art after 1945. Gütersloh was very versatile. His early literary work may be termed Expressionist and his early paintings Surrealist. He was the precursor and mentor of the 'Vienna School of Fantastic Realism'.

The Österreichische Galerie possesses two works by Gütersloh — a portrait of his daughter painted in 1934 and the landscape of 1926, *Torbole*, illustrated here. This work is also one of the gallery's contemporary acquisitions: it was donated in the year of its execution by the Julius-Reich-Künstler-Stiftung. In this complexly structured, many-layered landscape, the real village of Torbole on Lake Garda becomes the embodiment of a transient beauty, mirrored in the lake and embedded in an almost tropical vegetation, above which there looms a threatening architecture of clouds.

Oskar Kokoschka (1886–1980)
The Tiger-Lion, 1926
Oil on canvas, 96 x 129 cm
Inv. No. 6323

The Österreichische Galerie possesses major works from every phase of Kokoschka's career. Of paintings produced during his travels of the 1920s there is the Impressionistic *Dulcie Bridge* (1929), painted in Scotland, and the overpowering *Tiger-Lion*, painted at London Zoo. Here Kokoschka took as his subject an exotic and unique cross between a lion and a tiger — an animal which, above all, he saw as a primeval force. This beast of prey left an indelible impression on the artist: 'Very early in the morning, before the first visitors arrived, I was able (as pre-arranged with the keeper) to set up my easel and my painting stuff inside the fence that ran around the tiger-lion's cage. This animal had been a gift from an Indian maharajah, and was a unique cross between a lion and a tiger. I was

Albert Paris Gütersloh, **Torbole**

leaning sleepily against the strong iron bars and expecting a shock when the keeper outside unchained the trap-door of the beast's night cage.... The shock I got when the giant cat leapt out of the darkness like a flaming yellow bomb, into light and freedom, and raced towards me as if he wanted to tear me to bits, was more than enough to wake me up!' Elemental, bestial, hostile, Kokoschka's wild beast is as individually treated as are Kokoschka's city scenes. Of the numerous 'portraits' of Prague (where Kokoschka's father had been born), the Österreichische Galerie possesses the important painting of 1936, *The Port of Prague*.

Anton Kolig (1886–1950)
The Artist's Family, 1928
Oil on canvas, 180 x 200 cm
Inv. No. 2891

Kolig's picture of 1928 is almost exactly contemporary with his brother-in-law Franz Wiegele's *Portrait of the Isepp Family*. Kolig's picture stresses the qualities of monumentality and plasticity; the arrangement of the various participants is like that of sculptures decorating a fountain: 'With the inner dynamism of his style, Kolig has recaptured the impetus of gestures achieved by Verocchio. The powerful standing, sitting, kneeling and reclining poses are awakened to new life.... This ship-borne family, advancing into empty space, refusing any approximation to a bourgeois interior, is closer to a monument than to a conventional family scene.... The depicted figures are as if under the spell of the observing, recording father. They are as earnest as the River Gods of Donner's Fountain (see pp. 44–45), or as the Apostles in the *Last Supper* in San Giorgio Maggiore' (Bohdan Heřmanský, 1975).

Kolig, who was born in Moravia, came to Vienna as a young man and was supported in his artistic ambitions by Gustav Klimt and Carl Moll. Through

Oskar Kokoschka, **The Tiger-Lion**

Anton Kolig, **The Artist's Family**

Franz Wiegele (whose sister he married in 1911), he soon came into contact with the circle of artists in Carinthia: 'I called the "Nötsch School", founded and led by Anton Kolig, imaginary because it is by no means so clear whether one can speak of a "Nötsch School" if one wishes thereby to refer to the activity of both Kolig and Wiegele. For, in fact, one could object that these two never worked or lived in Nötsch at the same time. Kolig came to Nötsch, and met Wiegele, for the first time in 1911. By 1912 Kolig was already in Paris.... Wiegele was then in Algiers, where he eventually became a prisoner-of-war, while Kolig, having lost all his pictures and all his other belongings, was able to cross the border [and return to Austria]. Wiegele then lived in Zurich, only returning to Nötsch in 1925. Shortly afterwards, however, Kolig accepted the offer of a post at the Art Academy in Stuttgart and only returned [to Nötsch] in 1943, that is to say a year after Wiegele's death' (Bohdan Heřmanský, 1975).

The central concern of Kolig's work was almost always the human figure, above all the study of the young male nude, to which a great many of his works are devoted. On occasion he treated still life, but he painted hardly any landscapes. The 1920s was the most important period for Kolig's work on a large scale. In 1925 he provided frescos for the Vienna Crematorium and in 1930 for the Landhaus in Klagenfurt. In 1927 he designed a large mosaic for the foyer of the Festspielhaus in Salzburg. Kolig survived the 1944 air raid on Nötsch in which Wiegele was killed, though he was buried under the rubble of collapsing buildings.

Oskar Laske, **The Ship of Fools**

Oskar Laske (1874–1951)
The Ship of Fools, 1923
Distemper on canvas, 195 x 240 cm
Inv. No. 2387

In this key example of Austrian paint-
ing in the period between the two World
Wars, the artist transposes the satirical
poem of 1494 by the Strasbourg Human-
ist Sebastian Brant to his own time.
Laske himself is found high up one of
the ship's masts, looking out over the
hustle and bustle of his contemporaries
and all the 'follies' of the world. Even
painters such as Egon Schiele and
Gustav Klimt, sculptors like Anton
Hanak, writers like Stephan Zweig,
architects and historians and the satirist
Karl Kraus do not escape his critical
gaze.

Laske, a member of the *Hagenbund*,
studied architecture at the Vienna
Academy under Otto Wagner and even
worked for a while as an architect
before turning in 1904 to the painting
and print-making that were to prove
his real vocation. Like many painters of
his generation, he drew a great deal on
the impressions gained during travel
abroad: he made sketching trips to Italy,
Turkey and North Africa, painting
watercolour landscapes and city views
wherever possible. One particular fun-
damental characteristic in Laske's work
distinguishes it from that of his contem-
poraries: it is the element of narrative
to be found in his landscapes, which in
style derive from 'Atmospheric Im-
pressionism'. His crowded, 'unmasking'
pictures are powerfully independent
works. Originality, fantasy and poetic
individuality are to be found through-
out Laske's oeuvre.

Sergius Pauser (1896–1970)
**Garden in the South of France
(Cap Ferrat)**, 1935
Oil on canvas, 73 x 92 cm
Inv. No. 3324

As was also the case with Wilhelm Thöny or Hans Egger, the encounter with France prompted Pauser to adopt a brighter, more 'cheerful' painting style. Of his work from the 1930s, two versions of the subject illustrated here. as well as numerous scenes of Paris, testify to this change.

In addition to landscapes. Pauser painted portraits and still lifes. During the formative period of his studies in Munich he was much impressed by the work of Carl Hofer, Otto Dix and the early Max Beckmann. In Vienna Pauser studied under Carl Sterrer from 1925 to 1926, and in 1927 he became a member of the Vienna Secession. His early work is above all to be associated with *Neue Sachlichkeit*. During the 1930s, however, he abandoned the coolness and austerity, even melancholy, of these beginnings in favour of an 'impression-istic' painting style using light, glowing colours. 'The painter captures the lush vegetation of this garden in loose, sketchy brushstrokes, the dominating green tones interrupted and enlivened by the luminous red points of colour of the flowers. Bright spots of sunlight play over the ground and bleach to a striking pallor those parts of the reddish facade of a house that are just visible through the thick foliage.... In this picture the painter has succeeded in capturing the sun-drenched atmosphere of a summer day in the idyll of a southern garden' (Cornelia Reiter, 1992).

Sergius Pauser, **Garden in the South of France (Cap Ferrat)**

Fritz Silberbauer (1883–1974)
My Son, 1926
Distemper on board, 40.5 x 35 cm
Inv. No. Lg 579

Depictions of children may be found in works in the Österreichische Galerie collection from all centuries. It is only in the twentieth century, however, that children have been presented to us as such, without an adult disguise.

Silberbauer, who was born in Leibnitz, near Graz, studied in Graz under Alfred von Schroetter-Kristelli (a pupil of Adolf Hoelzel), then at the School of Applied Arts in Dresden, and finally under Ferdinand Schmutzer in Vienna. In contrast to his fellow co-founders of the Graz Secession, Wilhelm Thöny and Alfred Wickenburg, Silberbauer

retained Graz as the central focus of his work. From 1928 he headed the Styrian Provincial Art School and trained several generations of artists there. It was during this period that he evolved, on the basis of Hoelzel's teaching, a theory of form and colour for his pupils.

This portrait of Silberbauer's son is very much in the spirit of *Neue Sachlichkeit*, yet it has a certain expressive power and is tender in its sentiment. '[Silberbauer's] first pictures are striking because of the unusual mixture of simplicity and technical skill, a combination only exceptionally achieved by modern man, while the picture in distemper, *My Son*, is painted with all the earnestness of an Old Master' (Ulrich Baumgartner, 1967).

Fritz Silberbauer, **My Son**

Wilhelm Thöny, **Paris, 11th November (Place de la Concorde)**

Wilhelm Thöny (1888–1949)
**Paris, 11th November
(Place de la Concorde)**, c 1935
Oil on canvas, 60 x 92 cm
Inv. No. 5826

Wilhelm Thöny, who was born in Graz, brought influences from Munich painting to Austrian art. This had commonly been the case during the first half of the nineteenth century as well. Thöny trained in Munich and he was also an important founder-member of the Münchner Neue Secession. Together with Alfred Wickenburg and Fritz Silberbauer, Thöny founded the Graz Secession in 1923. In 1931 Thöny moved to Paris, a city he then proceeded to discover for himself in order to record it in visionary architectural landscapes full of linear charm with occasional points of colour. Thöny himself often wrote of his impressions of Paris: 'I have just come from my studio, where I spend 8–10 hours a day working on large pictures.... the other [picture of] Paris, is just as large, with Nôtre-Dame almost at the centre, and a lot of sky' (letter of 1935 to Alfred Kubin).

In contrast to the melancholy, dark and expressive works of Thöny's Graz period, those painted in Paris are characterized by a gently 'fuzzy', loose style. The change may be closely related to his first impressions of the French capital: 'Now the yellowish bundled rays of the evening sun have broken through the clouds and grope their way, like a gigantic searchlight, through the labyrinth, thus, piece by piece, rescuing the fantastical city from the haze and greyness of a late autumn day. Far away Montmartre gleams; Nôtre-Dame shimmers palely from the Île de la Cité, the festive golden dome of Les Invalides soars, and down here the Seine, with its thirty-two bridges, its countless steamers and tugs, glitters amongst the sea of houses.' Writing in 1950, Bruno Grimschitz described Thöny's experience of colour in Paris: 'The longer [Thöny] stayed in Paris, the looser his oil painting style; [it became] transparent, similar to the transparency of watercolour, and he also attained, in a systematic development, the luminosity of this medium. Thöny's palette took on a very personal, unmistakeable "physiognomy". Blue becomes the underlying tone of chromatic invention, light-saturated, turbulent and unusually powerful in its suggestion of a hovering distance. Within the blue, a similarly cool green is integrated, [establishing] the most extreme colour contrast to white and black'

Franz Wiegele,
**Portrait of the
Isepp Family**

Franz Wiegele (1887–1944)
Portrait of the Isepp Family, 1927/28
Oil on canvas, 180 x 100 cm
Inv. No. 2835

For painters in Austria at work in the 1920s and 1930s artists' associations were of great importance. In 1911 Wiegele exhibited for the first time with the progressive *Hagenbund*, showing his large *Nudes in the Wood*. Like the picture illustrated here, the earlier painting was a form of family portrait, and such works were to prove a recurrent type in Wiegele's oeuvre. The most important of these was the *Portrait of the Isepp Family*, which includes a self-portrait of the painter in the frame. In this slightly slanting 'human tower', Wiegele's brilliant, lucid colouring is used both for finely executed details and for passages that appear unfinished. The still life of fruit displayed on an oval platter is merged with the still life character of the portrait to achieve an uncommon unity.

Wiegele, who was discovered by that great supporter of young talent, Carl Moll, travelled in Africa, Paris and Switzerland, where he produced mostly portraits. *Portrait of the Isepp Family* was, however, painted in his native Nötsch in the Gailtal (Carinthia), where Wiegele had converted his father's forge to make a studio for himself. Wiegele, the leader of the 'Nötsch Circle' (to which Anton Kolig, Sebastian Isepp and Bohdan Heřmanský belonged), had a particularly strong influence on the work of many young artists from Carinthia. In an essay of 1970, Heřmanský wrote of Wiegele's family portraits: 'Wiegele was capable of spending days, even weeks at his easel waiting for the moment when he would feel able to go on with his work in a spirit of sovereign certainty. The tranquility [of

the *Portrait of the Isepp Family*] might well remind one of Manet's *Breakfast in the Studio*, but the strict 'Gothic' construction, the brilliant top-lighting, the rhythmic colour planes ... all this belongs to another world.... In terms of colour too, this picture is a high-point in Wiegele's oeuvre.'

Carl Hofer (1878–1955)
Girl with a Plant, 1923
Oil on canvas, 106 x 73 cm
Inv. No. 2501 (NG 1239), acquired in 1925
from the Galerie Flechtheim, Berlin

The work illustrated here enables us to make an instructive comparison between Austrian and foreign art of the inter-war years. In particular, we can compare the work of the German Carl

Carl Hofer,
Girl with a Plant

Ernst Ludwig Kirchner, **The Mountains at Klosters**

Hofer with that of the Austrian Franz Lerch, and specifically the former's *Girl with a Plant* (of 1923) with the latter's *Open Window* and *Girl in a Hat* (both 1929).

Carl Hofer was born in Karlsruhe in 1878 and also studied at the Art School there before transferring to the Stuttgart Academy. In 1923, the year he painted the picture illustrated here, he became a member of the Academy in Berlin. It was at precisely this time that he evolved his own distinctively restrained type of Expressionism. Carl Hofer's colours — in this case the characteristic bright yellow of the dress — and his faces are very distinctive. They exude a luminous calm and, in this, they approach the work a number of *Hagenbund* artists.

Branded 'degenerate' by the Nazi regime, Hofer was dismissed from his teaching post at the Berlin Academy in 1934.

Ernst Ludwig Kirchner (1880–1938)
The Mountains at Klosters, c 1923
Oil on canvas, 121 x 121 cm
Inv. No. 2475, acquired in 1924 from the Galerie Schames, Frankfurt am Main

For Kirchner, the encounter with the mountains marked a turning point in his life. 'Very seriously ill, Kirchner was brought by friends to Switzerland in 1917. Here the unexpected happened. Surrounded by this mountainous world, Kirchner recovered; and, in a new chapter of his oeuvre, he created an inspired artistic embodiment of his new environment' (Annemarie Dube-Heynig, 1987). A dark destiny awaited this theorist and ideologist of the artists' group *Die Brücke*. In 1937 six hundred and thirty-nine of his works were seized by Nazi agents and thirty-two of these were included in the touring exhibition of 'Entartete Kunst' [Degenerate Art]. Deeply depressed, Kirchner committed suicide on 15th June 1938.

For Kirchner, art and life were always closely intertwined. 'Feeling alienated in the city, he retreated to Switzerland. This change of place was accompanied by changes in both the subject matter and the style [of his paintings]. The dancers, acrobats and street crowds of Kirchner's images of Dresden and Berlin were now replaced in his works by the solitude and sublimity of the Swiss mountain landscape and its inhabitants; splintery, jagged entities gave way to firmer, more rounded forms striving towards greater clarity and monumentality, and to the use of deeper, more saturated colour' (Hella Markus, 1989).

Georg Ehrlich (1897–1966)
The Siblings, 1933
Bronze, h. 167 cm
Inv. No. 76

Ehrlich's sculptural group entered the Österreichische Galerie collection a year after its creation, as a long-term loan from the Verein der Museumsfreunde in Vienna.

Georg Ehrlich is one of the leading figures in Austria art between the two World Wars and from 1925 to 1938 a member of the *Hagenbund*. Initially established as a print-maker, he turned to sculpture in 1926, bringing to this new field his own explicitly lyrical and sensitive quality. The life-size bronze group *The Siblings* was made five years

Georg Ehrlich,
The Siblings

Anton Hanak,
Venus Vindobonensis

before Ehrlich emigrated to London. Preparatory sketches reveal that the artist originally intended to make a more conventional group with mother and child. In the finished work, the sense of vulnerability and helplessness — appropriate expressions for the early 1930s — is emphasized through the smaller child's act of seeking protection from the larger (who here takes on the role of an 'adult').

Ehrlich, who taught himself his sculptural techniques, was strongly influenced by the work of Georg Minne and Wilhelm Lehmbruck. In this tall, columnar group he was, nonetheless, able to go beyond their influence and to create a work of undeniable independence that has come to be recognized as one of the major examples of Austrian sculpture between the wars.

Anton Hanak (1875–1934)
Venus Vindobonensis ('Panzer Venus'),
1924–31
Laas marble, h. 209 cm
Inv. No. 8330

Hanak worked on this project from 1924 to 1931. The figure as we know it now marks the end of a long process of evolution. He presented his first idea for a 'city as sculpture' in a lecture given in Vienna in 1924. To house such a 'city', he proposed to create a space with supra-personal values. The scheme would include a 'Temple of the Viennese Venus' to house a cult figure — the *Venus Vindobonensis* that Hanak eventually made. Numerous sketches document evolution of this scheme.

The figure illustrated here is made of Laas marble, similar to Carrara

marble but more resistant to erosion. The *Venus Vindobonensis* was installed in 1931 in the Skywa-Panzer villa in Hietzing, a suburb of Vienna. After Dr Panzer's death in 1936, it survived all manner of adverse circumstances until it was seized and removed, along with other works of art, after the Nazi *Anschluss*. For a long time it remained untraced. Given as a loan to the Anton-Hanak-Museum in Lang-Enzersdorf (Lower Austria) by Dr Basil Panzer of London in 1971 (Plaster studies for the figure are also in that collection) it was purchased by the Österreichische Galerie in 1989. As revealed by a large wooden figure of the same type found among Hanak's works after his death, the notion of this 'un-Classical' type of Venus preoccupied his thoughts for decades.

Fritz Wotruba (1907–75)
Torso, 1928/29
Bronze cast of 1979, taken from the limestone version, h. 140 cm
Inv. no. I. N. 6291

In the Österreichische Galerie's collection we can trace a certain continuity within Austrian sculpture back to the end of the nineteenth century. This is clearest in the links between later works and a portrait style by the important sculptor Edmund von Hellmer, whose volume *Lehrjahre in der Plastik* [An Apprenticeship in Sculpture] established a theoretical basis for the training of future generations of sculptors. Hellmer's demands, in particular for truth to materials, were absorbed by pupils such as Anton Hanak, passed on by Hanak in turn to his pupil Fritz Wotruba, and then passed on by Wotruba to sculptors

Fritz Wotruba, **Torso**

training under him in the 1950s and 1960s, such as Roland Goeschl.

Both as painter and as sculptor, Fritz Wotruba was a central figure in twentieth-century Austrian art. He studied under Hanak in the years 1928–29, and it was then that he produced his first male torso in limestone. Its formal qualities were to prove exemplary even for sculptors of the next generation. 'When Maillol, his attention having been drawn to Wotruba's sculpture, saw an exhibition of Austrian art in the Galerie du Jeu de Paume in Paris, he could not believe that *Torso* had been made by a 22-year-old' (Jean-R. de Salis, 1948).

Alexander Archipenko (1887–1964)
Female Nude, c 1920
Bronze, h. 52 cm
Inv. No. NG P 120, acquired in 1923 from the artist

This work dates from Archipenko's move to Berlin, where he opened an art school in 1921. He briefly studied painting and sculpture in Kiev before continuing his studies at the École des Beaux-Arts in Paris. Disappointed by the approach to art of Rodin's followers, he found his true 'school' in the collection of Antiquities in the Musée du Louvre. By the time the Nazis branded Archipenko's work 'degenerate', he had left Europe and was teaching at the New Bauhaus in Chicago. In Germany twenty-two of his works were removed from public display.

In the female nude illustrated here a powerfully expressive quality is combined with a sense of the lyrical, while the potentially strong sense of movement is restrained through its absorption within an overall formal integrity: 'Archipenko was the first Expressionist sculptor . . . the entire new generation of sculptors in Germany has much that is derived from him. . . . He swiftly shifted direction away from Expressionism, and then found his own style' (Iwan Goll, 1921).

Alexander Archipenko,
Female Nude

Art after 1945

However disputable the notion of the 'zero hour', it is nevertheless certain that all the traditions of Modernism in Austrian art were entirely buried by 1945. The situation was aggravated by the fact that, even during the two decades before the Nazi *Anschluss*, painters and sculptors in Austria had already ceased to absorb a great deal of what was then being achieved by the international avant-garde. Though some artists were 'moaning and groaning' and others were self-concious and aggressively irritating, after 1945 parts of a newly evolving art scene nonetheless sought out contact and exchange with the experiences of avant-garde artists abroad. Partial points of contact within the Austrian tradition itself were provided by 'Old Masters' (now newly appointed Academy professors) such as Herbert Boeckl or Albert Paris Gütersloh. Oskar Kokoschka, too, though remaining abroad, was an influential figure in Austria.

In the realm of sculpture a figure of particular importance was Fritz Wotruba, around whom a 'school' formed. His own work and the influence of his teaching ensured that Vienna became a centre for contemporary sculpture in the post-war period. Oppositional currents, stretching beyond what is usually considered part of a school, are represented by such renowned and diverse figures as Alfred Hrdlicka and Joannis Avramidis. Very few works by either, alas, are to be found in the Österreichische Galerie, as is also the case with Rudolf Hoflehner, Josef Pillhofer, Andreas Urteil and Karl Prantl.

In later decades new developments with regard to style, material and technique — as found, for example, in the work produced by Bruno Gironcoli or Walter Pichler from the 1970s — led to an enlargement (in every sense) of the concept of the 'sculptural' in the direction of object art and conceptual art. Among the younger generation of sculptors, Erwin Wurm, to cite only one example, has explored the temporal and spatial boundaries and conditions of sculpture in his analytically reductionist works.

Out of the widespread response to Surrealism in the first post-war years (Austrian knowledge of this movement being largely indirect), there evolved the briefly very successful 'Vienna School of Fantastic Realism', with Arik Brauer, Ernst Fuchs, Rudolf Hausner, Wolfgang Hutter and Anton Lehmden as its leading figures. It soon became clear, however, that the concerns of these artists were quite different from those of the Fathers of Surrealism. Nonetheless, as an extreme resort of object-related painting, the Viennese variant of Magic Realism, with its consciously traditional working methods and overriding concern with content, stood in diametrical opposition to the avant-garde that sought not only to abstract from reality but itself to be abstract. Friedensreich Hundertwasser, meanwhile, protesting against the dictatorship of the straight line and other manifestations of artistic conformism, discovered his own subject in abstract ornament.

After the various attempts at geometrical abstraction, it did not take very long for Informal Art to establish itself in Austria. In the place of conceptual discipline and clearly defined forms, there emerged (following the lead of Paris and New York) a form of painting that introduced emotion, vehemence of gesture, furious speed and the element of the aleatory. The leading representatives of the early stage of Austrian Informal Art were Maria Lassnig (in whose class at the Vienna Academy there evolved an integration of painting and film), Oswald Oberhuber (who has continued to elude every artistic dictatorship of systematic style through his spontaneity) and Arnulf Rainer (who rose to international fame by painting

over his own and others' pictures). An uncompromising Informal Action Painting was evolved by painters such as Hans Staudacher (a self-taught artist from Carinthia) and Markus Prachensky (from Tyrol).

During the 1960s the 'happening' gave rise to scandal-provoking 'Viennese Actionism': its leading exponents included Otto Mühl, Günter Brus, Rudolf Schwarzkogler, Valie Export, Adolf Frohner and Hermann Nitsch. This last was notorious for his 'Orgien-Mysterien-Theater'. In his attempt at freeing art and the artist from conventional constraints — his widely admired work had a taboo-breaking, and often brutal, bodily component — he provided the Austrian contribution to the revolutionary upheavals of 1968. Most artists who were outsiders or broke with conventions understood art as a political statement. One of the consequences was that, in 1983, freedom for art was enshrined in the Austrian constitution. Another important group (the art critic Karl Diemer, in 1969, called them 'Vienna Naturalists') included painters such as Fritz Martinz or Georg Eisler and the painter and sculptor Alfred Hrdlicka. Associated with the international return to expressive figuration and the restitution of easel painting in the 1980s were painters such as Christian Ludwig Attersee and the so-called 'Neue Wilden': Siegfried Anzinger, Erwin Bohatsch, Alois Mosbacher and Hubert Schmalix.

When the Museum des 20. Jahrhunderts [Museum of the Twentieth Century] was established in the Schweizergarten in 1962 and the Museum moderner Kunst [Museum of Modern Art] was opened in 1979, the limited funds available for the acquisition of art by the state were principally directed towards the development of these collections. Only from the mid-1980s, when the lack of clarity regarding the respective responsibilities of the Österreichische Galerie and the Museum moderner Kunst started to cause ever graver problems, has the former itself embarked on systematic collecting of art made after 1945.

Basically only rather traditional concepts of painting and sculpture were acknowledged. Experimental works that questioned social relations and the conditions of artistic production, and those evolving from a much wider understanding of art — object art, video and installation — were not collected. As a result, the modern collection suffers from serious gaps. There is nothing at all, for example, of 'Vienna Actionism', while the group associated with the once celebrated 'Galerie nächst St Stephan' — Mickl, Hollegha, Prachensky, Rainer, Oberhuber — is poorly represented. Even where famous names are not absent, their importance is not reflected in major works. As yet, therefore, the modern collection lacks examples comparable in their quality or their singularity to those found in the other sections of the Österreichische Galerie.

Fritz Wotruba (1907–76)
Large Seated Figure (Cathedral), 1949
Limestone, h. 145 cm
Inv. No. 4769

The human figure is central to the oeuvre of Fritz Wotruba. At the same time, and in no small part due to this artist's compelling personality, the human figure has also become — as subject as well as exhortation and touchstone — one of the constants in Austrian post-war sculpture, a body of work that soon achieved international recognition. After the end of the Second World War, and his return to Austria from exile in Switzerland, Wotruba increased the architectonic stabilization of his sculptural forms according to archaic principles. In place of anatomical elements, he used cubic forms accommodated to the scale of the figures. This process of reduction was implemented according to a strict underlying concept: by means of a totality of plane, incision and edge, the sculptor filtered out every connection with the individual figure. Accordingly, in this early major work *Large Seated Figure* Wotruba achieved what might be termed an 'architectonic simile', fully justifying the alternative title *Cathedral*.

Fritz Wotruba, **Large Seated Figure (Cathedral)**

Anton Lehmden, **Summer and Winter**

Anton Lehmden (b 1922)
Summer and Winter, 1951
Distemper on fibre-board, 29 x 54 cm
Inv. No. 4626

Anton Lehmden was born in Slovakia and began his studies at the Vienna Academy in 1945. Along with Rudolf Hausner, Ernst Fuchs, Wolfgang Hutter and Arik Brauer he was a main exponent of the so-called Vienna School of Fantastic Realism. The early work illustrated here — Lehmden was twenty-two when he painted it — already bears all the marks of the artist's mature view of art and of his Weltanschauung.

Two spits of land carved up by bays extend into the balmy depths of a primitive seascape. The few trees and bushes are not escapees from a massive destruction by man, but rather tender shoots of a world *in statu nascendi*, in which water and earth are only now separating, while summer and winter still co-exist, their distinct identities as yet undecided. Nonetheless, of all the millions of years required for this evolution, Lehmden's picture records only a fraction of a second, without any sense of urgency and no element of the spec-tacular. Lehmden embodies his concept of landscape and the myth of creation with purely graphic means and, notably, a most delicate application of line. On the other hand, the black storm-birds and the hints at turbulence in the sky recall, in their evocative symbolism, the 'Weltlandschaft' [world landscape] of sixteenth-century painting, in particular that of the 'Danube School' of Albrecht Altdorfer and Wolf Huber.

Arnulf Rainer (b 1929)
Easter Morning, 1953/54
Oil on canvas, 32.5 x 48 cm
Inv. No. Lg 543

This is still the only work by the dazzling painter Arnulf Rainer in the Österreichische Galerie collection. This austere composition of clearly defined planes of colour in 'corporeal' Indian red, blue, yellow and white, was produced at a time when the young Rainer, having abandoned Magic Realism for micro-structures and centralized forms, was becoming interested in a completely distinct, geometric abstraction. While this phase (during which he was especially preoccupied with the work of Piet Mondrian and with exercises in proportion) did not last long, it was still of some significance within his overall development. For the feeling for balance and composition refined during this phase was never entirely abandoned even during the most savage of Rainer's later colour tempests. Rainer became internationally famous (and notorious) for his series of over-paintings, in which the unrestrained thrusts of his brush, as anarchic as they were provocative, did not baulk even when confronted with the work of other artists.

Arnulf Rainer, **Easter Morning**

Friedensreich Hundertwasser, **The Large Path**

Friedensreich Hundertwasser (b 1928)
The Large Path, 1955
Polyvinyl acetate on canvas, 160 x 160 cm
Inv. No. 5495

Hundertwasser decisively reversed the elemental language of abstraction of the art of the first post-war years (he accused its practitioners of soullessness) into something individual and personal. For Hundertwasser, who is an architect as well as a painter, the geometry of linearity is a symbol for human alienation. In terms of the language of form, Hundertwasser himself may be seen to work in the same tradition as the Viennese Secession, while also drawing on the legacy of Paul Klee. In the work illustrated here, his favoured spiral form dominates the square canvas, advancing outwards from its origin at the centre of the picture, and yet never losing its relation to this centre. The magic of this large-scale and essentially flat composition (given to the Österreichische Galerie by the artist in 1962) derives from the calligraphic poetry of ornamentation combined with the pulsating 'contest' between the colours — a radiant red, flashes of yellow, then a powerful blue, tending at the edges to tones of green.

Andreas Urteil (1933–63)
Standing Figure with Raised Arms ('Dread'),
1958
Bronze, h. 44.8 cm
Inv. No. Lg 1040

Among the many talented artists to emerge from the 'Wotruba School', Andreas Urteil, who died at thirty, was among the most original. He created vitalistic, 'baroque', gristly figures that were emphatically painterly in their suggestion of lively gesture. Equivalents to this sculpture are in fact to be found in Austrian Informal Painting but also in the spots of colour of French *Tachisme*.

The work illustrated here is a bronze cast made after a cement cast that was in the artist's possession on his death. Through the strong element of turbulence, Urteil bestows on this piece a dimension that Wotruba had never permitted himself. In Wotruba's own words: 'I was always indifferent to movement, and in fact found grimaces repugnant. I was drawn to what was fixed, rigid, to things that didn't give way at the touch; looking back now, I'd say that very early on I already had a passion for the statuesque.'

Andreas Urteil
**Standing Figure with
Raised Arms ('Dread')**

Hans Staudacher, **3x**

Hans Staudacher (b 1923)
3x, 1958/59
Oil and collage on fibre-board,
170 x 130 cm
Inv. No. 8979

As one of the most consistent Austrian representatives of Gestural Abstraction, Hans Staudacher (a self-taught artist from Carinthia) created pictures that stood mid-way between spontaneous immediacy and intellectually controlled composition. In his work, Staudacher took literally the concept of 'handwriting' (which, since the work of Van Gogh, had been a crucial artistic principle for the European avant-garde,

and of particular relevance to Informal Art) and enlarged it into the 'scriptural'. Increasingly, Staudacher abandoned constructively arranged figurations in favour of a dynamic impulsive record, giving the initial impression of movement and furious speed. As is especially clear in the work illustrated here, the freedom thus obtained related not only to the scope for expression but also to new possibilities for encipherment. From their starting point in the two central block-like forms, scriptural elements run across the pale blue picture surface. For Staudacher this signalled: 'Painting and poetry no longer narrate, they operate.'

Roland Goeschl (b 1932)
Figure in Movement, 1965
Wood, painted blue and red, h. 274 cm
Inv. No. 8883

Goeschl's *Figure in Movement* may be seen as a development of the forms constructed with massive cubes by his teacher Fritz Wotruba. This work is not only a major example of Austrian sculpture of the 1960s — it was exhibited at the Venice Biennale of 1968 — but it also seeks to be nothing less than the exemplary combination of the sister arts of painting and sculpture. Using massive wooden beams nailed into a fan shape to create a gigantic striding figure, Goeschl creates a construction that is as dynamic as it is solid, an achievement clearly signalling an ultimately Futurist inspiration. The primary colours red and blue, meanwhile, which remain crucial in Goeschl's work, make it clear that his sculptures are already concerned to 'occupy' the space surrounding them. Having meanwhile added both yellow and green to his 'palette', Goeschl is able to use both the strength and purity of colour harmonies to intensify the dynamic quality in this work.

Roland Goeschl, **Figure in Movement**

Max Weiler, **Like a Landscape, the End of the Mountains**

Max Weiler (b 1910)
**Like a Landscape,
the End of the Mountains**, 1965
Distemper on canvas, 90 x 130 cm
Inv. No. Lg 654

Max Weiler was born in Tyrol in 1910. Not only by virtue of his great age, he is considered the doyen of Austrian art. Between fountain-like outbursts and deep mountain gorges, Weiler leads us into a realm that seems to relate as much to his native Tyrol as to any associative inherent dynamism. Painted over a white chalk ground, which remains visible in numerous passages, fluent cascades of colour condense into richly nuanced tones of ochre and green. From the Second World War onwards, landscape has been the principal concern and the criterion of Weiler's work. In common with Cézanne, albeit with entirely different means, his forms are not derived from nature but created parallel to it. Weiler paints from memory and seeks to capture merely suggestions of a particular landscape, an approach that some critics have compared to old Chinese watercolours. In 1964 Weiler moved from Tyrol to Vienna to teach at the Academy. At the height of his creative career, in the 1960s, he painted the series jointly titled 'Like a Landscape'. This phase of his work, between 1961 and the iron-curtain project for the Tyrol Landestheater in 1967, in Otto Breicha's words, 'has to be felt and discovered beyond appearance.' From his special position Weiler has contributed to post-war Austrian art a body of work whose central theme of landscapes is of importance beyond the borders of his country.

Maria Lassnig (b 1919)
Double Self-Portrait with Camera, 1974
Oil on canvas, 180 x 180 cm
Inv. No. Lg 842

Maria Lassnig, who resigned in 1990 from her teaching post at the Hochschule für angewandte Kunst due to her advancing age, has, without question, long been regarded as Austria's most important woman artist. All her work centres on the body's sense of itself and the translation of this sense into painting. Although one of the earliest Austrian exponents of Informal Painting in the early 1950s together with her then-companion Arnulf Rainer and others, she later returned to expressive-figurative forms. In 1968 she moved to America, where she lived for ten years and where this *Double Self-Portrait* was painted.

Here the artist herself appears twice: once seated, in the foreground, and a second time standing, holding a camera, in a 'picture within a picture' hanging on the wall. (Lassnig was also an experimental film-maker, and in 1981 she established a studio for animated cartoon films at the design school). Only the camera lens points directly at the viewer, while the facial expression of the standing Lassnig is hard to define and that of her seated (almost crouching) figure is not clear because the face is distorted. By means of idiosyncratic colouring and the impact of her incisive irony, Lassnig uses her body-awareness paintings to convey the notion of distance between 'herself' and 'her own self', a process during which a sense of tragedy or pathos may also emerge.

Maria Lassnig, **Double Self-Portrait with Camera**

Franz Ringl, **The Manipulated One**

Franz Ringl (b 1940)
The Manipulated One, 1979
Mixed media on paper, laminated and stuck
down on to fibre-board, 150 x 120 cm
Inv. No. 8506

A dominatrix in suspenders, with shrivelled breasts and electrified hair, and looking at us with four eyes, is pushed so far towards the picture plane as sheer naked corporeality that her extremities and everything else recedes (she recalls, indeed, the prehistoric *Venus of Willendorf*). Yet the intention, and the effect, are contradictory here. Ringl's urinating woman transfixes male desires and anxieties and is aptly described as painting 'from the guts'. As a highly unconventional contribution to

the enduring debate on the human image, Ringl's vividly imagined figures from the twilight zone between desire and neurotic or regressive instinct offer a commentary on artistic renunciation, using the umbilical cord twining around the body as a metaphor of alienation.

The violence of the image corresponds with the violence of the processes used in its creation — erasing, scratching out and over-painting. Yet the 'beautiful' a-perspective space with the Pompeii-red — or is it plush red? — wall and the caricature drawn on it (qualifying the repulsive in the image of the woman) prompt us, together with decorative elements such as the treatment of the sofa, to think as much of the Viennese faith in ornament as of autism.

Hubert Schmalix (b 1952)
Christ I, 1992
Oil on canvas, 172 x 133 cm
Inv. No. Lg 1090

Hubert Schmalix, one of the chief representatives of contemporary Neo-Expressionist painting in Austria, has so far treated three principal subjects — depictions of the female nude, schematically composed pictures of houses and sacred themes. Schmalix's engagement with the image of Christ resulted in a richly varied series of paintings.

The work illustrated here offers an archetypal image of the Saviour, made up of interlocking planes of colour. The dominant impression of the vertical construction of the figure at the centre of the picture, shown in profile, is offset by means of the chromatic emphasis on planarity. In this work, where the penetration of essence goes beyond mere representation, European and non-European influences are found to mingle. The strict image of Christ in the iconography of Early Christianity is here paraphrased into the appearance of an idol, in order to allow one the better to approach that aspect of the figure that in itself cannot be represented.

Hubert Schmalix, **Christ I**

The Gustinus-Ambrosi-Museum and Studio in the Augarten

Geographically separated from the Belvedere complex yet institutionally linked to it since 1978 is the museum dedicated to the sculptor Gustinus Ambrosi, which is located in his former studios in the Augarten, in the northeast part of Vienna. In 1992 this museum was allotted an additional role: it is now partly used, under the auspices of the Österreichische Galerie, for exhibitions of the work of young artists.

The studios, built in the streamlined style of the 1950s by Georg Lippert, are imbued with the artist's Renaissance dreams. Gustinus Ambrosi in fact did more than merely advise in the project to adapt the building, though sadly he did not live to see it come to fruition in the museum that opened in 1978. The concept of a museum dedicated to a single sculptor is most readily associated with examples such as the Bertel Thorwaldsen Museum in Copenhagen or the Musée Rodin in Paris. These are solemn temples of art for large-scale sculpture. Many of their contemporary equivalents, however, seek to confront the work of the specially honoured artist with contemporary currents in sculpture. In the Augarten the opportunity to do this was seized: in the former studios a collection of Ambrosi's works is joined by new art — whether in the form of temporary exhibitions or as spontaneous artistic 'actions'. In addition to all this new life, the former studios are also distinguished by their very even north light, the surrounding verdure of old plane trees and the presence of rare or exotic vegetation.

Ambrosi was best known as a portrait sculptor, those who sat for him including celebrated artists, politicians, even popes. He also produced figural groups based on mythological or biblical themes, for example *The Fate of the Sons of Prometheus*, *Icarus* or *Cain*. The works on display in the museum in the Augarten are made in bronze or marble; also notable are their bases, selected by the artist himself and usually of valuable stone.

Gustinus Ambrosi, **Stephan Zweig**

Gustinus Ambrosi (1893–1975)
Stephan Zweig, 1913
Bronze, h. 41.5 cm
Inv. No. A 6

This is one of Ambrosi's earliest works as a sculptor. The Austrian writer Stephan Zweig, who in 1913 had just published *Der verwandelte Komödiant* [The Transformed Actor], was later forced to leave Austria, emigrating in 1938 to England and in 1941 to Brasil, where he committed suicide. (Ambrosi too killed himself, albeit in entirely different circumstances).

Becoming deaf at the age of seven, Ambrosi studied at the School of Applied Arts in Prague and then at the State School of Applied Arts in Vienna. He continued his sculpture studies under Edmund von Hellmer, Josef Müllner and the by now aged Caspar von Zumbusch, through all of whom he could claim a link to a long tradition of Austrian sculpture.

The individual, lyrical expression arising from the inclination of Zweig's sensitive head, is characteristic for this early phase of Ambrosi's work, that is to say from about 1909 to the early 1920s. As he became more famous and received formal recognition for his work, Ambrosi's portraits tended to become more shallow and generalized.